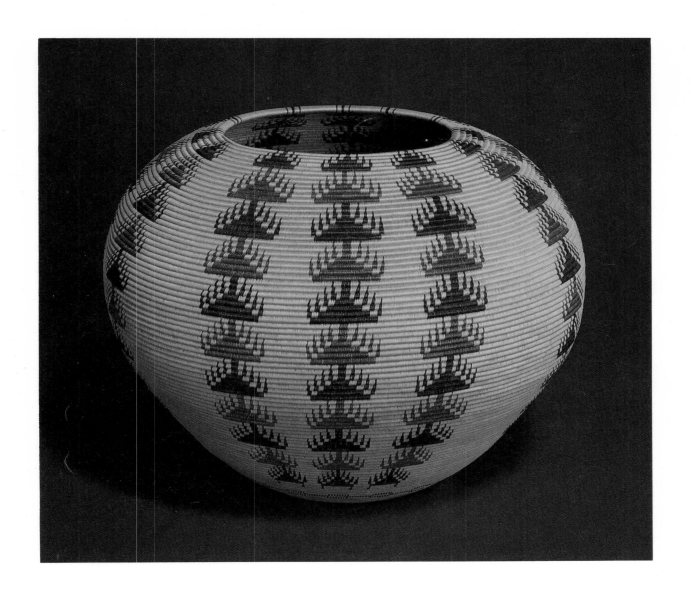

Native American Art at Philbrook

Native American Art

at Philbrook

August 17 - September 21, 1980

Philbrook Art Center
Tulsa, Oklahoma

FRONTISPIECE:

Datsolalee (Louisa Keyser), Washo, ca. 1850-1925
Mountain willow, bracken root, Nevada redbud bark

This basket is the crowning achievement of the most famous of Native American basketmakers. Begun in March, 1917, and completed eleven months later, it is fifty-two inches in circumference and has more than 100,000 stitches—more than thirty to the inch. Although made for ceremonial use, the shape is that of a food bowl. To Datsolalee, the design meant "We assemble to discuss the happy lives of our ancestors."

Library of Congress Catalogue Card Number LC 80-82374

EDITING AND DESIGN: Carol Haralson
PRODUCTION ASSISTANCE: Gregory Pitts
PREPARATION OF CATALOGUE ENTRY DATA: John Mahey, Isabel McIntosh
PHOTOGRAPHY: Ronda Kasl

Maps courtesy of Walker Art Center and The Minneapolis Institute of Arts.

The Indian verbal form is given visual form in Indian art. The language is beautiful and poetic. When the Indian speaks of nature, it is like one of the elements speaking of another element. The Indian lived in nature so long that he became part of it.

Oscar Howe, 1969

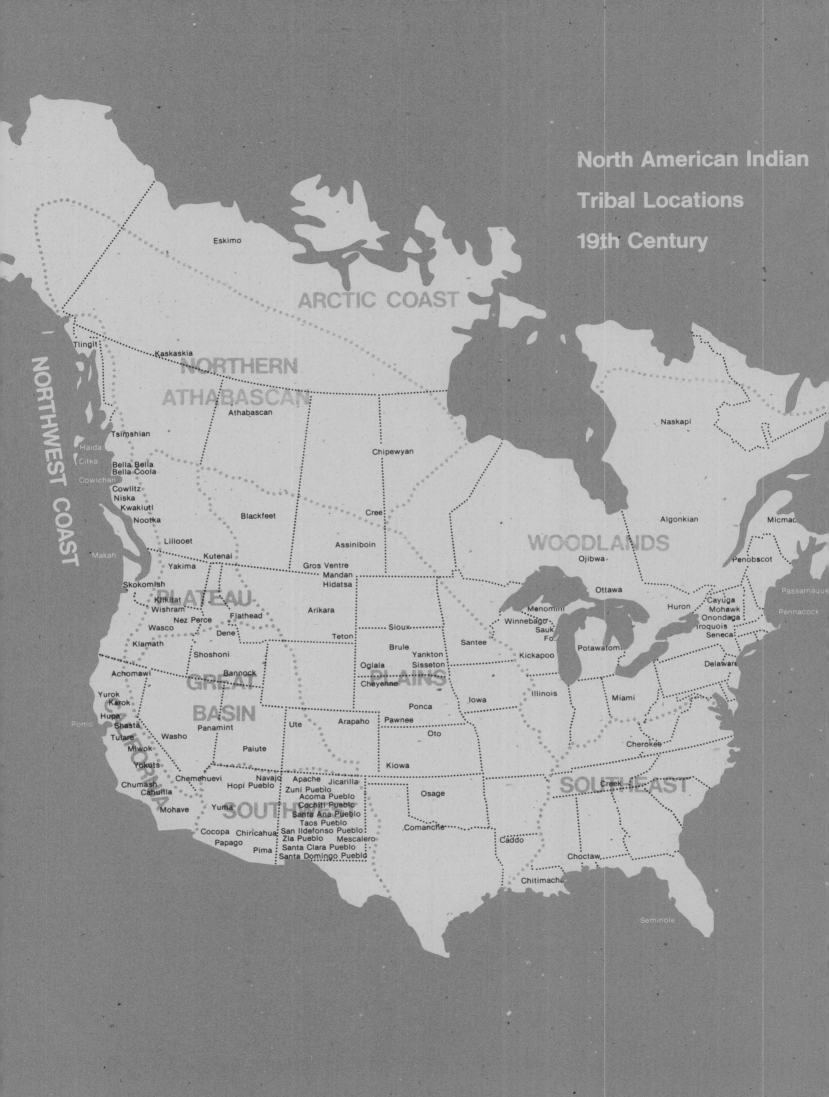

North American Indian

Tribal Locations

19th Century

ARCTIC COAST

NORTHERN ATHABASCAN

NORTHWEST COAST

WOODLANDS

PLATEAU

GREAT BASIN

PLAINS

CALIFORNIA

SOUTHWEST

SOUTHEAST

Eskimo

Tlingit
Kaskaskia
Naskapi

Tsimshian
Chipewyan

Haida
Sitka
Cowichan
Bella Bella
Bella Coola
Cowlitz
Niska
Kwakiutl
Nootka
Cree
Algonkian
Micmac

Lillooet
Assiniboin
Ojibwa
Penobscot

Makah
Kutenai
Gros Ventre
Ottawa
Huron
Passamaque

Yakima
Mandan
Hidatsa
Menomini
Cayuga
Mohawk

Skokomish
Klikitat
Wishram
Nez Perce
Wasco
Flathead
Arikara
Winnebago
Sauk
Fo.
Onondaga
Iroquois
Seneca
Pennacock

Dene
Teton
Sioux
Kickapoo
Potawatomi
Delaware

Klamath
Santee

Achomawi
Brule
Yankton
Oglala
Sisseton
Illinois
Miami

Yurok
Karok
Hupa
Shasta
Cheyenne
Iowa

Pomo
Ponca

Panamint
Ute
Arapaho
Pawnee
Oto
Cherokee

Tutare
Washo
Bannock
Shoshoni

Miwok
Paiute
Kiowa

Yokuts
Chemehuevi
Navajo
Apache
Jicarilla

Chumash
Cahuilla
Hopi Pueblo
Zuni Pueblo
Acoma Pueblo
Cochiti Pueblo
Santa Ana Pueblo
Taos Pueblo
San Ildefonso Pueblo
Zia Pueblo
Santa Clara Pueblo
Santa Domingo Pueblo
Osage
Creek

Mohave
Yuma

Cocopa
Chiricahua
Mescalero
Comanche
Caddo
Choctaw

Papago
Pima

Chitimacha

Seminole

North American Indian

Tribal Locations

20th Century

ARCTIC COAST

Eskimo

NORTHWEST COAST

NORTHERN ATHABASCAN

WOODLANDS

PLATEAU

GREAT BASIN

CALIFORNIA

PLAINS

SOUTHWEST

SOUTHEAST

Tlingit
Kaskaskia
Athabascan
Tsimshian
Haida
Sitka
Bella Bella
Bella Coola
Cowichan
Cowlitz
Niska
Kwakiutl
Nootka
Lillooet
Makah
Skokomish
Kutenai
Klikitat
Wishram
Yakima
Flathead
Wasco
Nez Perce
Dene
Klamath
Achomawi
Yurok
Karok
Hupa
Shasta
Pomo
Tulare
Miwok
Yokuts
Chumash
Cahuilla
Mohave
Yuma
Washo
Paiute
Shoshoni
Panamint
Ute
Shoshoni
Paiute
Chemehuevi
Hopi
Navajo
Apache
Jicarilla
Cocopa
Papago
Chiricahua
Pima
Mescalero
Chipewyan
Cree
Gros Ventre
Blackfeet
Assiniboin
Cree
Arikara
Hidatsa
Teton
Mandan
Northern Cheyenne
Plains Ojibwa
Sioux
Brule
Oglala
Arapaho
Sisseton
Yankton
Santee
Ponca
Winnebago
Sauk & Fox
Kickapoo
Potawatomi
Kickapoo
Iowa
Oklahoma Tribes
Pueblo Tribes
Ojibwa
Menomini
Ottawa
Huron
Naskapi
Algonkian
Micmac
Penobscot
Passamaquoddy
Pennacook
Mohawk
Onondaga
Iroquois
Cayuga
Seneca
Cherokee
Choctaw
Creek
Chitimacha
Seminole

*Pueblo Tribes
Acoma
Cochiti
Santa Ana
Taos
San Iidefonso
Zia
Santa Clara
Santo Domingo
Zuni

*Oklahoma Tribes
Creek
Cherokee
Sauk & Fox
Osage
Ponca
Miami
Seminole
Potawatomi
Choctaw
Southern Cheyenne
Pawnee
Oto
Arapaho
Caddo
Kiowa
Comanche
Delaware
Illinois

Contents

Catalogue of the Exhibition

Board of Trustees

Staff

Foreword

JESSE G. WRIGHT, JR.
Director, Philbrook Art Center

Since its beginning as a general art museum, Philbrook has collected and exhibited Native American art and artifacts, becoming widely known as the home of the Indian Annual, a significant national survey of contemporary Native American art. This year's exhibition is intended to pay homage to the thirty-five years of the Indian Annual, to demonstrate the extraordinary quality of Philbrook's holdings, and to firmly reassert our dedication to the collection, preservation, and exhibiting of Native American art.

This catalogue, I trust, will serve at least two important purposes. It will illustrate and document the first comprehensive exhibition of Philbrook's Native American art, and it will serve as a useful guide for those who may in the future wish to form an overview of our holdings. While the present exhibition contains almost six hundred objects chosen to suggest the nature and breadth of Philbrook's Native American holdings, it still must be seen as only representative of a collection of several thousand objects.

During recent months, the professional staff concerned with the Native American collection at Philbrook has been deeply involved in that process of reassessment which from time to time is essential in planning the most productive use of collections, resources, and facilities. Part of the result of our ongoing evaluation of Philbrook's Indian program is a plan for next year's Indian Annual which will take the form of an invitational exhibition. As such, it will survey contemporary Native American art, emphasizing the quality and diversity of this important art form.

Mounting the current exhibition and producing its catalogue have involved the skills and energies of many people. The support of our Native American Art Committee has been invaluable, and one member of that committee, Dr. Rennard Strickland, has been especially generous in writing the catalogue essay, bringing to the task his unique understanding of Indian history and appreciation of Indian art.

Objects chosen for the exhibition were selected by a team of the museum staff headed by chief curator John Mahey, and including Marcia Manhart, Isabel McIntosh, and Charles Taylor. Catalogue entries were written by Mrs. McIntosh and Mr. Mahey, while the exhibition design was developed by Charles Taylor. Catalogue design and production were skillfully undertaken by Carol Haralson with the assistance of Greg Pitts, while photography—a labor of many months—was in the capable hands of Ronda Kasl. In a small museum such as Philbrook, a project of this breadth necessarily involves the entire staff in one way or another. To everyone, therefore, I convey my congratulations and appreciation for a job well done.

Introduction

JOHN A. MAHEY
Chief Curator, Philbrook Art Center

It should come as no surprise that Oklahoma, with the largest Native American population of any state in the Union, is extremely rich in Native American art. By the time statehood was achieved in 1907 several museums in other parts of the country were already actively collecting. Thus, the Smithsonian Institution, the Peabody Museum at Harvard and the American Museum of Natural History, among others, were well on their way to forming vast collections at a time when Oklahomans had hardly begun to think of such things. Yet the people of Oklahoma, both Indian and white, possessed a vast wealth of Native American art and artifacts much of which has come to rest in late-established Oklahoma museums, historical societies and institutions of higher learning. Further, many Oklahomans with a keen sense of history and interest in preserving a record of Native American culture have actively engaged in collecting and preserving cultural artifacts wherever they could be secured.

Although no Oklahoma museum owns encyclopedic Native American collections, there are several key collections of great significance. Tribal museums such as those at Tahlequah, Pawhuska, Okmulgee and Muskogee have given great attention to collecting and preserving the art of tribes with strong contemporary cultures in the state. The University of Oklahoma owns important collections, as do Bacone College and the museum at Woolaroc near Bartlesville.

It is undoubtedly in Tulsa, however, that one finds the largest concentration of Native American art in Oklahoma. It is spread among the collections of the University of Tulsa, the Gilcrease Institute of American History and Art and Philbrook Art Center.

The University of Tulsa has long been a pioneer in advancing the study of Native American history and law. Its collection of manuscripts and printed material in these areas, together with unique curricular opportunities and a distinguished faculty, have placed it in the forefront of those universities giving credence and priority to Native American studies. Significant also are the University of Tulsa's programs in Native American anthropology and archaeology and its continually growing collections. Much of the university's ethnographic material has been on indefinite loan to Philbrook for many years, while a large part of its archaeological material may be found at the Gilcrease Museum.

When Thomas Gilcrease began forming his great collection of Indian and non-Indian art, there was no guarantee that it would finally come to rest in Tulsa, but fortuitously for Tulsa it did. It is widely recognized as the premiere collection of paintings and sculpture depicting the opening of the West. Its Morans, Remingtons, Russells, and Catlins are unmatched and probably unmatchable. Yet the Gilcrease Museum, owned and operated by the City of Tulsa, has much more, including an invaluable library and several thousand pieces of Native American art.

Philbrook is an equally important repository of Native American art in Tulsa. It opened its doors as a general art museum in 1939, and obtained its first Indian art objects as early as 1940 with acquisition from the Colorado Fine Arts Center of a small collection of prehistoric Southwestern pottery. Soon thereafter, larger and more important collections began arriving and fine loan collections were obtained. Some, such as the Clark Field Collection and the Roberta Campbell Lawson Collection, were later given to Philbrook and now form the core of its permanent collection of Native American art. There were also loans from other museums, e.g. Northwest Coast Indian

art from the museum at the University of Washington in Seattle, and Eskimo art from the Haggin Memorial Gallery in Stockton, California. When the first guide to the museum was published in 1942, fully half the pages were devoted to descriptions of Indian art on display at Philbrook from Mound Builder material obtained from the University of Tulsa to contemporary American Indian painting, already at this early date being collected actively by the museum. Indeed, in 1942 Philbrook was primarily a museum of Indian art and history.

As years have passed, emphasis has changed at Philbrook. The Indian Department, established very early in the museum's history, remains its only separately distinguished curatorial department. Its collections have continued to grow, but space devoted to its exhibition has diminished as other collections have been developed. The Samuel H. Kress Collection of Italian paintings, the Laura A. Clubb Collection of 18th-20th century European and American paintings, the Taber Collection of Chinese art, the Gillert Collection of Chinese and Southeast Asian ceramics, African sculpture and individual American, European and Asian works have come to share gallery space once devoted exclusively to the exhibits of Native American art. In truth, Philbrook today is much more a general art museum than when it began. A consequence of such development, however, is that a new generation has grown to adulthood without an appreciation of the richness and extent of Native American art at Philbrook. This is one reason why we have organized the present exhibition and published this catalogue. Another is to demonstrate the implicit and potential importance of the Native American collections at Philbrook when considered in relation to other collections in Tulsa and elsewhere throughout the state.

These Native American collections at Philbrook comprise roughly eight thousand objects, predominately dating to the nineteenth and early twentieth centuries. In addition, there are uncounted thousands of lithic objects — spear and arrow points, maces, axe heads, awls, scrapers, etc. — dating from pre-historic to relatively modern times. About two-thirds of these objects belong to Philbrook, while the remaining are on deposit from the University of Tulsa. Very little of this material is supported by recorded provenance. In an anthropological context such a lack of documentation would impose serious limitation to the use of the material. The situation is also less than ideal when the same material is treated as art, but the consequences are not quite so limiting to research and interpretation for art museum purposes. Apart from the paintings and a handful of objects which stand out for their artistic importance, only a few have ever been exhibited publicly outside Tulsa. Hundreds have never been on public view at all, and because of difficult storage problems, have not been easily available for study.

The largest of the University of Tulsa collections at Philbrook is one acquired by purchase many years ago, the Ellis C. Soper Collection. It is comprised of well over a thousand objects, not counting lithic material. Particularly impressive are its many examples of Great Lakes and Plains bead and quill decorated objects, including an outstanding group of shoulder bags (bandoleer bags), smaller bags and pouches of all kinds, pipe bags and dozens of ceremonial pipe stems and bowls. There are also many items of Plains clothing, moccasins, clothing accessories, ornaments and jewelry, as well as weapons and pottery.

The Bright Roddy Collection, also the property of the the University of Tulsa, consists of over five hundred objects, largely from the southern plains and Oklahoma. As a young man, Roddy had traded among the Winnebago Indians in Wisconsin with his father. For more than thirty years he was a trader among the Osage at Pawhuska. Outstanding among his acquisitions are a fine group of beaded saddle blankets, moccasions, hair ornaments, jewelry and pipes.

The University's Alice M. Robertson Collection contains cooking implements, clothing, jewelry, beadwork, baskets and some pottery, mainly representing the southern plains and Oklahoma region. It is a small collection, numbering about one hundred and fifty items. Miss Robertson, who died in 1931, was a remarkable woman. A daughter of pioneer missionaries to the Creek Nation, she played in important role in Oklahoma's early history as the State's first postmistress and the Nation's second congresswoman. In 1885 she built Minerva Home in Muskogee, which later developed into Henry Kendall College and is now the University of Tulsa.

Rounding out the University of Tulsa material deposited at Philbrook is the George M. Tredway Collection, a varied group of some one hundred and twenty objects, including some fine beaded articles, moccasins, pipes and clothing, largely from the central and northern plains.

Among the several thousand Native American works of art that constitute Philbrook's permanent collection, the most widely known and exhibited are its twentieth century American Indian paintings. Dr. Rennard Strickland comments in detail upon the history and nature of this collection in the essay which follows.

Equally important, and perhaps as unique, is Philbrook's collection of American Indian baskets, given to the museum in 1942 by Clark Field, together with an important collection of Southwestern pottery. Clark Field (1882-1971) was born in Dallas, Texas. While still in his teens, working as a newspaper reporter, he covered the opening to white settlement of Kiowa, Comanche and Apache lands in southwest Oklahoma. For two years (1903-1904) he attended the University of Oklahoma, and then, until 1917, worked as a traveling salesman. In 1918 he settled in Tulsa and founded the Field Stationery Company, which he continued to operate until his retirement in 1957. His collecting daughter, Dorothy, became the wife of the noted authority and dealer in Southwestern textiles, Gilbert Maxwell.

Although the Clark Field Pottery Collection, comprising five hundred and seventy-one pieces, is outstanding in its representation of all significant pueblo ceramic traditions of the nineteenth and twentieth centuries, the greater achievement is the Clark Field Basket Collection.

Very early in his collecting career Clark Field set as this goal a comprehensive collection of American Indian basketry. The collection, as it developed, came to include 1,110 baskets. A total of 172 basket-making tribes are represented, from Alaska and Canada, throughout the whole of the United States, through Mexico and Central America. While a number of the baskets were acquired from other collectors, the majority were sought out by Mr. Field during the course of extensive annual travels with his wife and daughter. He was very successful in obtaining examples from tribes, especially in the eastern United States, where basket making has ceased to be practiced. And while his aim was to assemble a typological collection which he himself valued primarily for study purposes, he fortunately acquired many examples of superb artistic quality. The famous Dat-so-la-le *degikup* basket, considered by many to be this noted basket maker's masterpiece, is only one among a number of baskets that might be singled out for particular admiration.

Since 1964 nearly half the baskets and more than half the pottery given to Philbrook by Clark Field has been on loan to the Maxwell Museum of Anthropology at the University of New Mexico. None of the examples for this exhibition were selected from those portions of the collections.

Clark Field gave to Philbrook a number of other objects besides baskets and pottery, most notably several thousand lithic specimens and the great center post sculpture from the last Delaware Big House near Copan, Oklahoma. The greatest part of Philbrook's collection of Native American art, however — other than baskets and pottery — is found in the Roberta Campbell Lawson Collection. This contains nearly two thousand objects, collected over many years from a wide variety of sources and representing many native cultures, with material from the plains, prairie and Oklahoma predominating.

Roberta Campbell Lawson (Mrs. Eugene B.) was another of those notable women who, like Alice M. Robertson, left an indelible stamp on the early history of Oklahoma, whose accomplishments can still be measured. But unlike Miss Robertson, Mrs. Lawson was a Native American, born in Indian Territory prior to Oklahoma statehood, and whose maternal grandfather was the Rev. Charles Journeycake, last Chief of the Delawares. Born in the small town of Alluwe, near Nowata, Oklahoma in 1878, Roberta Campbell took an early interest in women's organizations, forming a chapter of the National Federation of Women's Clubs in Nowata. Later, in 1935, she was elected international president of the Federation. She was a woman of many talents and many interests, equally at home with Will Rogers, presidential candidate Thomas E. Dewey, or members of the Native American community. She traveled widely, worked effectively

for causes as diverse as the strengthening of the public school system and the appreciation of Indian music, and formed a collection of Indian art and artifacts, as well as an important library, that would be welcomed by any museum with a commitment to Native American art. Following her death in late 1940, her library and the greatest part of her collection came to Philbrook where, together with the Clark Field Collections, it forms the broad base of the Indian Department.

There are several other small collections that go to round out Philbrook's holdings in the area of Native American art. In addition, many interested individuals have given important single objects, small groups of objects, and purchase funds. The L.J. Woodruff Collection contains several dozen Hopi, Navajo and Saltillo textiles which illustrate with examples of good to fine quality the major types of Southwest blankets and rugs from about 1885 onward. With the addition of textiles from other collections previously mentioned, the total number of Southwestern textiles at Philbrook numbers approximately one hundred seventy-five examples.

Apart from the Clark Field Collections, the strength of Native American material at Philbrook lies in art of the prairie, the plains and the Oklahoma region. There is little from the Northeast, the Northwest and Alaska — again, with the notable exception of baskets. This is understandable in a collection that has been built almost entirely upon gifts. From time to time Philbrook has made purchases, but—except in the area of contemporary painting—these have not been made with any regularity.

Unlike a museum of anthropology, Philbrook looks upon all the art within its walls not as scientific specimens but as unique expressions of man's artistic consciousness and creative thought. Certainly, the study of Native American art finds a place for the ethnographer, the archaeologist, the anthropologist, but more important is the role of the cultural historian, the art historian and the connoisseur. For with a work of art we are dealing with an expression of individual uniqueness which overshadows the shared traditions within which the individual worked. It would be interesting to know the names of the countless artists who produced these objects, and to know something of their lives, their associations, their thoughts about the works they produced. Anthropology can give us information and insight into the societies and cultures of which these nameless artists were a part, and it can aid us in developing value systems for appreciating and understanding works of art that derive from cultures other than those into which we were born. Ultimately, however, appreciation rests with each of us, the viewers, who must develop the skill to see sensitively, to open the eye and the mind to accept the full force of form, color, texture, emotional and intellectual content embodied in each object by its creator. This exhibition presents ample opportunity to do so. We have assembled it with the purpose of demonstrating how importantly Native Americans have contributed to the greater history of world art, hoping that each visitor will take delight in making new discoveries, and perhaps gain a keener appreciation of the museum's responsibility to collect and preserve such treasures for today and the future.

The Changing World of Indian Painting and Philbrook Art Center

The Changing World of Indian Painting and Philbrook Art Center

RENNARD STRICKLAND

John W. Shleppy Research Professor of Law and History
University of Tulsa

In the art of painting there is a new day dawning, for the Indian is equipped with powers and possibilities capable of immeasurable development. God has planted a tremendous hungering in his soul for just such development . . . God surely would never plant a hunger he would not satisfy. The Indian's longing for power to achieve, to create, to do great things, so his people will be better understood, will have a glorious realization in the future.

— *Monroe Tsa Toke, Kiowa*

Carl Sweezy's "Tepee" (oil on canvas), was given to Philbrook by the Tulsa Art Association in 1939. This depiction of a peyote scene was one of the museum's first permanent acquisitions. Sweezy, the most important early painter represented in depth in the collection, is at the height of his creative powers in the portrayal of peyote rituals and figures.

"For the U.S. Indian," *Time* magazine of July 7, 1947 noted, "the art world centers far from Manhattan's 57th Street, in the luxurious Tulsa palace of oil millionaire Waite Phillips. . . ."[1] Thus began *Time's* coverage of Philbrook's Annual National Exhibition of American Indian Painting which had begun a year earlier with the first annual museum-sponsored "American Indian fine arts painting competition." Philbrook described this competition as "unique in the annals of art and Indian history." Its purpose was "to foster the significant art expression of those whose paintings retain some of the traditional manner of their forefathers."[2]

Philbrook in 1946 unabashedly proclaimed Tulsa "a logical center of activity in connection with the renaissance of American Indian painting."[3] And so it has been. Principally because of the competitive show, Philbrook Art Center became a major force in the dramatic evolution of the world of contemporary Indian painting. Over the years Philbrook's role, like Indian painting itself, has changed. The art world for the Indian painter no longer centers at Villa Philbrook. This essay attempts to look back on the decades since the founding of the Philbrook Indian Annual and make some observations about the Annual, about Philbrook's role in the changing world of Indian painting, and about some of the artists and their works which form the core of Philbrook's permanent collection of American Indian painting.

The significance of the Indian Annual has often overshadowed Philbrook's other contributions to Indian painting. The hundreds of paintings in Philbrook's Indian collection constitute what the Indian Arts and Crafts Board described in a 1966 citation as "the most well-rounded collection of Indian paintings in the United States."[4] Philbrook's Indian painting collection is the most important documentation of the development of traditional Indian painting. Regrettably, however, the collection does not so adequately reflect recent painting developments.

From the very beginning, Philbrook purchased some of the best paintings from the competition each year for its own collection. These were intended to serve as the basis for traveling exhibitions of Indian paintings, to provide illustrations for books on the American Indian and to be displayed on a regular basis in the museum.[5] If Philbrook has a collection without peer, unique in all respects, that collection is the American

Monroe Tsa Toke, one of the Five Kiowas, captured the pride of the Plains people in "Indian Warrior." The flat, unmodeled style, the application of color and the absence of background make this a classic example of the "traditional style" encouraged in early Philbrook Annuals.

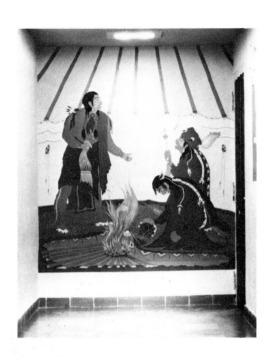

Much of early Indian painting was mural painting, created for post offices, public libraries, Indian schools and commercial establishments such as department stores and airports. Woody Crumbo's "Burning of the Cedar" (left) is one of two such murals at Philbrook.

Indian painting collection. Both in artistic and ethnographic significance the Philbrook collection is a treasure worthy of the title it is sometimes given — The National Gallery of American Indian Painting. The story of the Indian Annual and the permanent collection are closely entwined.

"The initial exhibition," the Philbrook archives reveal, "was a heartening beginning." From 200 entries, seventy-six were selected to be shown. The jurors, Woody Crumbo and Charles Banks Wilson, were described as "two of Oklahoma's outstanding younger artists." Twenty-eight paintings were sold of which fourteen were purchased for Philbrook's permanent collection. The Grand Prize Award Painting by Hopi Fred Kabotie was a museum purchase. The highest price asked for a painting was $200; the average was nearer $25; some were as low as three and five dollars.[6]

To understand the initial motivation and potential for the Indian Annual, one must understand the world of Indian painting in the period immediately following World War II. A significant number of young Indian artists had just returned from the armed services, having been exposed for the first time to the world beyond their Indian community.[9] For many the experience intensified their pride in being Indians, increased their respect for tribal traditions, made them hungry to know more of the old ways and created a determination to preserve their heritage for their children and children's children. Even before the war Indian painting had begun to attract the serious attention of the art world. A few museums and private collectors had encouraged the Indian painter. Acee Blue Eagle had traveled to lecture at Oxford and the paintings of the Hopis, Pueblos and Five Kiowas had been shown throughout Europe. A magnificent portfolio of Indian paintings had been published and distributed to fine arts collections in libraries and museums. Now as Indian servicemen returned from Europe and Asia, the stage was set for new developments.

By 1945 the white community was increasingly interested in traditional Indian painting.[10]. Excitement had been generated by movements such as the Hopi painting revival, the Five Kiowas, the Santa Fe School and the birth of the Bacone Art Department. Wealthy whites traveled to the Southwest and returned to decorate informal rooms in their homes with Indian rugs, pottery and paintings. Important Indian painting collections — the Katherine Harvey, Dorothy Dunn, Nettie Wheeler and Oscar Jacobson — were being built. Many of the individuals associated with these independent, but related, Indian art developments — Susie Peters, Oscar Jacobson, Millicent Rogers, Mrs. William Denman, Clark Field, Dorothy Dunn, Nettie Wheeler — were involved in launching the Philbrook Indian Annual. This exhibition was not just a local "tourist gimmick." Support for it was nationwide and represented a cooperative effort to attract Indian painters to the museum's show. There was about the Philbrook Indian Annual a missionary zeal exemplified in the long-term commitment of art critic Maurice de Vinna who had organized Indian art showings in Tulsa as early as the 1930s. In the early Indian Annuals a group of dedicated men and women came together determined to provide a national showcase for what they believed to be a particularly unique American art form.

Philbrook was fortunate to have been located in the center of a dramatic and exciting native art movement. The 1940s was a time in the history of the movement when the services of a museum could make a difference, a time when the tribal nature of utilitarian art had to be replaced with a broader commercial market, a time when recognition of Indian painting as an art form was important. Philbrook did not create, nor could any institution have created, the varied forces in the Indian world that erupted in the period between the nineteenth century end of traditional tribal life ways and the revitalization of tribal spirits brought on by the Second World War. The Philbrook Annual was born during a period of intense change for Native Americans, a time when the pent-up forces of change produced an intense artistic creativity which both preserved and extended the meaning of Indian life. In this era, Indian painting had both a celebrating and a sustaining mission. The Indian artist was drawing upon tradition as sustenance in an age of rapid change. Thus, the artist became historian and philosopher — recorder of an old way intended to serve as a model for the new.

During the first twenty years of the Philbrook Annual, the world of Indian painting changed — and changed dramatically. By 1966 a sculpture category had been added to the competition, there was a division for students and the "special category" which was "designed to recognize new trends in American Indian art" was open to all artists

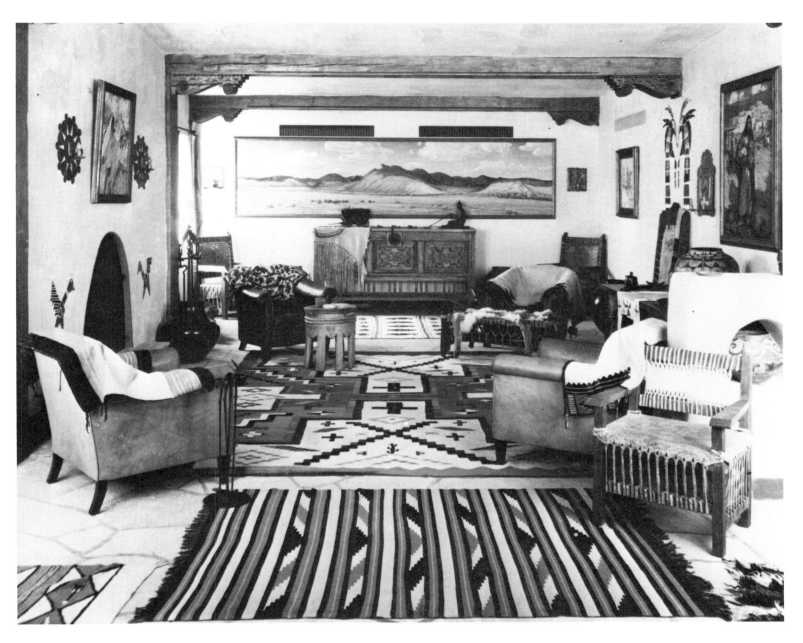

regardless of region. Artists were asking and receiving significantly higher prices for their works. Much of what the founders of the Indian Annual had hoped would happen in the field of Indian painting had taken place within the first twenty years.[7] The invitation to the 21st Annual (1966) defined for Philbrook a broadened and matured Indian art mission to "foster the significant art expression of the contemporary American Indian artists."[8]

When viewing periods of intense creativity, one asks why London in the Elizabethan age produced a Shakespeare and that remarkable body of poets and playwrights who surrounded him? What was responsible for the "flowering of New England" in the age of Emerson and Thoreau? Dublin in the age of Joyce? Paris at the birth of Impressionism? The conditions for the unleashing of creative genius are difficult to predict. And yet there are moments in history which seem to be electrified with a kind of spontaneous charge of creativity. The American Indian painting movement was the result of such creativity during a brief moment in the middle of the twentieth century. These first creative sparks, kindled at the beginning of the century, reached the full blaze of maturity in the years following the Second World War.

Anyone familiar with the personalities of Woody Crumbo, Dick West, Blackbear Bosin, Cecil Dick, Oscar Howe, Allan Houser, Stephen Mopope or Acee Blue Eagle must reject the notion that traditional Indian painting was the product not of Indian creativity but of white dictates and domination.[11] Their traditional Indian style was

The Santa Fe Room in Villa Philbrook is an example of the use of Indian motifs by wealthy whites who traveled extensively in the Southwest and sought to encourage Indian painters, weavers and potters. Philbrook's Indian Annual has benefited from the philanthropic tradition of such backers, including many of modest means who have had a great interest in Indian painting.

never a single style and the so-called "rules" or "canons" of traditional Indian art were no more rigid to the artists themselves than were the percepts of Impressionism, Cubism or abstraction to their practitioners. The term "traditional" was largely a white label. Although it did identify a recognizable style, the work of individual Indian artists within that style varied significantly. Philbrook's collection of the earliest Indian paintings, including works by the Five Kiowas and such artists as Carl Sweezy, are remarkably diverse and uniquely individual. And yet, the so-called "school" with which Philbrook is so strongly identified does have a common core of principles which the museum attempted to define and upon occasion to enforce in the exhibitions.

From the beginning Philbrook was strongly committed to what sponsors described as "traditional Indian style." Philbrook was even willing to specifically define the boundaries of the acceptable style. Information distributed to artists and the public prior to the second Indian Annual attempted this definition:

> *The exhibition is largely limited to subject matter concerned with traditional, ceremonial, or mystic themes relating to the life or thought of Indian peoples. For the most part, the traditional technique employs flat design and solid color areas. The compositions are most frequently arranged in formal, often symmetrical designs. The careful execution of detail is an integral part of the Indian's approach to his art, since every variation of costume and decoration has some religious, tribal or ceremonial significance. None of these is to be depicted hastily or carelessly, or with anything less than reverence and respect. Animal's hair, in many pictures, is brushed on with infinite patience. Although figures in action are highly animated, they are suggestive of the actual restraint and control which govern the movements of the Indian whether in work or sport or ceremony. In view of these faithful delineations of character, custom and costume, these paintings are valuable ethnologically as authentic records of American Indian culture, as well as being a significant art expression worthy of recognition.*[12]

Therefore, Philbrook found itself in the difficult position of an institution with a self-defined mission of fostering "those American Indian artists whose paintings retain some of the traditional manner of their forefathers." The command to the first Indian Annual jurors was "to eliminate non-traditional styles and influences."[13] And so, Patrick Desjarlait's magnificent "Maple Sugar Time" was excluded from the first Indian Annual as "non-traditional" but purchased by Philbrook to be added to the permanent Indian collection. Thus began a battle over painting style that has raged throughout the history

Cecil Dick's "Deer Hunt," with the foliage of the Cherokee homeland, contrasts sharply with the bare, horizonless landscape of traditional Plains paintings. Some Indians believe that Cecil Dick's winning of a painting prize in a 1945 Oklahoma artists' competition helped to stimulate non-Indian support for the separate Indian painting show which began at Philbrook the following year.

Woody Crumbo's "Land of Enchantment" is a wonderfully ironic and delightfully humorous twist of viewpoint, conveying the Indian's perception of the white tourist. Fred Kabotie's murals for the Harveys in the Bright Angel Lodge at Grand Canyon caricature typical tourists as well as Navajo dancers in much the same way. Indian paintings make important statements about tribal culture and values as well as recording historic events and ceremonies.

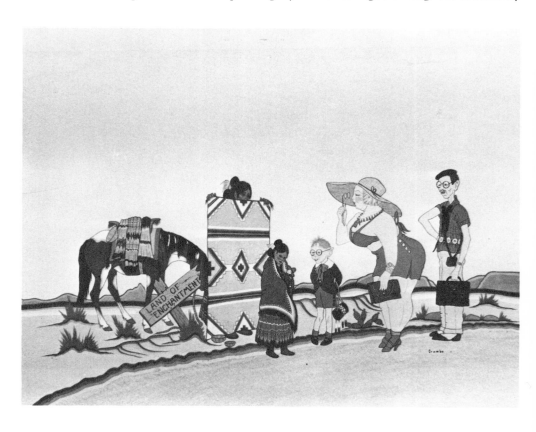

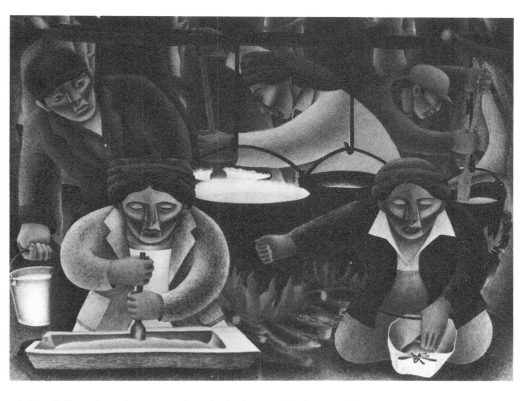

Patrick Dejarlait's "Maple Sugar Time" was rejected for the first Indian Annual but purchased for the museum's permanent collection. Regarded as "non-traditional" at the time, the painting is now recognized as a masterpiece of American Indian art. The influence of Mexican muralists is strong in the work of Dejarlait as it is in that of later artists such as R.C. Gorman.

of the Philbrook Indian Annual and which is at the heart of the question of the evolution of Indian art.

One Indian's traditional art is another's abstraction. Perspective on the "traditional vs. modern art" issue is found in a letter from Susan Peters complaining that a painting of the traditional Creek artist Fred Beaver should have been excluded from the show and a Kiowa painting substituted because Beaver had put wooden sheds in the background of his painting which violated the principles that she had tried to teach the early Kiowa artists.[14] To most students of Indian painting Fred Beaver is the most traditional of the traditionalists. An eloquent statement of the problem of the maturing Indian artist seeking to develop new directions in painting is found in a letter from Oscar Howe to Jeanne Snodgrass — then curator of Indian Art at Philbrook — written after one of his paintings was rejected from the 1958 Annual because it embodied a "non-traditional Indian style."

> Who ever said, that my paintings are not in the traditional Indian style, has poor knowledge of Indian Art indeed. There is much more to Indian Art, than pretty, stylized pictures. There was also power and strength and individualism (emotional and intellectual insight) in the old Indian paintings. Every bit in my paintings is a true studied fact of Indian paintings. Are we to be held back forever with one phase of Indian painting, that is the most common way? We are to be herded like a bunch of sheep, with no right for individualism, dictated as the Indian has always been, put on reservations and treated like a child, and only the White Man knows what is best for him. Now, even in Art, "You little child do what we think is best for you, nothing different." Well, I am not going to stand for it. Indian Art can compete with any Art in the world, but not as a suppressed Art. I see so much of the mismanagement and treatment of my people. It makes me cry inside to look at these poor people. My father died there about three years ago in a little shack, my two brothers still living there in shacks, never enough to eat, never enough clothing, treated as second class citizens. This is one of the reasons I have tried to keep the fine ways and culture of my forefathers alive. But one could easily turn to become a social protest painter. I only hope, the Art World will not be one more contributor to holding us in chains.[15]

Howe's letter was a catalyst for discussion, artist's meetings and proposals which ultimately produced the new category of non-traditional painting and forced Philbrook to address the nature and purpose of the Indian Annual. Philbrook's director at the time, Denys P. Myers, painfully articulated the institutional dilemma in his response to Howe:

Grand themes of majestic proportion were occasionally carried over from room-sized mural walls to smaller canvas, board or paper; an example is Jose Rey Toledo's "Dancing Spirits." This important painting conveys many levels of the Pueblo dance, both inspirational and instructional. The entertainment of the mudheads, the looming presence of the Shalakos, the calm spirituality on the faces of the dancers, plus the meticulous detail of the costumes characterizes this exquisite work.

It is certainly not the desire or purpose of Philbrook Art Center to discourage or inhibit freedom of expression on the part of artists, be they of American Indian, European, Asiatic or African descent. I can readily understand your feeling that the policy of encouraging stylized American Indian painting of the sort which has come to be thought of by many people as "traditional" has been adopted through a discriminatory and conservative "reservationist" psychology on the part of whites with a paternalistic attitude of superiority. It is most unfortunate that this misunderstanding has arisen, because, in actual fact, the only reason for encouraging conservative modes of expression has been a result of the somewhat contradictory double purpose behind our American Indian Annuals. One purpose has been to encourage and assist American Indian pictorial record of American Indian life and customs. It appears that, in a number of instances, the two purposes are operating as cross purposes. I am aware that several of your fellow artists share your views . . . I am confident that a satisfactory solution, probably a broader definition of what constitutes "traditional" American Indian painting, will be reached.[16]

The problem was a difficult one which divided not only the show's sponsors but the artists themselves. Traditional painters, too, felt that competition between the two styles was unfair. In 1955 Fred Beaver wrote Philbrook:

I also think that some of the original Indian painters quit exhibiting and some others have dropped out or submit fewer paintings . . . due to the fact that some of the exhibitors were submitting abstract art and other modern art into the Indian art and some of the judges being modern artists would select some of this type as prize winners. A lot of us thought that this was not fair as [we saw] the annual show as strictly Indian art. At one time, [Philbrook] told us that they would create a separate division for this type of art aside from the original Indian art but nothing came out of it, so far.[17]

Jeanne Snodgrass was in large part responsible for the museum's resolution of this conflict and its more enlightened attitude toward changes taking place in Indian art in the late 1950s and early 1960s. A highlight of her era was the one-man/one-woman show that enhanced appreciation of both older and younger artists and featured Indian painters with styles as varied as those of Blackbear Bosin, Joan Hill, R. C. Gorman and Jerome Tiger.[18] She summarized her philosophy to the Philbrook Board following the "Directions of Indian Art" Conference held in March 1959 at the University of Arizona:

The air was filled with the feeling that IF interested people do not "do something" Indian art on the whole will enjoy a quiet and gentle demise. The point was well taken throughout that the potential is there and these people must have help. At Philbrook we are more actively concerned and associated with Indian art in the form of painting. If Indian art IS TO SURVIVE IT MUST NOT BE DICTATED TO and controlled; it MUST be allowed freedom to develop.[19]

Valjean Hessing presents an original and human interpretation of "Choctaw Removal," a topic which because of its tragic overtones has in recent years become a favorite of artists of the Five Civilized Tribes. Note that Ms. Hessing does not make her Choctaws into Plains warriors as do so many of the imitative painters of the "Trail of Tears" theme.

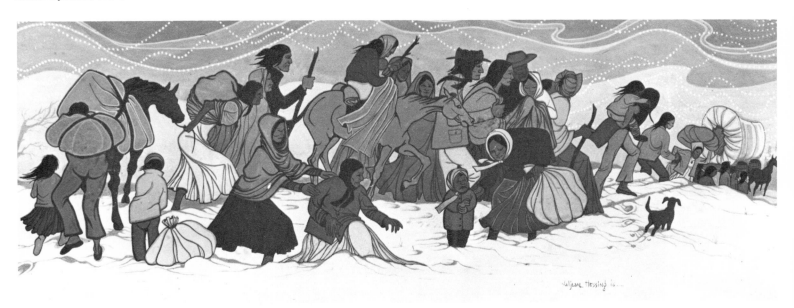

The Philbrook permanent collection represents considerable freedom of development by at least five generations of Indian painters who have worked on paper and canvas. In a way, each of these generations represent a different phase of the American Indian experience. The earliest of the artists whose work is represented in depth is Carl Sweezy, described by his friend and biographer Althea Bass an as artist "historian and philosopher" who was "a link between the old, free-roaming, buffalo-hunting days of his forebears and the modern Indian. . . ." More importantly, "the paintings in his portfolio . . . were a link between the work of the skin painters of pre-reservation days and that of the modern Indian painters who have studied in art schools and have never lived in a tipi or worn their hair in braids or painted their faces and bodies in preparation for a battle."[20] Philbrook's Carl Sweezy paintings are among the most important in the collection and reflect the major themes of this important artist's work including village life and peyote rituals. Sweezy, who began painting at fourteen for the ethnologist James Mooney, describes how he came to be a painter. His story is reflective of many of the painters of his and earlier generations including the prisoners who drew in ledger books.

Blackbear Bosin's painting "Prairie Fire" is the most popular and most widely reproduced American Indian painting. Bosin, on far right, submitted the painting to the 1953 Annual at which time Philbrook acquired the work for its permanent collection.

> I had been trying to draw ever since I was a little fellow, and a woman at the Agency had showed me how to use water colors. When Mr. Mooney said he wanted an artist to draw some of the designs on the handwork that was brought in and to restore the paint on some of the old shields that had been dug up, I was the best they could offer him. I sat nearby while he talked with the Indians about the shields and robes and leggings they brought in. Then I went to the room that Mr. Mooney had given me in the hotel and went to work. The next day, before the talks began, I had made copies of what we had been looking at the day before. Mr. Mooney laughed and seemed surprised when I showed him the first one of these pictures, and praised it because the colors were true and the design was exactly like the original. So I worked for him as long as he stayed at the Agency, and after he left I kept on drawing and painting whenever I had the time and the materials.[21]

The Philbrook permanent collection reflects in the paintings of the Five Kiowas what Oscar Jacobson called "one of the most interesting artistic phenomena in American painting . . . the vigorous renaissance of Indian painting."[22] Of a generation born immediately before statehood, Monroe Tsa-Toke, Spenser Asah, Steve Mopope, Jack Hokeah and Bou-ge-tah Smoky have come to symbolize the new movement of Indian painting in Oklahoma. The Kiowa and the Hopi and Pueblo painting revivals, sparked by this and a later generation, provided the initial impetus for the great collections like Philbrook's. Acee Blue Eagle, the Creek artist whose work also came to symbolize traditional Indian painting, in a tribute to the Kiowas describes the birth of modern Indian painting and its relationship to the Indian concept of art.

> Indian art is as old as the Indian and was expressed in everything he did, wore, or used; in his ceremonies, stately dances, and in his prayer. It was expressed in beauty of line and color, gesture and word. . . . Indian painting is a most ancient art, although it has come more to the attention of the white world during the last three decades, it has a long history and great continuity. The renaissance of Indian painting in Oklahoma started in the early nineteen hundreds when some of the Oklahoma Indian boys were placed in U.S. government schools for Indians. This resulted in a tremendous impetus to their creative talents. At first with colored crayons on cardboard or any kind of paper available and later with water colors, they began to produce the Indian paintings, that, acclaimed in the beginning by a few white artists, eventually won the recognition of the general public. From that beginning . . . Indian art came forth into world recognition.[23]

In many ways Blue Eagle was himself the quintessential American Indian artist of the early renaissance period. The range of his paintings in the Philbrook collection, the varied themes and styles, the painstaking execution, and the wonderfully humorous and bitterly ironic undertones capture much of what the Indian artist of his generation was seeking to do. In one of his poems, Acee Blue Eagle addresses his reason for being a painter. His desire to paint described in this selection parallels the motivation felt by many other artists of his generation.

Why Injun Artist Me

Many peoples was wonders why
My eyes not on the stars and sky
Sed it to my fren's, he easy could
Make good lawyer, doctor an' should
Oh could make it lots of money
Fo' him it sure would be good

I'm long years ago, use to think so
But like that, don' think it no mo'
I'm jus' don' know'd why is so
But som'thing sed nother way to go
Maybe Great Spirit, high in a sky
He's know heap much better than I

Guess lots of it nother of man
Be Doctor, lawyer, so many can
So want me paint Indian and sacred sun
Sacred dances, games and lot of fun
So people see for many years to com'

So that's why I'm not go like
Injun to be like white man
But paint Sacred, many pictures
of Injun and hope it can
Be good medicine, with sacred beauty,
Like Injun Priest paint with sand.[24]

Acee Blue Eagle

The developing painting careers and evolving styles of many Indian artists can be traced in the Philbrook collection. Acee Blue Eagle's "Pawnee Human Sacrifice Dance," for example, shows strong traditional Plains Indian influence, while his "Creek Women Cooking Fish," painted approximately a decade later in 1950, not only deals with a more modern theme but is painted in a mature Woodland style.

What the dean of Oklahoma historians, Angie Debo, wrote of Acee Blue Eagle suggests something of the personality of the Indian artists most closely associated with the Philbrook Art Center: "His art was the total expression of his spirit; and in spite of the discipline of the white man's schools and his tolerant understanding of the white man's ways, his spirit was all Indian."[25] One can almost see Acee Blue Eagle, Dick West and Blackbear Bosin meeting with Jeanne Snodgrass and Philbrook officials to hammer out the new non-traditional Indian category for the Philbrook Annual.[26] Thus one generation of Indian artists prepared the way for the next.

The generation most closely associated with the Philbrook Indian Annual and the permanent collection is that generation of Indian painters whose careers blossomed following the Second World War. Philbrook was a major artistic outlet for artists such as Fred Beaver (b. 1913), Blackbear Bosin (b. 1921), Allan Houser (b. 1915), Oscar Howe (b. 1915), Solomon McCombs (b. 1913), Al Momaday (b. 1913), Chief Terry Saul (b. 1921), Pablita Velarde (b. 1918), and Richard West (b. 1912). This was a generation only slightly removed from the free-spirited days of Indian nationhood and still close enough to have been influenced by the men and women who had themselves been a part of the old Indian life. Many were schooled in the most sophisticated techniques of

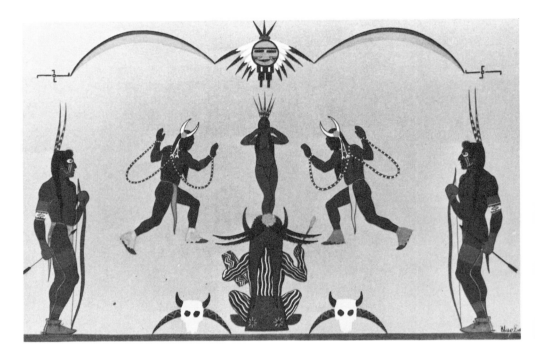

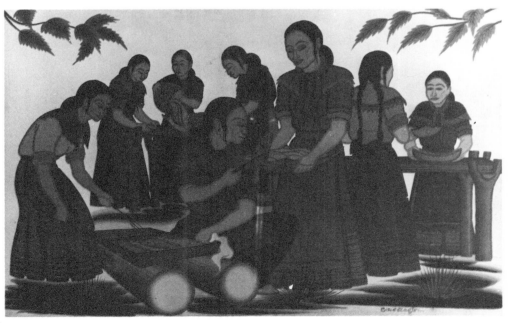

modern painting but deeply rooted in the traditional ways of their people. They were the artists whose mature work came to symbolize the Philbrook Indian Annual and whose paintings are the artistic backbone of the museum's permanent collection.

Among these artists there was a tremendous rapport, a sharing of experience, a sharing of goals and a sharing of technique. Theirs was a world of immense pressure and great potential which brought a shared sense of responsibility for the preservation of a passing tradition to a generation which had never fully shared in the tradition. N. Scott Momaday records something of this in his autobiography, *Names*. He recalls the relationship of his father, Al Momaday, and Acee Blue Eagle.

> *By the time he was a young man my father had got enough of farming. He wanted to be an artist, a painter. At Bacone College, where he was a student for a time, he became acquainted with the Creek artist Acee Blue Eagle. When Blue Eagle painted Kiowa war dance figures, my father was his authority on the rich, intricate costumes, so that the work might be as authentic as possible in its detail. For his part my father learned from this collaboration how to mix watercolors, how to apply them delicately, effectively to paper. He became a patient, confident craftsman. And he had otherwise become a tall, good-looking, reckless man. . . . At some point he moved out of that old world of the Kiowas. Like [his father] Mammedaty, he would make a life for himself. I know now that this was an act, not of renunciation, but of profound affirmation, and that it required considerable courage and strength. My father was born in a tipi in a world from which it was both necessary and costly to succeed.[27]*

The *espirit de corp* of these artists is reflected in a letter written to Jeanne Snodgrass by Fred Beaver soon after the death of Blue Eagle.

> *I used to go by his place in Okmulgee and we would sit and chat and drink gin for many hours and have been with him couple of times during his TV show in Muskogee. . . . For some reason of his own he used to confide in me and seems to enjoy talking both Creek and English and told me about his travels . . . and his ideas of the future and what he planned to do. . . . Acee used to tell me about various works and I know he had a group of paintings about the Creeks that he was working on. . . .[28]*

These artists saw their individual and collective task as the recording of the life and culture of their people. And in this task they were most successful. For example, much of the traditional world of the Cheyenne is preserved in the Philbrook permanent Indian painting collection of the works of Richard West. There is no richer archive of Indian history and culture than the one provided by West's paintings such as "Viewing the Medicine Arrows," "Cheyenne Winter Games," "Dance of the Soldier Societies," "Animal Dance" and "Cheyenne Sun Dance." The ceremonial life of the Choctaws is likewise beautifully recalled in the Terry Saul paintings in the Philbrook collection. Fred Beaver's works are as complete and important an ethnographic record of the Creeks and Seminoles as the West paintings are for the Cheyenne. In addition to documenting the history of their tribes, the Philbrook collection beautifully documents the artistic career of many of these artists, particularly West, Howe, Blue Eagle, Bosin, Velarde and McCombs.

Philbrook's collection is strong in Southwestern as well as Woodlands and Plains paintings. For almost thirty years the traditional painting competition was divided into these three regional categories and the permanent collection was built to reflect strengths in all three. Among the Southwestern paintings are works by Quincy Tahoma, Harrison Begay, Robert Chee, Jose Rey Toledo, Andrew Tsihnahjinnie, Fred Kabotie, Gilbert Atencio, Joe Herrera, Gerald Nailor, Wolf Robe Hunt and Rafael Medina. Navajo, Pueblo and Hopi daily and ceremonial life are reflected in the works of these artists. The depictions of Southwestern artisans at work provide wonderful views of the traditional life of the Indian artist.

The drive to preserve Indian tradition is seen in several jewels of the Philbrook collection. The Cherokee painter Cecil Dick, represented by six paintings, captured the feeling of Woodland Indians as did Patrick Desjarlait, whose "Maple Sugar Time" and "Making Wild Rice" are among the most important paintings in the permanent collection. Desjarlait's description of "Making Wild Rice," the 1947 Woodland Prize

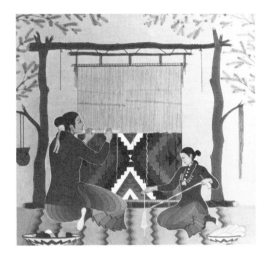

The tasks of everyday life, such as weaving in Harrison Begay's "Navajo Women Weavers" (above), provide subject matter for a number of paintings in the Philbrook collection. Paintings of craftsmen at work are important ethnographic documents which supplement Philbrook's rug and pottery collections. Another prevalent theme in the Philbrook collection—and one found in many of the most dramatic paintings—is an idealized and romanticized view of "the old ways." An example is Quincy Tahoma's "In the Days of the Plentiful" (below), which captures the free riding days after the white man brought the horse but before he destroyed the buffalo and confined the Indian to the reservation.

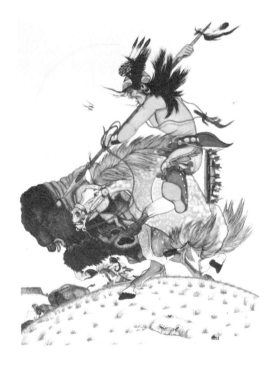

Winner, conveys much of the sense of urgency which motivated American Indian painting in the early years of the Indian Annual.

> *My people still carry out traditions like "Wild Rice Making," in the same way their forefathers did, although they dress in the style of the white man. The Indians that live on the reservation are still primitive in custom and environment. Even though many live like the white man there is still that feeling of distance in the races of men. I feel that in years to come the tradition of the American Indian will be only a memory. It is up to the Indian artist to paint and preserve these traditions or tradition will vanish with time.*[29]

Not all the paintings of this era are ethnographic history. For example there is Blackbear Bosin's "Prairie Fire," a dramatic vision of a common threat in the open Indian lands. It is the most widely reproduced American Indian painting. More letters have come to Philbrook regarding this scene than all other works owned by the museum. "Prairie Fire" is an appealing work which captures the imagination of the public in a way which few other works of Indian art have ever done. The painting conveys the drama and spirit of early Indian life. In this painting, clouds of smoke and flames drive a herd of antelope, a pack of wolves and two mounted Indian warriors across the broad and open plains. One senses in this flight that man, like beast, cannot escape the awesome power of nature.[30]

Painting by artists such as Bosin, Howe, West and Blue Eagle dominated the interest of the Philbrook sponsors in the early years of the Annual. In the archives at Philbrook is a letter from Willard Stone inquiring about entering a piece of sculpture in the first Indian Annual. The answer is that Stone may enter some of his drawings but Philbrook does not intend to provide sculpture competition.[31] Ironically, the sculpture competition when added became one of the most vital elements of the Annual, with Stone recognized as a premier sculptor and distinguished painters such as Allan Houser and Dick West achieving new dimensions of interpretation in wood. In recent years younger artists like Hyde, Hoover, and Glass have extended the range of Indian sculpture as have Charles Pratt's metal sculptures and the wood sculpture of Bruce Wynne.

The next generation of Indian painters, often students of artists like Dick West, Oscar Howe and Allan Houser, has been most consistently and successfully represented in the Philbrook Annual by Joan Hill (b. 1930). Others of this era include Gilbert Atencio (b. 1930), Jerome Tiger (b. 1941), Loren Pahsetopah (b. 1939) and David Williams (b. 1933). This generation continued the work of the previous one. In many respects their

The excitement and drama of a Cochiti ritual dominates the action in Joe Herrera's "Initiation of a Young Koshare." Tribal religious and ceremonial occasions such as Sun Dances, peyote meetings and False Face Dances are among the most frequent themes of Indian painters represented in Philbrook's collection.

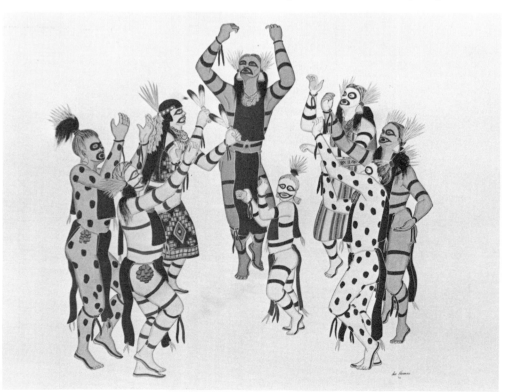

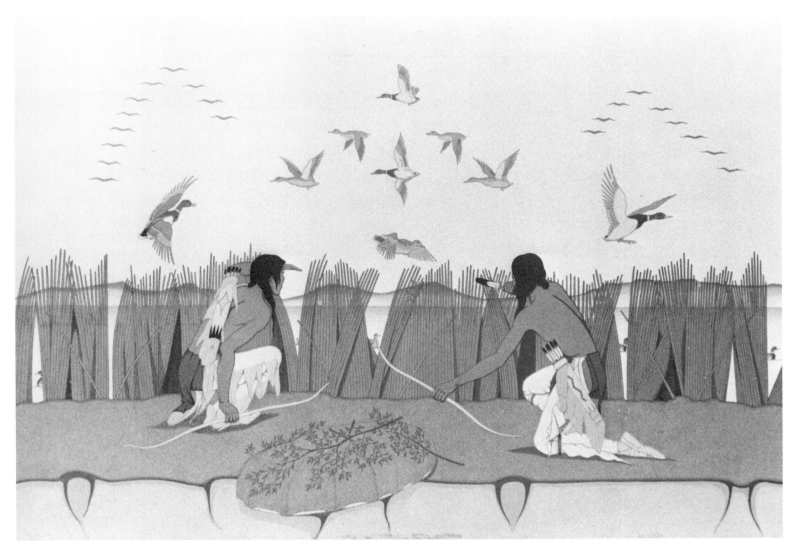

paintings are more traditional than earlier ones. Their teachers and models, Howe and West and Bosin, are all represented in the Philbrook collection with works in new non-stylized forms while they have tended to be less experimental. Even the highly original Joan Hill paintings such as "War and Rumor of War" are the direct Indian descendents of the works of Howe and West. Nonetheless, Indian painting among this group has remained vital and dynamic. The most widely known Indian painter of this generation, Fritz Scholder (b. 1937), has had relatively little association with the Indian Annual, having entered early in his career and later serving as a juror with a few of his paintings exhibited in a special juror's show held in conjunction with the Annual.

R. C. Gorman, in a statement prepared for the "New Directions in American Indian Art" catalogue of his Philbrook show, attempted to answer a frequently asked question about the direction of his own painting and that of the "younger generation" of Indian painters.

I have all too often been asked the same dreary question, "why have you strayed from the traditional Indian painting?" First I see no progress in traditional anything. Second, I have not strayed — merely improvised. The only straying that I have done is to live off the reservation as much as I can. The reservation is my source of inspiration for what I paint but yet I never come to realize this until I find myself in some far-flung place like the tip of Yucatan, or where-have-you. Perhaps when I stay on the reservation I take too much of what it has to offer for granted. While there, it is my inspiration, and I paint very little. Off of the reservation it is my realization. Realization of reality. Art is a personal thing. What is seen on a canvas should be experienced as an individual thing. Likewise, an artist's experience with his work. To lose the individuality is to lose oneself in a muck of sameness.[32]

Oscar Howe's "Dakota Duck Hunt" was reproduced in *Time* magazine during the second Indian Annual. Howe, like Dick West, painted in both a "traditional" and "modern" style and achieved remarkable action and excitement in his abstracts while retaining a decidedly Indian theme and tone. For Howe's more modern style, see page 77, number 413.

Dick West's "Water Serpent" contrasts sharply in style with many of West's traditional paintings such as "Cheyenne Winter Games." (See page 79, number 427.) The question of "non-traditional" paintings dominated much of the development of the Indian Annual and yet works like West's "Water Serpent" with its mythological theme are so decidedly "Indian" that today the storm over style is difficult to understand. Contrast this "modern" West painting with the "traditional" Pablita Velarde, "Dance of the Avayu and the Thunderbird" on page 79, number 425.

Jerome Tiger's "Walk Through the Great Mysteries" is an elegant painting whose soft and gentle style has been widely imitated with less successful results. Tiger's one-man show at Philbrook launched the young Creek on what promised to be a major career. Tiger was developing a sensitive and imaginative style at the time of his tragic death.

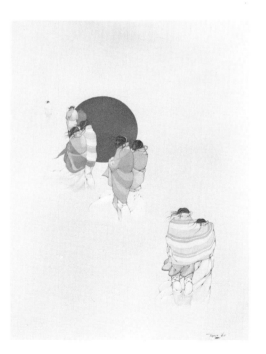

There is this kind of stereotypic sameness to much of white America's picture of the American Indian. For white Americans know almost nothing about Indian Americans. It has been so since the very beginning. Over the years whites have created many versions of the American Indian, reflecting white society's particular needs, interests and neuroses. Ranging from the devil incarnate of the wilderness-subjugating Puritan to the Sierra Club's anti-polluting redman-at-one-with-nature, these images are the creation of white society. They are a mirror reflecting perception of the whites' struggles in their own lives. To some ages the Indian is evil, to others the Indian is noble; in some he is to be subjugated; in others he is to be saved. The Indian moves full circle and is seen in other ages as savior. The one constant from James Fenimore Cooper to Carlos Castenada has been that the image of the Indian was a white image with little basis in the real world of the American Indian.[33]

The white American who is genuinely interested in learning about the Indian American has little opportunity. Most of what passes for Indian history is written from the documents of white society and is concerned about white Indian policy. In many other accounts the Indians are romanticized beyond recognition; in others they are blackened beyond belief. Being a people of an oral rather than written tradition, relatively little of the Indian's own history has survived and when it has, the legends, poetry, chants and songs are often taken out of context. The paintings of the American Indian artist provide a unique opportunity for the white man to look into the world of the Indian. And the Philbrook permanent collection, drawing as it does upon the very best of traditional Indian painting, is a particularly rich storehouse of images of the Indian created by the Indian.

While the ethnographic significance of Indian painting is widely understood, the place of American Indian painting in the broader world of art is not so clear. Traditional Indian painting has yet to receive serious study and broad recognition. Perhaps this is because Indian painting is not easily classified: Native painting is not folk art and it is inaccurate to describe it as primitive art because it is at once ancient and modern. Nevertheless, the power of design and line in Indian art has long been sensed and its peculiarly mystical qualities much admired. Theodore Roosevelt in reviewing the Armory Show remarked, "There is more fine abstract art in one of my Navajo rugs than in the entire lot of new paintings hanging on the Amory wall." Traditional American Indian painting is a truly unique art form reminiscent of the long, historic line of highly stylized Oriental paintings and drawings. While vitally new in its action and themes, Indian painting is rooted in a more ancient world of decorative design in kivas and on tipis . In the next twenty or thirty years the place of Native Indian paintings will become more secure as the subtle beauty and great strength of this uniquely American art form becomes more widely understood and appreciated.

Paintings in the Philbrook collection are not only winners selected from the Indian Annual but also earlier works donated by patrons and purchased by the museum. In tone and theme, these paintings are worlds away from the Indians of western painters like Remington and Russell. Yet they are surprisingly close to much of the earlier documentary works of Catlin, Miller, Bodmer, Stanley and King. Perhaps it is not surprising that only one painting in the entire Indian Collection deals with white-Indian battlefield confrontation. Most of these paintings are faithful efforts to recreate the drama, the excitement, the exhilaration of Indian hunting and ceremonial life. Many address the simple daily tasks of life. A large number are rooted in the religious complex of ancient ways and in the evolving religious worlds of peyotism, others in the modern pan-Indian world of the fairs and pow-wows. Fewer than might be suspected deal with myths and legends. A few are simple decorative designs or figures. A hallmark of the early traditional painters was a meticulous attention to the accuracy of the Indian elements in the paintings. Thus, the Philbrook permanent Indian painting collection is not only an important source for insight into Indian culture and values but also an important guide to material culture as well.

In the early 1960s a determination was made to recognize the artist's significant contribution to this preservation and extension of Indian culture with a special award. The coming of age of the Philbrook Indian Annual was perhaps symbolized in 1963 by the addition of this Waite Phillips Indian Artist's Award, designed to transcend all other awards and reflect the artist's career achievement. The recipients of the trophy,

beginning with Fred Beaver, reflect the interrelationship of Philbrook and the careers of the great figures in the post World War II Indian art world. The list of winners include:

1963	Fred Beaver	1970	C. Terry Saul
1964	W. Richard West	1971	Willard Stone
1965	Solomon McCombs	1972	*no award given*
1966	Oscar Howe	1973	Joan Hill
1967	F. Blackbear Bosin	1974	Wolf Robe Hunt
1968	Pablita Velarde	1975	Al Momaday
1969	Allan Houser		

An original and highly decorative style which utilizes subtle lines and colors was developed by Robert Chee, whose "Fire Dance" is a cornerstone of the Southwestern paintings in Philbrook's collection. Like Tiger's, Chee's untimely death silenced a developing talent.

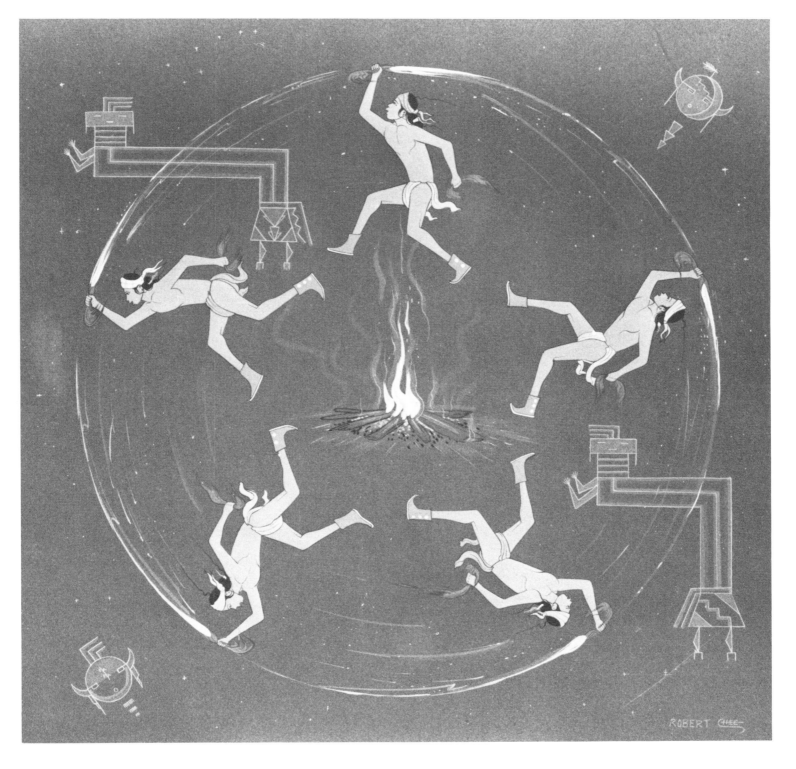

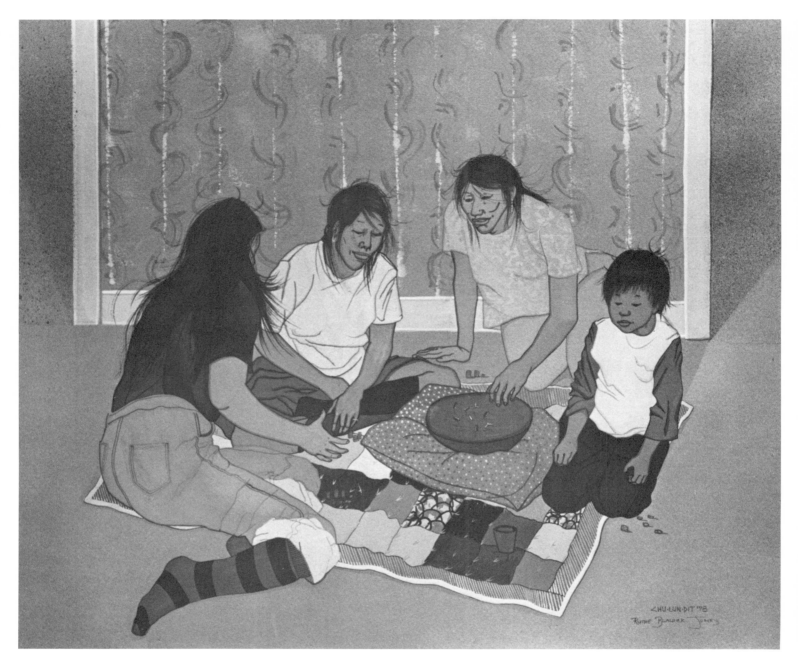

"Shawnee Playing Dice" by Ruthe Blalock Jones is one of the best of the modern Indian paintings which focus on contemporary Indian life. Ms. Jones, currently director of Indian art at Bacone College, follows in the tradition of great artist-teachers such as Woody Crumbo, Acee Blue Eagle, Dick West and Terry Saul.

In recent years, despite some particularly interesting and exciting individual works, the Philbrook Indian Annual has been disappointingly derivative and sadly imitative of older traditional Indian painting and newer trends of modernism. Much of the old creative charge of new and important developments has been missing. Some artists — Ruthe Blalock Jones, T. C. Canon, Helen Hardin, Valjean Hessing, Ben Harjo, Jr., Minisa Crumbo, Joseph Kabance, Virginia Stroud, Robert Anseley — have extended Indian painting and suggest the promise of yet other generations of Indian artists capable of building upon the great Indian artistic tradition. The recent addition of the graphics category to the Philbrook Annual is particularly significant in light of recent work by Indian artists in lithography and etching.

So very much of recent painting is weak. There is little that is imaginative and less that is original. One critic has cynically noted that more Indians have died on painted Trails of Tears than in all the nineteenth century removals combined. Particularly disturbing are tired treatments of burial and spirit ascension and confused ceremonials and historic reenactments in which tribal cultures are transposed, with Kiowa braves being driven from the Florida everglades on Comanche ponies carrying Sioux shields. There is no guarantee that the quality work of the talented young artists will prevail against this mass of second-rate painting. The prospects are frightening. To find ways to assist those who are struggling for the best is a continuing challenge for Philbrook.

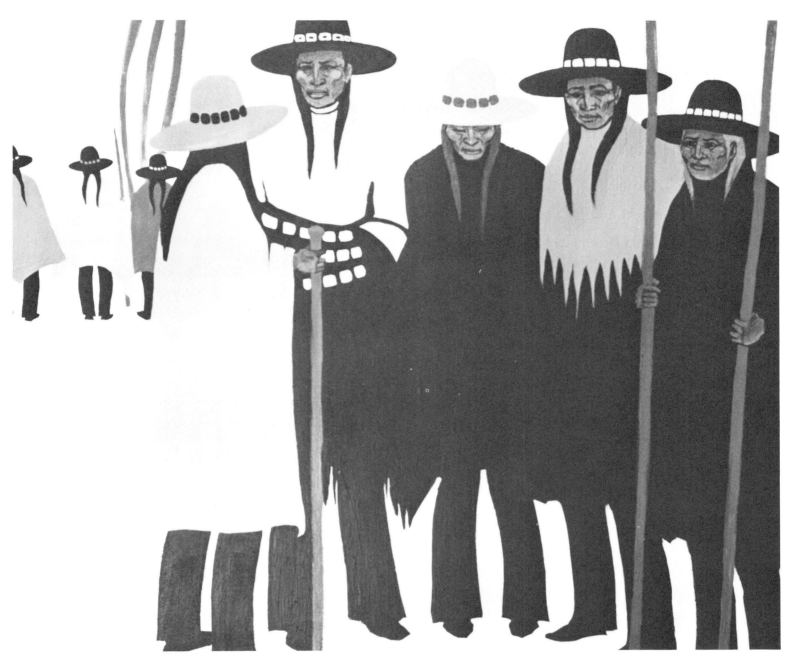

Almost twenty years ago at the artistic height of the Philbrook Indian Annual Maurice de Vinna, the *Tulsa World's* conservative art critic, wondered about the future of Indian painting. "It is interesting to speculate," he began, "as to what direction American Indian painting can take beyond this point. . . ." Noting that "in Philbrook Indian exhibitions we see on the one hand the work of young artists too impatient to master their crafts," he concluded that "tasteless imitations . . . mark the beginning of decadence in any school."[34]

Predictions of the end of Indian painting are not new. Doomsayers have seen the end almost from the beginning. One is reminded of a terrible spring storm which arose while a group of collectors were preparing an exhibition honoring Willard Stone, the Cherokee sculptor. At the insistence of the group, Anna Kilpatrick, the Cherokee folklorist and linguist, recited a sacred Cherokee Medicine formulae to divide the clouds and send them in either direction around the house. As she recited the words in Cherokee, Anna warned that only fools expect only clear spring days, those who try to avoid storms miss much of life — that the air is clearest and the colors purest at the center of the storm.

Over the last forty years, in one way or another, Philbrook has been at the center of the storms of Indian art, in the eye of the rapidly moving whirlwind that is American

Many Indian paintings in oil or acrylics rather than watercolor or tempera are classified as "modern" or "non-traditional Indian." Joan Hill's "War and Rumor of War" is starkly traditional in composition. Completed during the height of the Vietnam crisis, this large oil depicts the meeting of a stoic Creek war council. Here is a haunting example of the contemporary relevance of the historic experience of the American Indian. (Detail).

Indian painting. And in the process Philbrook has weathered many an artistic, ideological, and financial storm. If it had not been for a few dedicated patrons like the Zink family and the support of determined generations of artists along with staff like Jeanne Snodgrass, the Philbrook Indian art programs would have died.[35]

Museums — like other educational institutions — are not so important for what they themselves do but for what they make it possible for others to do. Letters from Indian artists to Philbrook indicate that Philbrook was most important to them because it gave major art world institutional support to the growing Indian painting movement, because it created collectors and markets, because it ultimately encouraged the refinement of Indian art and because it took seriously what too many traders and promoters thought of as curios.[36]. Thus, Philbrook's Indian art program — the Annual, the permanent collection, the one-man shows, the traveling exhibitions — has contributed more to this important art form than early boosters dreamed possible. It is a tribute to Philbrook that the world of Indian art no longer centers so squarely at the Waite Phillips mansion.

Philbrook looks forward to continuing to serve a larger art world, one beyond the curio shops. To provide a forum for the very best of contemporary Indian art and to encourage the continued development of American Indian painting is a challenge which Philbrook should be prepared to accept. While the nature of the Indian painting world of the 1980s is vastly different from that of the 1940s, the opportunity for Philbrook is just as great. "Philbrook is very dear to the heart of every Indian artist," Oscar Howe once wrote, "and since it has fostered Indian art from the beginning it is looked upon with great hope and confidence for the future development of Indian art."[37]

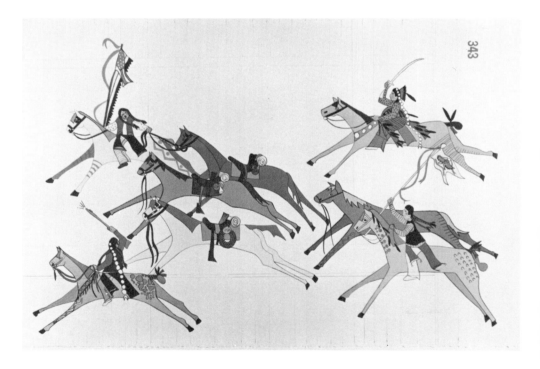

The program cover from the 14th Philbrook Indian Annual features a prize-winning painting by Blackbear Bosin. Philbrook's competitive show, held from 1946 to 1979, has been a major influence in the careers of several generations of Indian painters. The cover from the 29th Annual contrasts sharply with that of the 14th. When Philbrook again sponsors a painting competition, the museum must be prepared to address the changing nature of Indian painting while retaining standards of the highest order. This is a great challenge to Philbrook and the tradition of the Indian Annual.

Traditional Indian painting is rooted in the painted tipi and ledger book painting of the late 19th century. A contemporary lithograph by Virginia Stroud, "Enemy Treasure," reflects this ledger book heritage in a strikingly fresh interpretation of Plains Indians capturing enemy horses.

24

NOTES

*The author is John W. Shleppey Research Professor of Law and History at The University of Tulsa. Strickland, of Cherokee and Osage heritage, has written extensively on Indian art and culture, including the popular Spirit Tales Series coauthored with Jack Gregory and illustrated by Willard Stone, Fred Beaver, Terry Saul and Joan Hill.

1. *Time* reported: "Some 3,000 Tulsans, some of them art lovers, the rest just curious, jammed into the former Phillips palace on opening night. What they saw . . . were mostly bright, flat watercolors of tribal life and lore."

2. All quotations, unless otherwise noted, are from the archives of the Philbrook Art Center (PAC). Copies are available of most cited letters in the Special Collections Division, McFarlin Library, The University of Tulsa (ML, UT). See 1946 Exhibition File, PAC.

3. See 1946 Indian Annual Files, PAC.

4. Letter, F. Dockstader to J. Snodgrass, May 3, 1966, PAC.

5. See particularly Traveling Exhibition Files and Painting Permissions and Reproduction Files, PAC.

6. See mimeographed catalogue for First Annual and 1946 Annual File, PAC.

7. For an overview of the history of American Indian painting see the following: Dorothy Dunn, *American Indian Painting* (Albuquerque: University of New Mexico Press, 1968); Clara Lee Tanner, *Southwest Indian Painting: A Changing Art* (Tucson: University of Arizona Press, 2nd Edition, 1973); Jamake Highwater, *Songs From the Earth: American Indian Painting* (Boston: New York Graphic Society, 1976); and Arthur Silberman, *100 Years of Native American Painting* (Oklahoma City: Oklahoma Museum of Fine Arts, 1978).

8. See 1966 Annual File, PAC.

9. See generally Chapter III in Rennard Strickland, *The Indian in Oklahoma* (Norman: University of Oklahoma Press, 1980). For biographical information see Jeanne O. Snodgrass (comp.), *American Indian Painters: A Biographical Directory.* (New York: Museum of the American Indian, Heye Foundation, 1958).

10. See J. J. Brody, *Indian Painters and White Patrons* (Albuquerque: University of New Mexico Press, 1971).

11. The native roots of modern Indian painting as seen in the gradual evolution of the art can be traced in the following: John Ewers, *Murals in the Round: Painted Tipis of the Kiowa and Kiowa-Apache Indians* (Washington: Renwick Gallery, Smithsonian Institute Press, 1978); John C. Ewers, *Plains Indian Painting: A Description of an Aboriginal Art* (Stanford: Stanford University Press, 1938); Hartley B. Alexander, *Sioux Indian Painting* (Nicé, France: C. Szwedzicki, 1938); Helen H. Blish, *A Pictographic History of the Oglala Sioux,* Drawings by Amos Bad Heart Bull (Lincoln: University of Nebraska Press, 1967); Karen Peterson, *Plains Indian Art From Fort Marion* (Norman: University of Oklahoma Press, 1971);

Dorothy Dunn, *1877: Plains Indian Sketch Book of Zo-Tom and Howling Wolf* (Flagstaff: Northland Press, 1969); Burton Supree, *Bear's Heart: Scenes From the Life of a Cheyenne Artist of One Hundred Years Ago With Pictures By Himself* (Philadelphia: J. B. Lippincott Co., 1977); O. B. Jacobson and Jeanne D'Ucel, *Les Peintres Indiens D'Amerique* (Nice, France: C. Szwedzicki, 1950); Patricia Broder, *Hopi Painting: The World of the Hopi* (New York: A Brandywine Press Book, 1979); Myles Libbart (ed.), *Contemporary Southern Plains Indian Painting* (Anadarko: Oklahoma Indian Arts and Crafts Cooperative, 1972); Bert Seabourn, *The Master Artists of the Five Civilized Tribes* (Oklahoma City: Private Printing, 1978); Indian Arts & Crafts Board, *Contemporary Sioux Painting* (Rapid City, South Dakota: Tipi Shop, Inc., 1970); and Norman Feder, *North American Indian Painting* (New York: The Museum of Primitive Art, 1967).

12. Mimeographed, Philbrook Art Center, "American Indian Painting," press release, June 1947, PAC.

13. *Ibid.*

14. Letters, Susan Peters File, PAC. For an example of Beaver's traditional style see his illustrations in Rennard Strickland and Jack Gregory , *Creek-Seminole Spirit Tales* (Muskogee: Indian Heritage Association, 1971).

15. Letter, O. Howe to J. Snodgrass, April 18, 1958, ML, UT. This artist's life is the subject of John R. Milton, *Oscar Howe* (Minneapolis: Dillon Press, 1976).

16. Letter, D. Myers to O. Howe, May 13, 1958, ML, UT.

17. Letter, F. Beaver to D. Myers, April 25, 1956, ML, UT.

18. See One Man Show Files and Catalogues, PAC.

19. Typed notes, Conference on Directions in Indian Art, Tucson, Arizona, March 1959, PAC.

20. Althea Bass, *The Arapaho Way: A Memoir of an Indian Boyhood* (New York: Clarkson N. Potter, Inc., 1966), vii, ix-x. An equally important portrait of a Southwestern Indian artist is *Fred Kabotie: Hopi Indian Artist: An Autobiography.* Told with Bill Belknap. (Flagstaff: Museum of Northern Arizona, 1977). An interesting biography of another Southwest artist long associated with Philbrook is Mary Carroll Nelson, *Pablita Velarde* (Minneapolis: Dillon Press, 1971). One gets a poignant insight into the life, work, and philosophy of art of one of the most significant of the Five Kiowa artists in *The Peyote Ritual: Visions and Descriptions of Monroe Tsa Toke* (San Francisco: The Grabbom Press, 1957). Susan Peter's "The Spirit of A Kiowa Artist," printed therein, is touching tribute by a teacher to a talented pupil.

21. Bass at 63.

22. Acee Blue Eagle (ed.), *Oklahoma Indian Painting-Poetry* (Tulsa: Acorn Publishing Co., 1959), no pagination.

23. *Ibid,* n.p.

24. *Ibid,* n.p.

25. *Ibid,* n.p.

26. Interview, J. Snodgrass-King, March 1980.

27. N. Scott Momaday, *Names: A Memoir* (New York: Harper & Row, 1976), 36-37.

28. Letter, F. Beaver to J. Snodgrass, July 1959, ML, UT.

29. Statement, Patrick Desjarlait, Mimeographed Guide to Philbrook Traveling Exhibition, 1947, PAC. See also Neva Williams, *Patrick Des Jarlait: The Story of an American Indian Artistt* (Minneapolis: Lerner Publications Co., 1975).

30. Strickland, *Indians in Oklahoma,* 1.

31. 1946 Annual File, PAC.

32. R. C. Gorman, Holographic Note to Jeanne Snodgrass, undated, ML, UT. See also Doris B. Montham, *R. C. Gorman: The Lithographs* (Flagstaff: Northland Press, 1978) and Guy and Doris Montham, *Art and Indian Individualists* (Flagstaff: Northland Press, 1975). Contrast this with Fritz Scholder's personal statement: "Being one-quarter Luiseno Indian from California, I have a unique perspective. I am a non-Indian Indian. I do not feel the pull of the dichotomy of two cultures. However I am aware of the incongruous nature of the two cultures." Scholder in *Indian Kitsch: The Use and Misuse of Indian Images* (Flagstaff: Northland Press and the Heard Museum, 1979), n.p. For a fuller view of this important artists own works see Fritz Scholder, *Scholder/Indians* (Flagstaff: Northland Press, 1972), and Clinton Adams, *Fritz Scholder Lithographs* (Boston: New York Graphic Society, 1975).

33. See Ellwood Parry, *The Image of the Indian and the Black Man in American Art,* 1590-1900 (New York: George Braziller, 1974) and Rena N. Coen, *The Red Man in Art* (Minneapolis: Lerner Publications Co., 1972). The standard account is Robert F. Berkhofer, *The White Man's Indian: Images of the American Indian from Columbus to the Present* (New York: Alfred A. Knopf, 1978).

34. *Tulsa World,* September 8, 1963.

35. "Without the Zinks, the Indian Annual might have gone under," according to a former curator of Indian art. Over the years, this Tulsa family was the major financial backer of the Indian painting competition.

36. See generally Artist Files, PAC.

37. Letter, O. Howe to D. Humphrey, April 23, 1959.

Catalogue of the Exhibition

NOTE: Dimensions are stated in inches, with height or length given before width or diameter, unless otherwise stated.

The following abbreviations are used to designate specific collections:

PAC Philbrook Art Center

 C. F. Clark Field Collection
 R. C. L. Roberta Campbell Lawson Collection
 L. J. W. L. J. Woodruff Collection
 A. L. D. A. L. Dade Collection

TU University of Tulsa

 A. M. R. Alice M. Robertson Collection
 B. R. Bright Roddy Collection
 E. S. Ellis C. Soper Collection
 G. M. T. George M. Tredway Collection

NN Source unknown

Objects in each subject category are arranged alphabetically by tribe, then consecutively by catalogue number, Tulsa University collections first, followed by those belonging to Philbrook.

In catalogue descriptions the term "hide" is used to designate any kind of animal hide of non-commercial production. The term "leather" indicates a commercially tanned product.

BAGS & POUCHES

Awl Cases

1. AWL CASE

Apache, late 19th C.

Hide foundation decorated with bands of beading in geometric patterns and with attachment thongs at the top, and a two-piece hide tassel at the bottom decorated with beads and tin jangles.

17 in. long

PAC, A.L.D., D-8

2. AWL CASE

Apache, late 19th C.

Hide foundation decorated with bands of beading and tin jangles and with attachment thongs at the top, and a slit one-piece tassel with beads, tin jangles and brass buttons.

15 in. long

PAC, A.L.D., D-9

3. AWL CASE

Cheyenne, ca. 1900

Hide foundation trimmed with beaded bands and two beaded tassels terminating in cowrie shells.

11 in. long

TU, E.S., 42-1222

4. AWL CASE

Cheyenne, late 19th C.

Leather foundation with beaded bands and hide tassels.

12 in. long

TU, E.S., 42-1227

5. AWL CASE

Sioux, late 19th C.

Leather foundation trimmed with beaded bands; beaded hide tassels terminating in tin jangles with yellow-dyed horsehair.

15 in. long

TU, E.S., 42-1223

Bags and Pouches (Miscellaneous)

6. BAG

Apache, ca. 1900

Two-piece hide construction with bottom fringe, decorated front and back with beaded geometric borders and large central medallions.

9 x 7 in.

TU, E.S., 42-1110

7. BAG

Apache, ca. 1920

Two-piece hide construction with multi-color bottom beaded fringe; the bag decorated in geometric patterns.

10 x 6 in.

TU, E.S., 42-1119

8. POUCH

Apache, ca. 1880

Of hide construction with carrying thong and long attached fringing. Both sides bear painted decoration in red and black consisting of both geometric and naturalistic symbols.

10 x 8 in.

PAC, A.L.D., D-4

9. POUCH

Apache, ca. 1920

Two-piece hide construction with closing flap and inserted fringe strips, partially beaded with geometric concentric border patterns and with fringe strips terminating in tin jangles.

6 x 5 in.

PAC, A.L.D., D-5

10. BAG

Arapaho, late 19th C.

Leather foundation and fringe, decorated with beadwork and a large brass button.

11¾ x 8¾ in.

TU, E.S., 42-1101

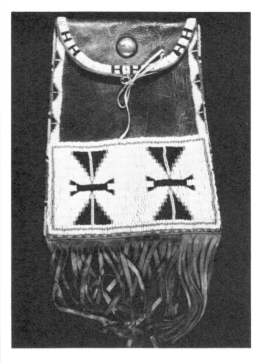

11. BAG

Arapaho, late 19th C.

Hide foundation; hide fringe with red pigment applied; front and back decoration of woven quillwork; decorative tassel on the front, quill-wrapped, and terminating in tin jangles with red-dyed horsehair.

7½ in. diameter

TU, E.S., 42-1102

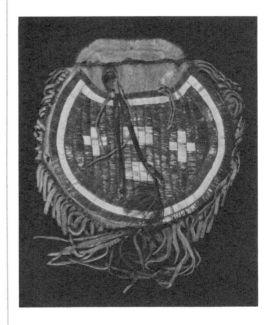

12. BAG

Arapaho, late 19th C.

Hide foundation and fringe with crenelated closing flap, with beaded and quilled decoration.

7 in. diameter

TU, E.S., 42-1204

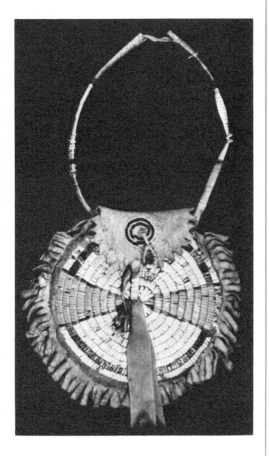

13. BAG

Cheyenne, late 19th C.

Leather foundation; hide fringe; completely beaded, front and closing flap; partially beaded back.

10¾ x 7½ in.

TU, E.S., 42-1185

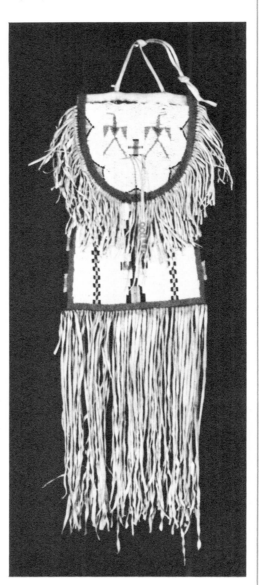

14. BAG

Comanche, late 19th C.

Hide foundation reinforced at the top with cotton fabric and cotton twined drawstring terminating in a brass bell; beaded decoration and beaded hide tassels.

9 x 1¾ in.

TU, B.R., 31-157

15. BELT POUCH

Probably Cree (Montana), ca. 1925

Leather foundation, the front completely covered with appliqué beadwork in a pattern of concentric half-circles.

6¼ x 6¼ in.

PAC, R.C.L., MI-2055

16. NEEDLE CASE

Delaware, late 19th C.

Cotton fabric ribbonwork designs across both pockets on front of flat rectangular wool flannel case with peak at top.

9¾ x 4 in.

PAC. R.C.L., MI-2040

17. BAG

Flathead, late 19th C.

Wool felt foundation with appliquéd beadwork in a stylized design of flowers, leaves and branches.

10 x 8 in.

TU, E.S., 42-1104

18. BAG

Iroquois (New York), ca. 1885

Cotton foundation with closing flap; decorated with floral beaded pattern within multiple beaded borders appliquéd on black velvet; closing flap with several tin sequins, and red silk ribbon bows at the top corners. The bag assembly is incomplete.

5¾ x 5½ in.

TU, E.S., 42-1150

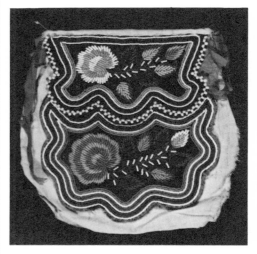

19. BAG

Probably Iroquois (New York), late 19th C.

Brown broadcloth foundation with cotton lining and binding; design of stylized floral appliquéd beadwork within beaded borders, and with beaded fringing.
5¼ x 4½ in.
PAC, Gift of Mrs. George Cunningham, MI-3318

20. BAG

Osage (Oklahoma), late 19th C.

Red flannel foundation with braided wool drawstring; ribbon binding at the mouth and edges; down the center of each side is a panel of appliquéd ribbon decoration. Bags of this type are frequently called "Cedar Bags," for their use in storing cedar wood for use in the services of the Native American Church.
19 x 11½ in.
TU, G.M.T., TR-7

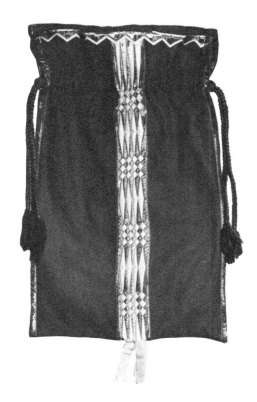

21. BAG

Southern Plains, ca. 1860

Otter skin with cloth, hide and bead inset at neck opening; cloth, beads and hide fringe added to limbs and tail.
16½ x 6½ in.
PAC, NN 105

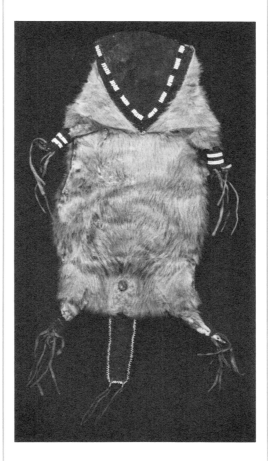

22. POUCH

Shoshone, late 19th C.

Hide foundation with large center beaded medallion and a row of beads around the edges.
9¼ x 7¼ in.
PAC, R.C.L., MI-2041

23. BAG

Sioux, late 19th C.

Hide foundation with beaded decoration, beaded hide ornaments, tin jangles and red-dyed horsehair.
7½ x 13 in.
TU, E.S., 31-1017

24. BAG

Sioux, ca. 1900

Hide foundation, handle and fringe, with closing flap; decorated with quillwork and beading.
5½ x 6½ in.
TU, E.S., 42-1103

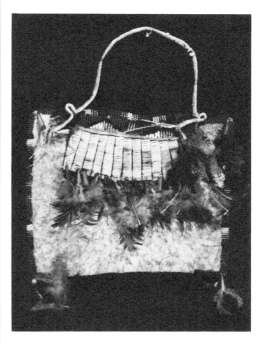

25. BAG

Sioux, ca. 1930

Hide foundation and fringe, the top reinforced with red silk fabric, and with beaded decoration.
14 x 8 in.
TU, E.S., 42-1132

31

26. BAG

Sioux, ca. 1900

Hide foundation and fringe, decorated with beadwork, tin jangles and red-dyed horsehair.
12 x 7½ in.
TU, E.S., 42-1135

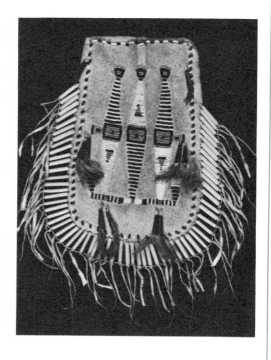

27. BAG

Sioux, late 19th C.

Hide foundation and fringe with beaded decoration.
8 x 4½ in.
TU, E.S., 42-1161

28. POUCH

Sioux, late 19th C.

Buffalo bladder, the mouth rim reinforced with cotton fabric; attached near the mouth of the bag is a wide hide collar and fringe decorated with quillwork, tin jangles and yellow-dyed horsehair.
10¼ x 6¼ in.
TU, E.S., 42-1163

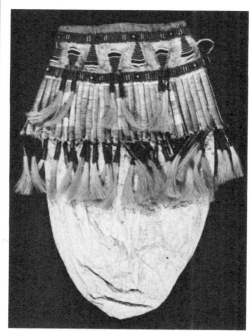

Ceremonial Shoulder Bags

29. CEREMONIAL SHOULDER BAG

Chippewa, ca. 1900

Brown velvet foundation bound with brown cotton fabric, and with patterned cotton fabric lining; appliquéd beadwork bag front, bandoleer and borders in realistic floral patterns; fringe of cut blue glass beads and wool tassels.
40 x 15 in.
TU, E.S., 31-864

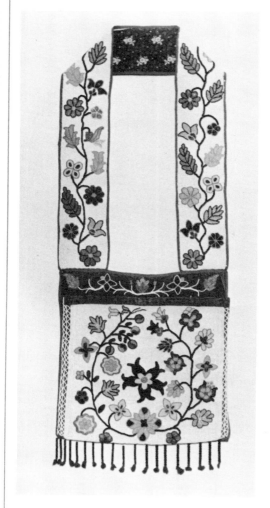

30. CEREMONIAL SHOULDER BAG
Chippewa, ca. 1890

Black broadcloth foundation, the bag bound with dark green cotton fabric and the bandoleer with red cotton fabric; patterned cotton fabric lining; applied loomwoven beaded panels on bag front and bandoleer; appliquéd beaded borders; loom-woven beaded fringe with wool tassels.
38 x 11 in.
TU, E.S., 42-1208

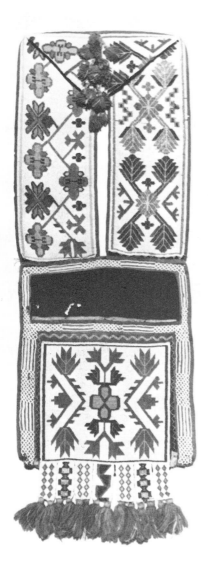

31. CEREMONIAL SHOULDER BAG
Chippewa, ca. 1890

Black velvet foundation with dark green cotton fabric binding; applied loom-woven beaded panel in geometric designs on bag front and on bandoleer; appliquéd beaded borders; loom-woven beaded fringe with wool tassels.
40 x 15 in.
TU, E.S., 42-1209

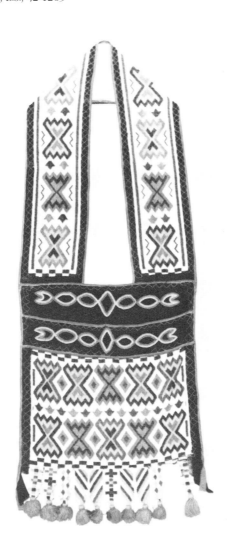

32. CEREMONIAL SHOULDER BAG
Chippewa, ca. 1900

Brown velvet foundation bound with brown cotton fabric and lined with patterned cotton fabric; bag front and bandoleer with appliquéd beadwork in realistic floral pattern; fringe of tubular cut white beads with wool tassels.
34 x 12 in.
TU, E.S., 42-1216

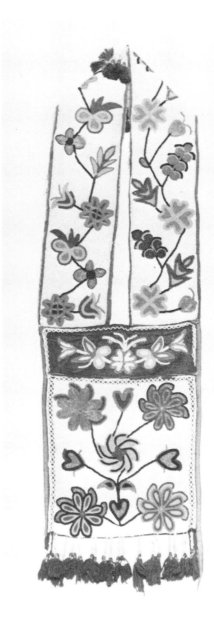

33. CEREMONIAL SHOULDER BAG
Chippewa, ca. 1885

Red broadcloth foundation with greenish-brown cotton fabric binding and patterned cotton fabric lining; applied loom-woven beaded panels on bag front and bandoleer in geometric patterns; appliquéd floral and geometric beaded borders; loom-woven beaded fringe with wool tassels.
38 x 12 in.
PAC, R.C.L., MI-2224

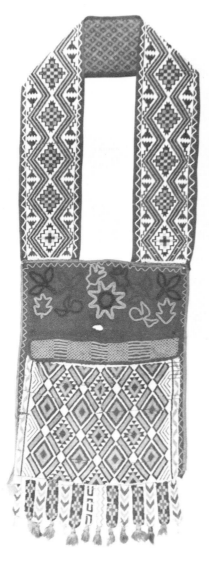

Knife Cases

34. KNIFE CASE
Nothern Plains, ca. 1880

Wooden handled knife enclosed in leather case decorated with rows of brass tacks.
Case: 12½ x 4 in.; Knife: 11 in.
TU, G.M.T., TR-101

35. KNIFE CASE
Sioux, late 19th C.

Hide case with geometric designs on front divided at center with row of tin jangles. Lower end has bead-wrapped hide strip with tin jangles on ends.
10 x 3 in.
PAC, R.C.L., MI-2019

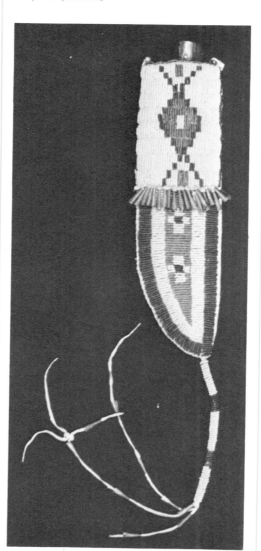

Pipe Bags

36. PIPE BAG
Cheyenne, late 19th C.

Hide foundation in two attached sections, and attached hide fringe. Decorated with beadwork and quillwork.
32 x 5½ in.
TU, E.S., 42-1203

37. PIPE BAG
Cheyenne, late 19th C.

Hide with floral beaded decoration.
15 x 3 in.
PAC, G.M.T., TR-31

38. PIPE BAG
Cree, ca. 1885

Hide foundation and fringe, with scalloped mouth bearing traces of black ribbon binding. Lower third of the bag decorated with beadwork in a floral design.
20 x 6 in.
TU, E.S., 42-1195

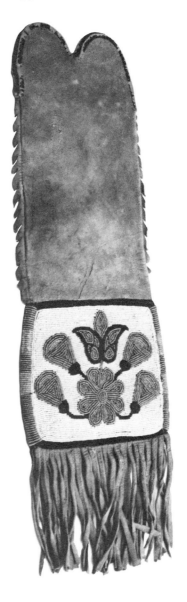

39. MINIATURE PIPE BAG

Sioux, late 19th C.

Hide foundation with scalloped top and hide fringe, with quill and beaded decoration, tin jangles and purple-dyed feathers.
15 x 2½ in.
TU, E.S., 42-1179

40. PIPE BAG

Sioux, late 19th C.

Hide foundation and fringe with beaded and quilled decoration.
35 x 6½ in.
TU, E.S., 42-1192

41. PIPE BAG

Sioux, late 19th C.

Hide foundation and fringe, the lower third of the bag with beaded panels and fringe with wrapped quillwork.
32 x 6¾ in.
TU, E.S., 42-1193

42. PIPE BAG

Sioux, late 19th C.

Hide foundation and fringe, all stained green. Decorated with beadwork, quillwork and tin jangles.
33 x 5½ in.
TU, E.S., 42-1200

43. PIPE BAG

Sioux, ca. 1900

Hide foundation and fringe with beaded and quilled decoration and red-dyed feathers.
32 x 7½ in.
TU, E.S., 42-1196

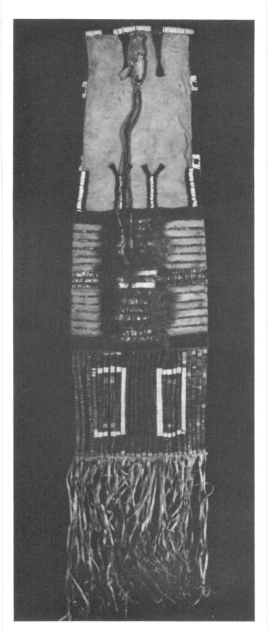

44. PIPE BAG

Sioux, late 19th C.

Hide foundation and fringe, decorated with beadwork, quillwork and tin jangles.
34 x 7 in.
TU, E.S., 42-1201

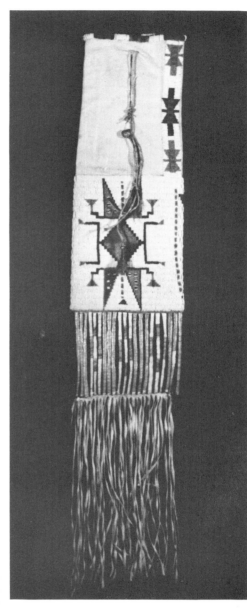

45. PIPE BAG
Sioux, late 19th C.

Hide foundation and fringe with all-over beaded decoration and secondary decoration of quillwork.
38 x 6 in.
TU, A.L.D., D-2

46. PIPE BAG
Sioux, late 19th C.

Hide foundation and fringe, decorated primarily with beadwork, secondarily with quillwork and with tin jangles.
30 x 6 in.
PAC, R.C.L., MI-2132

47. PIPE BAG
Sioux, late 19th C.

Hide foundation of two joined sections and attached hide fringe of two long, triangular tabs. Sewn to the upper front of the bag is a small beaded pouch for steel and flint or matches. The design is entirely in beadwork.
33 x 8 in.
PAC, NN-104

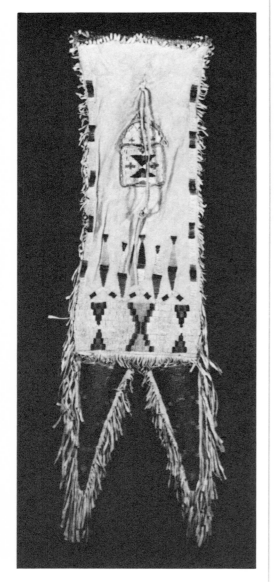

Saddle Bags

48. SADDLE BAG
Crow, ca. 1885

Hide foundation with strips of beaded decoration; binding of red ribbon; triangular ornament of beaded red strouding in lower right corner.
8 x 15 in.
PAC, R.C.L., MI-2137A

49. SADDLE BAG
Sioux, late 19th C.

Hide construction with wide panel of geometric design beadwork across front; narrow beaded strip topped with tin jangles and horsehair across flap, and narrow (beaded) strips up sides.
16 x 23½ in.
TU, B.R., 31-131

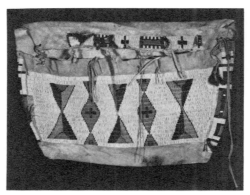

Strike-a-light Bags

50. STRIKE-A-LIGHT BAG
Arapaho, ca. 1880

Hide foundation, beaded decoration, and fringe of tin jangles.
5¼ x 3¼ in.
PAC, R.C.L., MI-2034

51. STRIKE-A-LIGHT BAG
Kiowa, ca. 1880

Hide foundation with beading and tin jangle fringe.
5½ x 3½ in.
PAC, R.C.L., MI-2037

52. STRIKE-A-LIGHT BAG
Kiowa, late 19th C.

Hide foundation with beading and tin jangles.
6 x 3½ in.
PAC, R.C.L., MI-2039

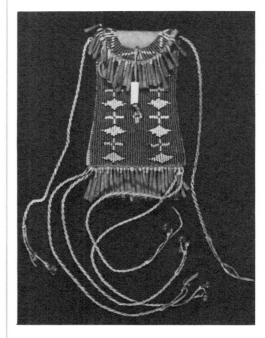

BASKETS

53. BASKET WITH HANDLE

Abenaki (New Hampshire), 19th C.

Plaited, plain. Splint warp and weft. Equal width warp and weft on flat, square base; narrow weft on wider warp on rounded sides. Handle extends above round top.

3½ x 4¾ in.

PAC, C.F., BA 435

54. TRINKET BASKET WITH LID

Aleut (Attu Island), ca. 1900

Twined, plain and open. Wild rye grass warp and weft; silk thread false embroidery. Open twining technique decorates flat base; floral and linear designs in false embroidery decorate straight sides and lid which has closed knob at top.

a: 3⅝ x 3⅝ in.
b: 1¼ x 3¾ in.

PAC, C.F., BA 178 a&b

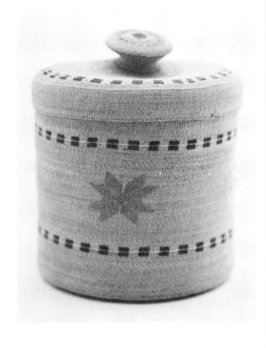

55. BERRY GATHERING BASKET

Aleut, ca. 1900

Plain twined and wrap twined with overlay technique. Wild rye grass warp and weft. Flat base; bands of silk thread decoration in weft or overlay around flexible straight sides. Braided weft handle and filet at rim.

5½ x 5½ in.

PAC, C.F. BA 187

56. TRINKET BASKET WITH LID

Aleut, ca. 1938

Twined, plain and open; false embroidery. Wild rye grass warp and weft; wool yarn decoration. Open twined flat base has warps crossed between rows of weft; false embroidery geometric designs decorate straight sides of basket and sloped lid with small knob at top.

a: 3 x 4 in.
b: 2 x 4¼ in.

PAC, C.F., BA 188 a&b

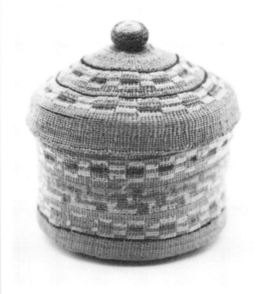

57. TRINKET BASKET WITH LID

Aleut (Attu Island), ca. 1900

Twined, plain and open. Wild rye grass warp and weft; silk thread embroidery. Flat open twined base has warps crossed between rows of weft; embroidery designs on straight sides added after completion of basket. Closed knob of lid decorated with false embroidery.

a: 2 x 3⅛ in.
b: 1⅛ x 3½ in.

PAC, C.F., BA 802 a&b

58. WALLET

Aleut (Attu Island), ca. 1900

Twined, plain and open. Wild rye grass warp and weft; silk thread decoration. Open twined circular bases fold to lay flat. Bands of open twining with both crossed and parallel warps alternate with bands of plain twining decorated with false embroidery on straight sides.

a: 4½ x 2⅞ in.
b: 4¼ x 3⅛ in.

PAC, C.F., BA 804 a&b

59. CONTAINER WITH LID

Algonquin (Quebec, Canada), ca. 1940.
Made by Mary Buckshot.

Birchbark construction. Sgraffito floral designs decorate straight sides which taper inward from rectangular base to round rim; Fleur-de-lis designs decorate flat lid which fits inside rim. Narrow hide handle.

a: 4¾ x 6½ in. max. diam. x 5 in. min. diam.
b: 1¾ x 4½ in.

PAC, C.F., BA 360 a&b

60. ALLIGATOR EFFIGY BASKET

Alibamu, ca. 1963
Made by Maggie Puucho.

Coiled. Pine needle (Longleaf Pine) warp; grass weft. Pine cone strobile decoration. Oval lid fits inside oval body with long neck and head, long tail and extended front legs. Single row of cone strobiles sewn from nose to tip of tail.

a: 3 x 14 in. max. diam. x 3½ in. min. diam.
b: 1⅜ x 5½ in. max. diam. x 2½ in. min. diam.

PAC, C.F., BA 1088 a&b

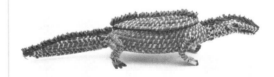

61. BASKET

Jicarilla Apache, ca. 1940

Coiled. Sumac warp and weft. Flat base with vertical geometric designs in dyed weft on straight sides. Slits for handles near rim.

11 x 11¾ in.

PAC, C.F., BA 36

62. BASKET TRAY
Mescalero Apache, ca. 1920

Coiled. Willow and yucca warp; yucca leaf and yucca root weft. Star design in darker weft expands on flat base and curved sides to rim.
3½ x 20¼ in.
PAC, C.F., BA 70

63. BASKET TRAY
San Carlos Apache, ca. 1938

Coiled. Willow warp; willow, martynia, tree yucca root weft. Star forms expand on flat base and widely flared sides; crossed flags between points at rim.
4½ x 18½ in.
PAC, C.F., BA 230

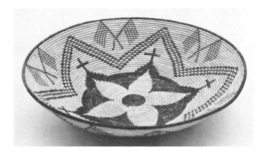

64. BASKET TRAY
Tonto Apache, ca. 1940

Coiled. Willow warp; willow and martynia weft. Whirlwind design and various random design elements in light weft swirl from near center of flat vase around flared sides to rim.
2¾ x 13 in.
PAC, C.F., BA 708

65. BASKET TRAY
Western Apache, late 19th C.

Coiled. Willow warp; willow and martynia weft. Various intricate geometric designs in dark weft expand from dark center of flat base on widely flared sides.
4 x 19¼ in.
PAC, C.F., BA 1008

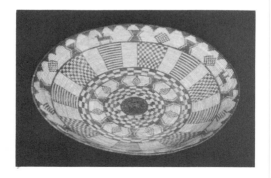

66. BASKET TRAY
Western Apache, early 20th C.

Coiled. Willow warp; willow and martynia weft. Geometric design elements form spaces which enclose human and animal figures on flat base and widely flared sides.
4¼ x 27½ in.
PAC, C.F., BA 1012

67. BASKET BOWL
Western Apache, ca. 1890

Coiled. Willow warp; willow, martynia and yucca (leaf and root) weft. Star design expands from dark center in flat base, up rounded sides to row of inverted triangles at rim.
3¼ x 12 in.
PAC, Gift of H.P. Bowen, MI 2673

68. BURDEN BASKET
White Mountain Apache, ca. 1905.
Made by mother of Alice Spinks (Bacone).

Twined with full twist overlay. Willow warp; willow and marthynia weft; hide. Three bands of geometric designs around tapered sides. Hide reinforces base, exterior of stick frame and is used as decorative fringe. Used at "Coming Out Dance" ceremony.
15 x 15¼ in.
PAC, C.F., BA 51

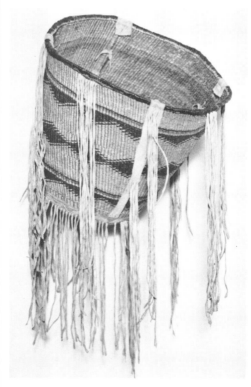

69. STORAGE BASKET
White Mountain Apache (Whiteriver, Arizona), ca. 1900

Coiled. Willow warp; willow and martynia weft. Diagonal dark weft lines enclose various design elements on sides which taper to high shoulder from flat base and curve inward to slightly flared neck.
30½ x 21¼ in.
PAC, C.F., BA 222

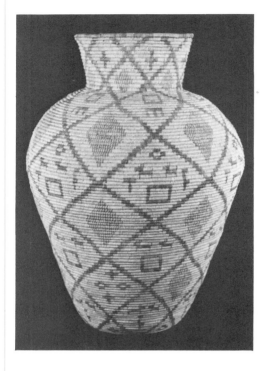

70. BASKET TRAY
Yavapai Apache, ca. 1937

Coiled. Willow warp; willow, martynia and tree yucca root weft. Star points extend to whirlwind design across curved surface, terminating with small flowers at rim.
1¾ x 13½ in.
PAC, C.F., BA 173

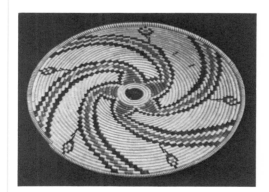

71. BASKET TRAY

Yavapai Apache (Ft. McDowell Reservation), ca. 1950.

Made by Minnie Lacy.

Coiled. Willow warp; willow and martynia weft. Alternating male and female figures in spaces between connected horizontal and vertical lines which expand from dark center and form border at rim of nearly flat surface.

7/8 x 14¼ in.

PAC, C.F., BA 890

72. BASKET BOWL

Cahuilla, ca. 1930

Coiled. Grass bundle warp; juncus weft. Flat oval base with four swastika designs in dyed weft on slightly curved sides.

3¼ x 10¼ in. max. diam. x 9½ in. min. diam.

PAC, C.F., BA 98

73. BASKET TRAY

Cahuilla, ca. 1937

Coiled. Grass bundle warp; plain and dyed juncus weft. Encircling design of rattlesnake is balanced by small dog and cat opposite head near center of nearly flat surface.

4½ x 19½ in.

PAC, C.F., BA 100

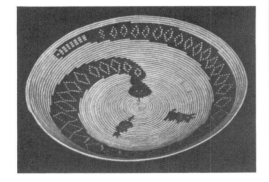

74. STORAGE BASKET

Cahuilla, ca. 1930.

Made by Mary Asuna.

Coiled. Grass bundle warp; juncus weft. Large petals in darker weft start at center of flat base and ascend to wide shoulders which are decorated with eagles between tips of petals; smaller petals ring straight neck. Collector says basket was used for gathering grasshoppers.

12¼ x 13¾ in.

PAC, C.F., BA 277

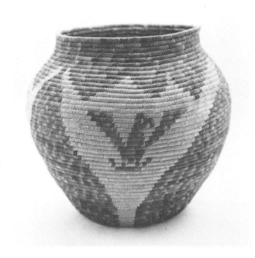

75. STORAGE BASKET

Chemehuevi, ca. 1920.

Made by Mrs. Hill.

Coiled. Willow warp; willow martynia and juncus weft. Alternate vertical plant and geometric designs in dark weft ascend flared sides and over shoulder to flared rim at top.

11¼ x 11 in.

PAC, C.F., BA 101

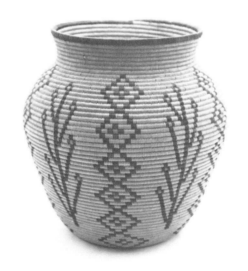

76. BASKET BOWL

Chemehuevi (Colorado River Agency, Parker, Arizona), ca. 1930.

Made by Mary Snyder.

Coiled. Willow warp; willow, juncus and martynia weft. Desert stink bugs in martynia weft against background of juncus surround light weft center of curved surface; rim finished with ticking.

3¼ x 14⅝ in.

PAC, C.F., BA 751

77. BURDEN BASKET

Cherokee, ca. 1940.

Made by Nancy Bradly.

Plaited, diagonal. Split cane (plain and dyed) warp and weft. Diamond designs in diagonal plaiting enclose swastika designs and expand on square base and widely rounded upper portion.

18½ x 21¼ in.

PAC, C.F., BA 323

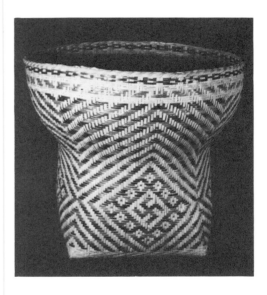

78. STORAGE BASKET

Cherokee, ca. 1942

Wicker, flat warp and round weft. Splint warp; root-runner (honeysuckle) weft. Alternate dark and light warp and weft forms vertical stripes from flat base over rounded shoulder to short neck at top.

15 x 14 in.

PAC, C.F., BA 406

79. MINIATURE BASKET

Cherokee, ca. 1940

Wicker, flat warp and round weft. Splint warp; root-runner (honeysuckle) weft. Alternate plain and dyed warp and weft forms vertical stripes on slightly bowed sides above flat base; handle extends above rim.

2 x 2½ in.

PAC, C.F., BA 407

80. QUIVER

Cherokee, ca. 1940

Plaited, diagonal. Split cane warp and weft. Geometric designs in dyed weft on tubular shape with cup-like handle near rim.
18½ x 4 in.
PAC, C.F., BA 411

81. BASKET WITH LID

Chippewa, late 19th C.

Coiled; bark construction. Sweetgrass bundle warp; thread weft. Birchbark with quill decoration. Straight coiled sides on flat birchbark base; lid is same construction with quillwork floral design on top.
a: 3¼ x 4¾ in.
b: ⅝ x 4¾ in.
TU, E.S., 31-706 a&b

82. SEWING BASKET WITH LID

Chippewa, 19th C.

Plaited, plain. Splint warp; splint and sweetgrass weft. Equal width dyed splint warp and weft of flat base forms warp on straight sides for narrow splint and braided sweetgrass weft. Lid is same construction with sweetgrass handle across center.
a: 2¼ x 5¼ in.
b: 1 x 5¾ in.
PAC, R.C.L., MI 2557 a&b

83. CONTAINER WITH LID

Chippewa, Ojibwa (Minnesota), ca. 1938

Birchbark, quills, sweetgrass, thread. Double-layered bark construction with flat base; vertical rows of quillwork up sides of container and of flat lid. Vertical quillwork extends over top to form border for red and green maple leaf and black beaver on white background.
a: 3½ x 8⅞ in.
b: 1½ x 9 in.
PAC, C.F., BA 231 a&b

84. STORAGE CONTAINER

Chippewa (Wisconsin), late 19th C.
Made by John Whitefish.

Birchbark. Etched floral designs on bowed sides of rectangular container used for storage of maple sugar.
12¼ x 18 in. max. diam. x 12 in. min. diam.
PAC, C.F., BA 305

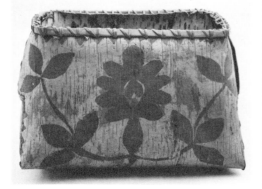

85. BASKET WITH LID

Chitimacha (Grand Lake, S. Charenton Island, Louisiana), ca. 1938

Plaited, diagonal; double weave. Split cane (plain and dyed) warp and weft. Rectangular with plain interior; design on exterior known as Alligator Intestines. Diagonal and line designs on lid which fits over top of basket.
a: 5½ x 9 in. max. diam. x 6½ in. min. diam.
b: 2¼ x 9 in. max. diam. x 6½ in. min. diam.
PAC, C.F., BA 224 a&b

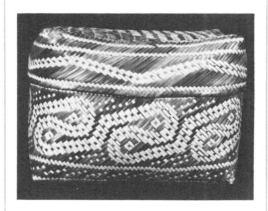

86. HOUSEHOLD UTILITY BASKET

Choctaw, 20th C.

Plaited, diagonal. Split cane warp and weft. Horizontal stripes encircle tubular basket with handle extending above rim.
5½ x 10½ in.
PAC, NN 74

87. GIFT BASKET

Choctaw (Bayou LaCombe, Louisiana), ca. 1942.
Made by Marellia Johnson.

Plaited, diagonal. Plain and dyed split cane warp and weft. Double-opening, elbow-shaped with arched handle connecting inner edges of top openings; geometric designs in dyed weft.
15 x 14 in.
PAC, C.F., BA 418

88. TRINKET BASKET WITH LID

Eskimo (Hoopers Bay, Shagaluk, Alaska), ca. 1930

Coiled. Wild rye grass warp and weft. Short lines of dyed weft ascend spirally around sides which curve widely outward from narrow base. Flat lid with hollow knob fits inside top.
a: 3 x 5½ in.
b: 1 x 4 in.
PAC, C.F., BA 803 a&b

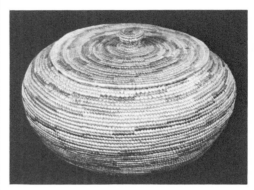

89. TRINKET BASKET WITH LID

Eskimo (Hoopers Bay, Shagaluk, Alaska), ca. 1930

Coiled. Wild rye grass warp and weft. Narrow base; widely curved sides continue to hollow knob at top of lid. Linear designs in dyed weft decorate both basket and lid.
a: 2¼ x 4¼ in.
b: 1½ x 3 in.
PAC, C.F., BA 854 a&b

90. TRINKET BASKET WITH LID

Eskimo (Point Barrow, Alaska), ca. 1920

Coiled. Whale baleen warp and weft; walrus ivory. Sides curve gently outward. Weft attached to flat ivory disc at center of flat base and to disc with carved polar bear at top of lid.
a: 2 x 3¾ in.
b: 1½ x 3½ in.
PAC, C.F., BA 667 a&b

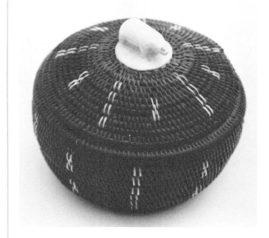

91. TRINKET BASKET WITH LID

Eskimo (Point Barrow, Alaska), ca. 1930

Coiled. Whale baleen warp and weft; walrus ivory. Widely curved sides. Weft attached to ivory disc at center of flat base and to disc with carved seal head at top of lid.
a: 1⅞ x 4¾ in.
b: 1⅞ x 4½ in.
PAC, C.F., BA 687 a&b

92. MINIATURE BASKETS

Great Lakes, ca. 1940

Plaited, plain. Splint warp; sweetgrass weft. Splint warps cross on rounded base; sweetgrass weft added on slightly rounded sides. Splint handle extends over top.
NN 78: 3/16 x ⅜ in.
NN 79: 3/16 x ⅜ in.
PAC, NN 78, NN 79

93. CRADLE

Fraser River, ca. 1900

Coiled and imbricated with plaited base. Cedar warp and weft; squaw grass, horsetail (rush) and cherry bark imbrication. Flat base; sides curve outward from head, inward to foot. Designs in both imbrication and plaiting.
27¼ x 11¼ x 5¾ in. depth
PAC, C.F., BA 680

94. TRINKET BASKET WITH LID

Haida, ca. 1940

Twined with false embroidery. Spruce root warp and weft; grass and fern stem false embroidery. Single lines of dyed weft enclose false embroidery designs around straight sides and at top of slightly concave lid.
a: 1¾ x 3⅜ in.
b. ½ x 3⅜ in.
PAC, C.F., BA 150 a&b

95. BASKET

Haida (Queen Charlotte Island), ca. 1937

Twined with false embroidery; plain plaited. Spruce root warp and weft; grass and fern stem decoration. Bands of plain plaiting enclose geometric designs in false embroidery around straight, slightly flared sides.
3¾ x 5⅜ in.
PAC, C.F., BA 176

96. BASKET WITH LID

Haida or Tlingit, collected in Hydaburg, Alaska, ca. 1920

Twined with false embroidery. Spruce root warp and weft; fern stem and grass decoration. Single lines of dyed weft around straight sides of basket and on slightly sloping lid enclose geometric designs in false embroidery.
a: 4 x 9⅞ in.
b: 2¼ x 10 in.
PAC, C.F., BA 184 a&b

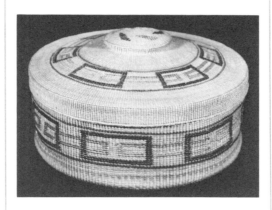

97. WATER JAR

Havasupai, ca. 1900

Twined, plain and three-strand. Unpeeled acacia warp; willow and martynia weft. Geometric designs in dark weft, bands of three-strand twining and red yarn decorate sides of ovoid basket with flared rim.
8 x 7¾ in.
PAC, C.F., BA 127

98. BASKET TRAY

Havasupai (collected Yavapai), ca. 1940. Made by Kate Joseph.

Coiled. Willow warp; willow and martynia weft. Eight-pointed star radiates from black center of flat base and is surrounded by linear geometric and checkerboard designs on widely flared sides. Collector calls this Quartz Design.
2⅝ x 14 in.
PAC, C.F., BA 772

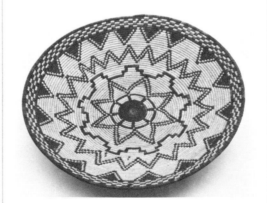

99. BASKET

Hopi, Second Mesa, ca. 1920

Coiled. Grass bundle warp; yucca and martynia weft. Five Kachinas, larger one the "Mother of all Kachinas," on deep tapered sides between wide geometric design bands at base and rim.
19 x 19¾ in.
PAC, C.F., BA 233

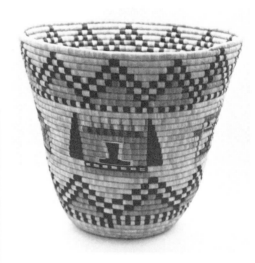

100. BASKET PLAQUE

Hopi, Second Mesa, ca. 1943. Made by Mrs. Cecil Calvert.

Coiled. Grass bundle warp; plain and dyed yucca weft. Expanding star motifs, eagles and deer in dyed weft on nearly flat surface.
2 x 13¼ in.
PAC, C.F., BA 558

101. HOUSEHOLD UTILITY BASKET

Hopi, Third Mesa, ca. 1890

Wicker. Sumac warp; plain and dyed rabbit brush weft. Yucca rim binding. Bands of dyed weft around slightly flared sides above broad concave base.
7¾ x 13 in.
PAC, Gift of Mr. C. Oliphant and Mrs. B. Mayo, MI 3307

102. HOUSEHOLD UTILITY BASKET

Hopi, Third Mesa, Hotevilla, ca. 1950.
Made by Hazel Koyiyumtewa.

Wicker. Willow warp; plain and dyed rabbit brush weft. Yucca rim binding. Dyed weft forms checkerboard design on concave base and stripes on deep, slightly flared sides.
8¼ x 14 in.
PAC, C.F., BA 976

103. BASKET TRAY

Hopi, Third Mesa, ca. 1940.
Made by Rea Loma.

Wicker. Sumac splint (bundle) warp; dyed rabbit brush weft. Yucca rim binding. Butterfly and concentric designs in dyed weft material on flat surface.
1¼ x 15¾ in.
PAC, C.F., BA 1100

104. STORAGE BASKET

Hopi, Shungopovi, Second Mesa, ca. 1956.
Made by Lola Joshongeva.

Coiled. Grass bundle warp; yucca leaf weft. Design of four corn ears representing the four seasons, Knob Head Clown and Crow Wing Mother above row of triangles around sides which taper to wide shoulder and curve inward to narrow orifice ringed by row of triangles at top.
12½ x 17½ in.
PAC, C.F., BA 1032

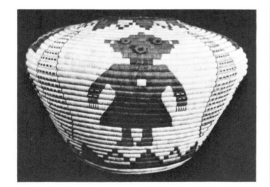

105. BASKET BOWL

Hualapai (collected Apache), ca. 1920

Twined, diagonal. Unpeeled cottonwood warp and weft. Design of three bands of exterior of widely curved sides; base deeply concave.
8 x 13¼ in.
PAC, C.F., BA 41

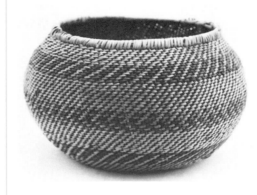

106. BASKET HAT

Hupa, ca. 1900

Twined with half-twist overlay and some wrap twining. Conifer root warp and weft; squaw grass and fern stem overlay. Concave center in round crown; overlay geometric designs around gently curved sides.
3¾ x 6¾ in.
TU, E.S., 31-716

107. BASKET HAT

Hupa, ca. 1920.
Made by Mrs. Charles Myers.

Twined with half-twist overlay. Hazel warp; conifer root weft. Fern stem and squaw grass overlay. Geometric designs on rounded crown; duck-wing-like designs around straight sides.
3½ x 6½ in.
PAC, C.F., BA 88

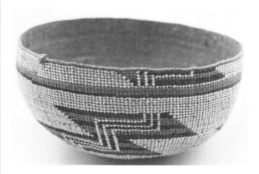

108. CEREMONIAL BASKETS

Hupa (Eureka, California), late 19th C.

Twined with half-twist overlay. Conifer root warp and weft; squaw grass and fern stem overlay. Hide and flicker feathers on ends of long slim baskets on hazel twig frame. Made by Shaman or Medicine Man and used in spring ceremonial fertility dance.
BA 515: 5 x 16 in. max. diam. x 5 in. min. diam.
BA 516: 3¾ x 16½ in. max. diam. x 4 in. min. diam.
BA 517: 3½ x 13 in. max. diam. x 3½ in. min. diam.
PAC, C.F. BA 515, 516, 517

109. MINIATURE BASKET

Huron (Quebec, Canada), ca. 1940.
Made by Gros Louis.

Plaited, plain. Splint warp; sweetgrass weft. Small base; sides flared to rim in fashion of larger utilitarian baskets.
1 x ⅞ in.
PAC, C.F., BA 627

110. WOMAN'S HAT

Klamath, ca. 1900

Twined with full-twist overlay. Tule warp and weft. Round crown; stepped geometric designs in dyed weft around sides.
4½ x 8¼ in.
PAC, C.F., BA 248

111. GAMBLING TRAY

Klamath, ca. 1900

Twined, plain and diagonal. Tule warp and weft, plain and mud-dyed. Diagonally-twined turtle at center; duck-wing designs spiral on outer sections of flat surface.
25½ in. diam.
PAC, C.F., BA 615

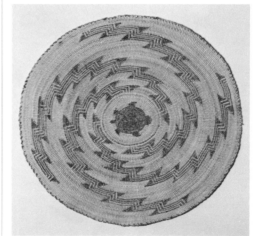

112. WOMAN'S HAT
Karok, ca. 1920

Twined with half-twist overlay. Probably myrtle warp and weft; bear grass, fern stem and (dyed) quill overlay. Slightly concave crown; overlay geometric and line designs decorate exterior of curved sides.
3½ x 7¼ in.
PAC, C.F., BA 89

113. BURDEN BASKET
Karok, ca. 1930

Twined with half-twist overlay and some three-strand twining. Hazel warp, spruce root weft, bear grass overlay. Collected Karok, materials are Hupa. Designs of stepped triangles, a variation of Flying Geese, on sides which curve gently outward from narrow base to wide reinforced rim.
9¾ x 13½ in.
PAC, C.F., BA 141

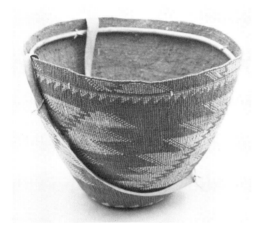

114. STORAGE BASKET
Karok, ca. 1940

Twined with half-twist overlay. Hazel warp; conifer root weft. Dyed conifer root, bear grass and fern stem overlay. Materials are Hupa; collected Karok. Concave base; widely curved sides turn inward to rim. Overlay design known as "Mountains and Clouds."
10½ x 21 in.
PAC, C.F., BA 524

115. BASKET WITH LID
Koasati (Texas), ca. 1941

Coiled. Pine needle (Longleaf Pine) warp; raffia weft. Dyed raffia diamonds decorate wide shoulders of flat base basket. Flat lid has knob at top, red border and fits inside rim.
8 x 10 in.
PAC, C.F., BA 365 a&b

116. TRINKET BASKET WITH LID
Koasati (Allen Parish, Louisiana), ca. 1936. Made by Fanny Puucho.

Coiled. Pine needle (Longfleaf Pine) warp; raffia weft. Dyed weft forms stripes around high shouldered sides above flat base. Lid with knot at top fits inside rim.
a: 1⅞ x 4¼ in.
b: 1½ x 3 in.
PAC, C.F., BA 393 a&b

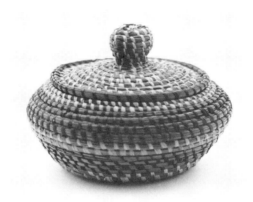

117. BERRY BASKET WITH HANDLES
Lillooet (British Columbia), ca. 1900

Plaited base, coiling technique; imbricated. Cedar warp and weft; horestail (rush) and cherry bark imbrication. Rectangular shape with handles at top. Coiling technique on non-spiralling coils. Imbricated geometric designs.
6 x 13¾ in max. diam. x 6¼ min. diam.
PAC, RCL, MI 2565

118. BABY CARRIER
Loucheux (Yukon River Valley, Alaska), ca. 1942

Folded and sewn birchbark; willow, hide and beads. Soft hide strips hold baby in lower seat portion; beads attached to upper exterior for decoration.
15 x 10½ in.
PAC, C.F., BA 668

119. BOWL
Loucheux (Yukon River Valley, Alaska), ca. 1942

Folded and sewn birchbark; willow. Square base with corners folded on sides and held in place with willow strips around circular rim.
3¼ x 7¼ in. max. diam. x 6½ in. min. diam.
PAC; C.F., BA 669

120. BURDEN BASKET
Northern Maidu, ca. 1900

Twined with full twist overlay. Willow warp and weft; grass and redbud overlay. Cone-shape reinforced with twined hide strips at tip; overlay design known as "Flying Geese."
20 x 20¾ in.
PAC, C.F., BA 110

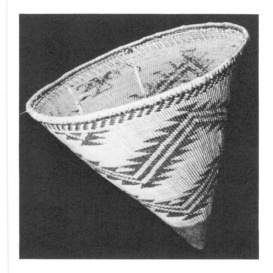

121. BASKET TRAY
Southern Maidu, ca. 1900

Coiled. Grass bundle warp; willow and redbud weft. Three bands of sunburst designs in dark weft encircle light weft center of nearly flat surface.
2⅛ x 12¼ in.
PAC, C.F., BA 253

122. CEREMONIAL CONTAINER
Menominee (Wisconsin), ca. 1870

Birchbark construction. Slightly flared sides above flat base have exterior circular and serrated border designs in darker structural material. Collected from a Medicine man; used in burial ceremony.
6¾ x 8 in.
PAC, C.F., BA 408

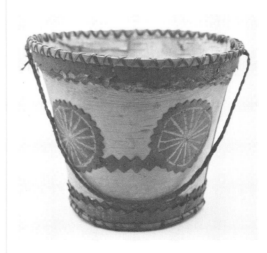

123. CONTAINER WITH LID

Micmac (Nova Scotia), late 19th C.

Birchbark construction with quillwork. Birchbark, wood quills, bark strips. Diagonal quillwork designs decorate straight birchbark sides above round wooden base; geometric floral design decorates top and bark binding, and quills the sides of flat top lid.
a: 2⅝ x 4 in.
b: 1 x 4 in.
PAC, C.F., BA 634 a&b

124. CONTAINER WITH LID

Micmac (Nova Scotia), ca. 1890

Wood and birchbark construction; quill decoration. Rectangular wooden box covered with birchbark and decorated with quills in a chevron design which continues on rounded ends of lid. Top of lid has circular and geometric quillwork designs; front and back are finished with bark binding laced with quills.
a: 4¼ x 7 in. max. diam. x 5⅞ in. min. diam.
b: 1⅝ x 6⅞ in. max. diam. x 6 in. min. diam.
PAC, C.F., BA 368 a&b

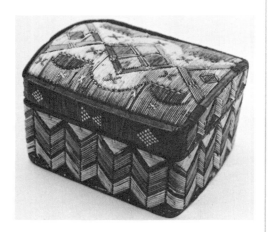

125. BASKET BOWL

Mission (Luiseno) (Pala, San Diego County, California), ca. 1930
Made by Casilda Welmas.

Coiled. Grass bundle warp; sumac and juncus weft. Star in center of flat base expands to floral design in darker weft on flared sides.
3½ x 12⅜ in.
PAC, Butler 9

126. BASKET WITH LID

Mission, ca. 1920

Coiled. Grass bundle warp; juncus weft. Jar shape with high shoulder and flat lid fitting inside rim. Butterfly and animal design in darker weft on opposite sides.
a: 5 x 10 in.
b: ¾ x 7⅛ in.
PAC, C.F., BA 886 a&b

127. BASKET BOWL

Mission, 19th C.

Coiled. Grass bundle warp; plain and dyed juncus weft. Random floral designs on flat base; quail and pelicans on slightly curved sides.
5½ x 15 in.
PAC, C.F., BA 949

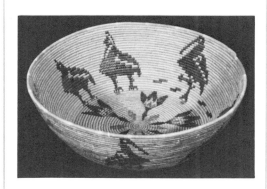

128. BASKET BOWL

Miwok (collected Maidu), ca. 1900

Coiled. Willow warp; (peeled) redbud and bracken fern weft. Flat base; nearly straight sides decorated with feather-like design in dark weft.
6 x 9¾ in.
PAC, C.F., BA 139

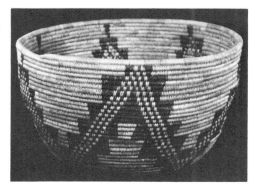

129. BASKET

Modoc, ca. 1900

Twined with full-twist overlay. Hazel warp; conifer weft. Squaw grass and fern stem overlay. Four sections of vertical geometric designs in overlay technique around sides which curve inward from ovoid base to bound and bordered rim.
6¾ x 8¼
TU, E.S., 31-708

130. BASKET WITH LID

Modoc, ca. 1920

Twined with full and half-twist overlay. Conifer root warp and weft; squaw grass, fern stem and conifer overlay. Floral design on concave base; geometric designs in overlay technique around bowed sides and on lid which fits inside rim.
a: 4¼ x 6½ in.
b: 2¼ x 5½ in.
PAC, Butler 7 a&b

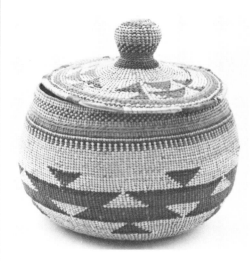

131. WINNOWING BASKET

Mono (collected Maidu), ca. 1920

Twined, open. Willow and redbud warp and weft. Fan shape with vertical stripes formed by alternate bands of peeled willow and unpeeled redbud warp. Use of same materials forms checkered pattern in twined weft.
20 x 16 in. w. x 6¾ in. deep
PAC, C.F., BA 134

132. BASKET BOWL

Mono, ca. 1900

Coiled. Grass bundle warp; willow and martynia weft. Two wide bands of rattlesnake design in dark weft encircle widely flared sides above flat narrow base.
7¼ x 16½ in.
PAC, C.F., BA 628

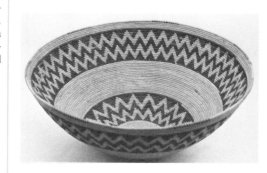

133. CEREMONIAL BASKET
Navajo, late 19th C.

Coiled. Sumac and yucca warp; sumac weft. Three Spider Woman's Crosses around widely curved sides; characteristic herringbone rim finish.
3⅞ x 13 in.
PAC, C.F., BA 710

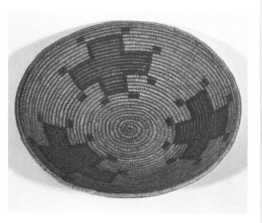

134. BAG
Nez Percé, ca. 1900

Twined with false embroidery. Hemp warp and weft; corn husk decoration with accents of dyed hemp. Designs of vertical connected triangles on one side; triangles divided both vertically and horizontally on reverse of flat rectangular bag.
26¼ x 20 in.
TU, E.S., 31-798

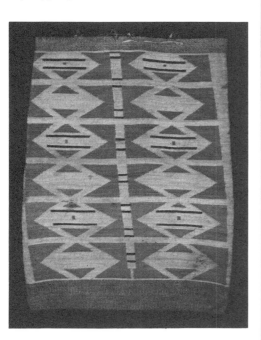

135. TRINKET BASKET WITH LID
Nootka (Makah), ca. 1920

Wrap twined with plaited base. Cedar warp; cedar, rush and squaw grass weft. Designs in rush and squaw grass weft on straight, slightly flared sides and on flat lid; techniques typical of Makah branch of Nootka.
a: 2¼ x 4½ in.
b: ½ x 4½ in.
TU, E.S., 31-722 a&b

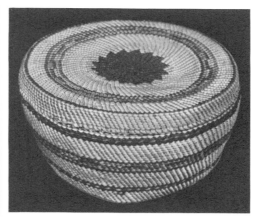

136. BASKET
Nootka (Quatsino) (W. Vancouver Island), ca. 1930

Plain twined and plain plaited. Cedar bark warp; grass and cedar bark weft. Rectangular with plaited base; plaiting and twining combined on sides.
3¾ x 6¾ in. max. diam. x 2 in. min. diam.
PAC, C.F., BA 367

137. CONTAINER WITH LID
Ojibwa (Manitoba, Canada) ca. 1933
Made by Mrs. John Keefer

Birchbark construction. Vertical hatched lines incised on four tapered sides between rectangular base and round rim and on flat top lid. Lid sets deeply into bound rim; handle fastens at sides.
a: 8 x 11 in. max. diam. x 9 in min.diam.
b: 2¾ x 5⅛ in. max. diam. x 4½ in. min. diam.
PAC, C.F., BA 397 a&b

138. BASKET JAR
Paiute, ca. 1930

Coiled. Willow warp; willow, martynia and juncus weft. Vertical arrowhead and geometric design elements on straight sides and top of shoulder of bottleneck shape with narrow base. Short straight neck finished with ticking.
5⅜ x 6½ in.
PAC, C.F., BA 107

139. BEADED BASKET
Paiute, ca. 1930

Coiled; beaded netting. Willow warp and weft; beads. Floral design on flat base and chevron designs on rounded sides in beaded netting of red and green on white background.
2⅝ x 5¼ in.
PAC, C.F., BA 143

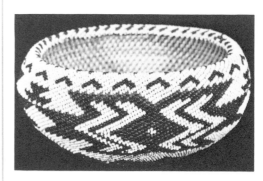

140. CRADLE
Paiute, ca. 1943.
Made by Maud Allen.

Open twined. Willow warp and weft; hide. Yarn design decorates hood fastened to wide upper portion of flat cradle; narrow end at foot bound with hide.
34½ x 12½ x 12 in. hood depth
PAC, C.F., BA 523

141. BEADED BASKET
Paiute, ca. 1950

Coiled; beaded netting. Willow warp and weft; beads. Circular designs on flat base and geometric chevron designs around sides in beaded netting over exterior of basket.
2 x 4 in.
PAC, C.F., BA 1068

142. BEADED BASKET
Paiute, ca. 1950

Coiled; beaded netting. Willow warp and weft; beads. Geometric designs on white background of beaded netting over flat base and angular sides.
1⅜ x 2¾ in.
PAC, C.F., BA 1069

143. BEADED BASKET
Paiute, ca. 1950

Coiled; beaded netting. Willow warp and weft; beads. Three sets of ascending triangles in beaded netting swirl from flat base up angular sides to join below rim.
1⅜ x 2¾ in.
PAC, C.F., BA 1070

144. BEADED BASKET

Paiute, ca. 1950

Coiled; beaded netting. Willow warp and weft; beads. Arrow designs on white background of beaded netting flow around flat base; same design in reverse direction around upper portion of angular sides.
1¼ x 2½ in.
PAC, C.F., BA 1071

145. BEADED BASKET

Paiute, ca. 1950

Coiled; beaded netting. Willow warp and weft; beads. Serrate designs in beaded netting swirl from white center of flat base over rounded sides to rim.
1¼ x 2½ in.
PAC, C.F., BA 1072

146. BASKET BOWL

Panamint (Shoshone), ca. 1937.
Made by Rosie Nobles.

Coiled. Willow warp; willow, martynia, tree yucca root and juncus weft. Star design on narrow base; birds on curved sides in martynia and juncus weft against background of willow weft.
3½ x 7¾ in.
PAC, C.F., BA 60

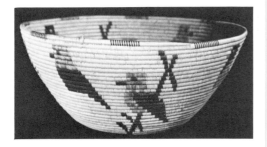

147. BASKET BOWL

Panamint (Shoshone), ca. 1900-1910.
Made by Sarah Hunter.

Coiled. Willow warp; willow, martynia and tree yucca root weft. Various zoomorphic and other forms in dark weft on flat base and widely curved sides.
8¼ x 23½ in.
PAC, C.F., BA 616

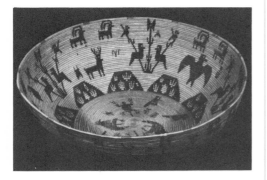

148. STORAGE BASKET

Papago, ca. 1938

Coiled. Bear grass bundle warp; yucca and martynia weft. Vertical lizards and bird designs on sides which taper outward to high shoulder from flat base and slope to widely flared neck.
16⅛ x 16 in.
PAC, C.F., BA 232

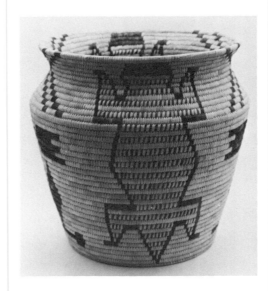

149. BASKET BOWL

Papago (Sells, Arizona), ca. 1920.
Made by Chalola.

Coiled. Bear grass bundle warp; willow and martynia weft. Modified fret design expands on widely curved sides from four points on wide flat base. Used in spring ceremonial dance and for storage of sacred material at other times.
7¾ x 15¼ in.
PAC, C.F., BA 294

150. CONTAINER WITH LID

Passamaquoddy (Malecite, Maine), ca. 1880-1890

Birchbark construction; embroidery. Birchbark, fabric, moose hair embroidery. Red fabric decorated with moose hair embroidery sewn to exterior of flat base and straight sides of octagon-shape birchbark container and lid. Edges bound with moose hair and thread.
a: 2½ x 4⅝ in.
b: 1 x 4¾ in.
PAC, C.F., BA 395 a&b

151. BASKET WITH LID

Pennacook (Merrimac River, Massachusetts), ca. 1840

Plaited, plain. Splint warp and weft, probably ash. Flat rectangular base; straight sides bow slightly to form round rim covered by round lid. Splints dyed on exterior; newspaper lining with items dated 1839 and 1840.
a: 14½ x 18¼ in.
b: 3¼ x 20 in.
PAC, C.F., BA 448 a&b

152. BASKET WITH LID

Penobscot (Maine), ca. 1936

Plaited, plain. Splint warp; splint and sweetgrass weft. Sweetgrass and narrow splint weft on flat base and top of lid; dyed narrow splint weft on wide warp of straight sides.
a: 1¼ x 3¼ in.
b: ½ x 3¼ in.
PAC, C.F., BA 13 a&b

153. BASKET

Penobscot (Maine), late 19th C.

Plaited, plain. Ash splint warp and weft. Narrow weft on straight sides which flare sharply to wide shoulder from double concave base. Wider weft between shoulder and reinforced rim; upright handles at sides.
5¼ x 11¾ in.
PAC, C.F., BA 373

154. TRINKET BASKET WITH LID

Penobscot (Maine), 19th C.

Plaited, Splint warp and weft. Open weave of crossed warps and single weft on hexagonal base and nearly straight sides. Flat top lid fits over round rim; handle extends over top.
a: 2½ x 3¼ in.
b: ⅝ x 3⅝ in.
PAC, C.F., BA 458 a&b

155. BASKET WITH LID

Penobscot, early 20th C.

Plaited, plain. Dyed splint warp; dyed splint and sweetgrass weft. Equal width warp and weft on flat square base forms warp for narrow splint and braided sweetgrass weft on straight sides. Loops on basket and on flat hinged lid for fastening.
2⅝ x 4½ in.
PAC, MI 2781 a&b

156. BASKET WITH LID

Pequot (Connecticut), ca. 1940

Plaited, plain; potato stamp decoration. Ash splint warp and weft. Equal width warp and weft on square base and lid top; alternate wide and narrow width weft on straight sides. Small floral and leaf designs in potato stamp decoration on exterior.
a: 12 x 18½ in max. diam. x 17¾ in. min. diam.
b: 2⅜ x 18½ in. max. diam. x 17⅜ in. min. diam.
PAC, C.F., BA 385 a&b

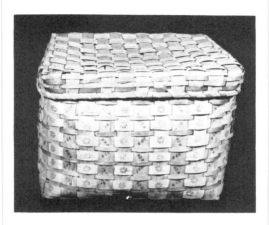

157. BASKET TRAY

Pima, early 20th C.

Coiled. Cattail bundle warp; willow and martynia weft. Squash-blossom design radiates from dark center, across flat base from dark weft center and up flared sides to herringbone rim.
2 x 11⅞ in.
TU, A.M.R., 31-452.1

158. BASKET TRAY

Pima, ca. 1940

Coiled. Cattail bundle warp; willow and martynia weft. Fret design on tapered sides around flat dark center; inverted triangles divide design at rim.
1½ x 8 in.
TU, A.M.R., 31-450

159. STORAGE BASKET

Pima, ca. 1940

Coiled. Cattail bundle warp; willow, martynia and mountain mahogany weft. Designs of saguaro cactus, lizards, turtles and geometric flowers decorate sides which taper to wide shoulder and slope inward to flared rim at neck.
11⅞ x 11½ in.
PAC, C.F., BA 140

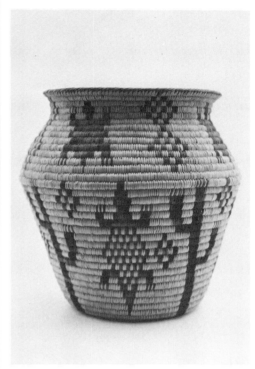

160. MINATURE BASKET

Pima (Gila River Reservation, Sacaton, Arizona) ca. 1940.

Made by Luchial.

Wicker. Horsehair warp and weft. Straight sides above nearly flat base flare widely to scalloped rim.
¼ x ½ in.
PAC. C.F., BA 725

161. MINATURE BASKET WITH LID

Pima (Gila River Reservation, Sacaton, Arizona), ca. 1940.

Made by Luchial.

Coiled. Cattail warp; willow and martynia weft. Design of ascending steps on straight sides above flat base; handle on lid which fits inside rim.
a: ¾ x ⅞ in.
b: ³⁄₁₆ x ¾ in.
PAC, C.F., BA 726 a&b

162. MINIATURE BASKET

Pima (Gila River Reservation, Sacaton, Arizona), ca. 1940.

Made by Luchial.

Coiled. Cattail bundle warp; willow and martynia weft. Alternate dark weft stitches form band around straight sides above flat base.
¼ x ⅜ in.
PAC, C.F., BA 727

163. MINIATURE BASKETS WITH LIDS

Pima (Gila River Reservation, Sacaton, Arizona), ca. 1940.

Made by Mrs. Newman.

Coiled. Cattail warp; willow and martynia weft. Geometric designs in dark weft on slightly rounded sides above flat bases. Flat lids with handles at top fit inside rims.
BA 788 a: ⁹⁄₁₆ x ¹¹⁄₁₆ in.
BA 789 a: ¹¹⁄₁₆ x ¹³⁄₁₆ in.
BA 790 a: ¹³⁄₁₆ x ¹³⁄₁₆ in.
BA 793 a: ⅞ x 1¹⁄₁₆ in.
BA 795 a: 1 x 1⅛ in.
BA 788 b: ⁵⁄₁₆ x ¹¹⁄₁₆ in.
BA 789 b: ¼ x ⅞ in.
BA 790 b: ¼ x ¹³⁄₁₆ in.
BA 793 b: ¼ x 1 in.
BA 795 b: ¼ x 1⅛ in.
PAC, C.F.

164. BASKET TRAY

Pima (Gila Reservation, Sacaton, Arizona), ca. 1940.

Made by Francis Blackbear.

Coiled. Horsehair bundle warp; horsehair weft. White star and crosses on black weft background of nearly flat surface.
⅞ x 4⅝ in.
PAC, C.F., BA 798

165. BASKET JAR

Pima (Gila Reservation, Sacaton, Arizona), ca. 1940.

Made by Francis Blackwater.

Coiled. Horsehair bundle warp; horsehair weft. Double-diamond designs in dark weft on straight sides which taper to shoulder and slope to slightly flared rim finished with cross stitches.
2½ x 3½ in.
PAC, C.F., BA 799

166. MINIATURE TRAYS

Pima, ca. 1950

Coiled. Cattail bundle warp; willow and martynia weft. Variations of fret designs in dark weft on flat surfaces.
BA 892: 2¼ in. diam.
BA 893: 2⁵⁄₁₆ in. diam.
BA 894: 2¼ in. diam.
PAC, C.F.

167. BASKET PLAQUE

Pima, ca. 1910.

Made by Susie White.

Coiled. Cattail bundle warp; willow and martynia weft; beads. Checkerboard designs in dark weft and in beads sewn with weft on nearly flat surface.
7¾ in. diam.
PAC, C.F., BA 1027

168. STORAGE BASKET

Pima (Gila Reservation, Sacaton, Arizona), ca. 1910

Coiled. Cattail bundle warp; willow and martynia weft. Concentric, diagonal and vertical lines form modified squash-blossom design on flat base and straight sides which flare to shoulder and slope to straight neck.
21 x 20 in.
PAC, C.F., BA 1052

169. BASKET TRAY

Pima, ca. 1930

Coiled. Cattail bundle warp; willow and martynia weft. Combined radial and concentric lines form squash-blossom design across flat base from dark weft center and up flared sides to herringbone rim.
1⅜ x 7 in.
PAC, Gift of Mrs. C. C. Bovey, P 449

170. BASKET

Pomo, ca. 1890

Coiled. Willow warp; sedge and bulrush root weft. Clam shell beads; quail feathers. Four duck-wing design motifs in dark weft start on flat base and ascend rounded sides spirally to rim. Four sets of shell beads and quail top knots sewn at rim.
6⅛ x 20 in. max. diam. x 15¾ in. min. diam.
TU, E.S., 31-730

171. FEATHERED BASKET

Pomo (Robinson Rancheria, Upper Lake, California), ca. 1930

Coiled; feathered. Willow warp, sedge root weft; mallard and woodpecker feathers; shell beads. Small red feather squares form line designs which curve down from rim and cross on flat base against background of mallard feathers. Single row of shell beads around rim.
4½ x 8¾ in.
PAC, C.F., BA 56

172. BASKET

Pomo (Robinson Rancheria, Upper Lake, California), ca. 1920.

Made by Mrs. Anderson.

Coiled; feathered. Willow warp; sedge and bulrush root weft. Feathers probably woodpecker. Diamond designs in dark weft expand on rounded sides from base to rim; feathers sewn into light weft on upper portion.
2 x 4¾ in.
PAC, C.F., BA 57

173. FEATHERED BASKET

Pomo, ca. 1910

Coiled; feathered. Willow warp; sedge root weft. Quail, mallard, meadowlark and woodpecker feathers; shell beads. Mallard feather floral design at center of flat base; diamond designs on rounded sides bordered by quail feathers and shell beads around rim.
1⅞ x 4½ in.
PAC, C.F., BA 116

174. MINIATURE BASKET
Pomo, ca. 1937

Coiled; feathered. Willow warp; sedge root weft; mallard and meadowlark feathers. Feathers fastened in weft of round miniature with flat base.
⅜ x 1 in.
PAC, C. F., BA 148

175. WEDDING BASKET
Pomo, ca. 1900

Coiled; feathered. Willow warp; sedge and bulrush root weft. Quail and (probably) woodpecker feathers; shell and glass beads. Duck-wing-like design in dark weft accented with shell and glass beads ascends spirally up rounded sides from center of flat base to rim. Feathers sewn to light weft between designs.
5¼ x 12½ in.
PAC, C.F., BA 164

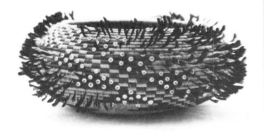

176. BEADED BASKET
Pomo, ca. 1920

Coiled; beaded. Willow warp; sedge root weft; beads. Beads sewn with weft form floral design on flat base and geometric designs on rounded sides against a white background.
1½ x 3¾ in.
PAC, C.F., BA 177

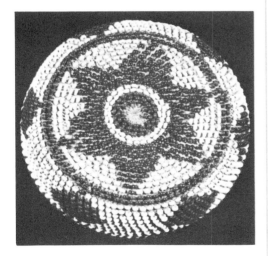

177. MINIATURE BASKETS
Pomo, ca. 1943

Coiled. Willow warp; sedge and bulrush root weft. Various designs in dark weft decorate rounded sides and flat bases.
BA 500: ⅛ x ⅜ in.
BA 501: ⅛ x ⅜ in.
BA 502: 3/16 x ⅜ in.
BA 503: 3/16 x ½ in.
PAC, C.F.

178. MINIATURE BASKET
Pomo, ca. 1910

Coiled. Willow warp; sedge and bulrush root weft. Vertical geometric design in dark weft on rounded sides above flat oval base.
5/16 x 15/16 in. max. diam. x 9/16 in. min. diam.
PAC, C.F., BA 629

179. MINIATURE BASKET
Pomo (Lake County, California), ca. 1944. Made by Lydia Faut.

Coiled; feathered. Willow warp and weft; mallard and meadowlark feathers. Feathers fastened in weft of round miniature with flat base.
⅜ x 1 in.
PAC, C.F., BA 632

180. MINIATURE BASKET
Pomo (Upper Lake County, California), ca. 1944

Coiled; feathered. Willow warp and weft; woodpecker and robin feathers. Feathers fastened in weft on rounded sides and flat oval base.
⅜ x 1½ in. max. diam. x ¾ in. min. diam.
PAC, C. F., BA 633

181. FEATHERED BASKET
Pomo, ca. 1920

Coiled; feathered. Willow warp; sedge root weft. Robin, mallard and meadowlark feathers. Brown (robin feather) flower on flat base expands with zigzag lines of meadowlark feathers on rounded sides against a background of mallard feathers.
2⅛ x 5 in.
PAC. C.F., BA 661

182. FEATHERED BASKET
Pomo (Lakeport, California), ca. 1920. Made by Mrs. Mary John.

Coiled. Willow warp; sedge root weft. Mallard, quail, meadowlark, robin and woodpecker feathers. Yellow (meadowlark) feathers form continuous line design which crosses on flat base and appears as diagonal lines against background of mallard feathers on nearly straight sides. Small rectangles and border complete design. Rim decorated with shell beads and quail feathers.
4¾ x 9½ in.
PAC, C.F., BA 685

183. BASKET
Pomo (Ukiah, California), ca. 1900. Made by Evlyn Lake Potter.

Coiled. Willow warp; sedge and bulrush root weft. Oval or canoe shape; three elements of duck-wing design in dark weft ascend diagonally around sides from flat base to rim.
4½ x 12½ in. max. diam. x 10¾ in. min. diam.
PAC, C.F., BA 686

184. BASKET
Pomo (Mendocino County, California), ca. 1900

Coiled. Willow warp; sedge and bulrush root weft. Shell beads; quail and woodpecker feathers. Red feathers decorate areas of plain weft between three dark weft geometric designs which ascend rounded sides from a flat base.
4½ x 11⅝ in.
PAC. C.F., BA 800

185. FEATHERED BASKET
Pomo (Hopland, California), ca. 1930. Made by Mrs. Cruz I. Billy.

Coiled; feathered. Willow warp and weft; shell beads, abalone pendants, mallard, meadowlark and quail feathers. Petal designs in yellow (meadowlark) feathers against background of mallard feathers across flat narrow base and exterior of flared sides. Shell beads form handle and pendants with abalone; beads and quail feathers decorate rim.
3 x 8¼ in.
PAC, C.F., BA 969

186. MINIATURE BASKET
Pomo (Ukiah, California), ca. 1952. Made by Elsie Allen.

Coiled. Warp probably willow (not visible); sedge and bulrush root weft. Flat base and rows of light and dark weft on this smallest basket in collection.
⅛ x 3/16 in.
PAC, C.F., BA 981

187. MINIATURE BABY CARRIER
Pomo, ca. 1952

Twined, open. Willow warp; hemp weft. Warps curve at lower end; upper end open with ring at right angles for stability and protection as in full-size baby carriers.
2 x 1⅛ in.
PAC, C.F., BA 982

188. FEATHERED BASKET

Pomo (Hopland, California), ca. 1930.
Made by Mrs. Cruz I. Billy.

Coiled; feathered. Willow warp and weft. Quail, mallard and meadowlark feathers; clam and abalone shell. Oval or canoe shape with flat base; arrowhead design in yellow and brown against a background of mallard feathers. Shell beads around rim and hung around sides with abalone pendants.
4 × 13½ in. max. diam. x 7¾ in. min. diam.
PAC, C.F., BA 997

189. BASKET

Pomo, ca. 1890

Twined, diagonal. Hazel warp; sedge root and redbud weft. Rows of successively larger broad-based triangles which start at concave center and expand on rounded sides from base to rim represent separate petals of a flower.
11½ x 16¾ in.
PAC, NN 66

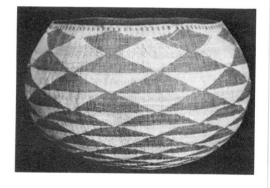

190. MINIATURE BASKET

Pomo, ca. 1940

Coiled; beaded. Willow warp; sedge root weft; beads. Beads sewn with weft on rounded sides above flat oval base.
⁵⁄₁₆ x ¾ In. max. diam. x ⁹⁄₁₆ in. min. diam.
PAC, NN 77

191. BARK CONTAINER

Potawatomi (Canada), ca. 1880

Birchbark, quills, sweetgrass, commercial thread. Double-layered rectangular container with flat base; corners sewn with quills, upper and lower edges bound with sweetgrass and thread. Exterior decorated in floral designs of plain and dyed quills.
2½ x 6½ in. Max. diam. x 5½ in. min. diam.
PAC, C.F., BA 454

192. GATHERING BASKET

Coast Salish, ca. 1900

Coiled; imbricated. Cedar warp and weft; squaw grass, horsetail (rush) and cherry bark imbrication. Oval shape with slightly curved sides; imbricated designs of human figures on exterior.
9 x 13 in.
PAC, Gift of Yeffe Kimball, MI 2683

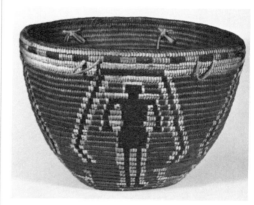

193. GATHERING BASKET

Interior Salish, ca. 1890

Coiled; imbricated. Cedar warp and weft; grass and cherry bark decoration. Deep and round with nearly straight sides; imbricated stepped zigzag designs.
13½ x 12¼ in.
PAC, C.F., BA 303

194. BAG OR WALLET

Sauk and Fox, late 19th C.

Twined, open; braided rim. Hemp, corn husk and commercial string warp and weft. Flat and rectangular with alternate sections of hemp and corn husk warp; materials combined for braided rim.
15½ x 19¼ in.
PAC, C.F., BA 83

195. BASKET

Shastan (Pit River), ca. 1900

Twined with full-twist overlay. Conifer warp and weft; squaw grass and fern stem overlay. Quail top-knot (hooked plume) design in fern stem overlay against light background around sides which slope inward from ovoid base.
5⅜ x 7¼ in.
TU, E.S., 31-715

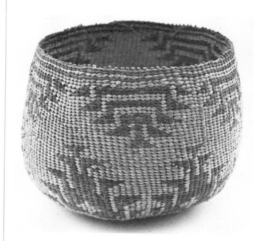

196. BASKET HAT

Shastan (Pit River), late 19th C.

Twined with half-twist overlay. Hazel warp, conifer root weft; squaw grass and fern stem overlay. Slightly concave crown with twine weft at center; hooked plume or pine cone overlay design ascends flared sides diagonally to rim.
3¾ x 8⅛ in.
TU, A.M.R., 31-461

197. GRAIN STORAGE BASKET

Shastan, ca. 1890

Twined: plain, diagonal and three-strand; full twist overlay. Hazel warp, hazel and conifer root weft; squaw grass overlay. Geometric step design ascends slightly curved sides from ovoid base with concave center.
21 x 23½ in.
PAC, C.F., BA 1050

198. COOKING BOWL
Siletz (Salem, Oregon), ca. 1920

Twined, plain and open; half-twist overlay. Hazel warp; cedar weft. Squaw grass and dyed cedar overlay. Slightly concave base; rounded sides curve inward to open twining below weft-wrapped rim. Banded geometric designs in half-twist overlay.
5 x 9 in.
PAC, C.F., BA 555

199. STORAGE BASKET
Skokomish (Puget Sound), ca. 1900

Twined with half-twist overlay. Cedar warp; squaw grass, cedar bark and horsetail weft. Slightly concave base, round and flexible sides with hemp cord fastened at intervals to rim. Geometric designs in four columns, two with plume motif, vertically on sides below band of small horses at top.
12¼ x 13 in.
PAC, C.F., BA 263

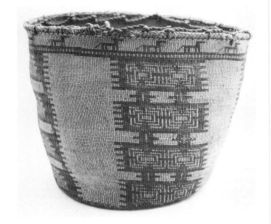

200. GATHERING BASKET
Snohomish (Coast Salish), late 19th C.

Wrap twined with overlay; plain twined base. Cedar warp; cedar, grass and dyed hemp weft. Flexible with rounded base and slightly tapered sides. Bands of narrow stripes in overlay technique decorate sides.
5½ x 6 in.
PAC, RCL, MI 2287

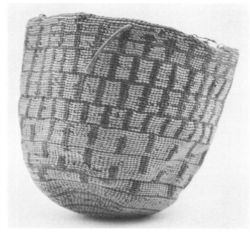

201. CONTAINER WITH LID
Tetes de Boule, Algonquin (Quebec, Canada), ca. 1942

Birchbark construction. Floral designs on straight sides which taper from rectangular base to bound oval rim; checkerboard designs atop flat lid.
a: 6¾ x 8¼ in. max. diam. x 7⅛ in. min. diam.
b: ¼ x 8¼ in. max. diam. x 6¼ min. diam.
PAC, C.F., BA 394 a&b

202. BASKET
Tlingit, ca. 1900

Twined with false embroidery. Spruce root warp and weft, some dyed; grass decoration. Base slightly concave; ascending designs in false embroidery over bands of dyed weft material on nearly straight sides.
8½ x 7¼ in.
TU, E.S., 31-703.2

203. BASKET
Tlingit, ca. 1900

Twined with false embroidery. Spruce root warp and weft; maidenhair fern stem decoration. Slightly concave base; bear face and salmonberry designs in false embroidery on straight sides which flare slightly to rim.
7¼ x 8½ in.
PAC, C.F., BA 807

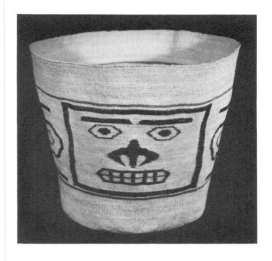

204. BASKET
Tlingit (Ketchikan, Alaska), ca. 1900

Twined with false embroidery. Spruce root warp and weft, grass and fern stem decoration. Bands of false embroidery over dyed weft enclose wide center band of geometric designs in false embroidery on straight sides which flare slightly to rim. Base slightly concave.
11⅜ x 13¼ in.
PAC, C.F., BA 809

205. TRINKET BASKET WITH LID
Tsimshian (Metlakatla), ca. 1920

Twined with false embroidery. Spruce root warp and weft; grass and fern stem decoration. Geometric designs in false embroidery encircle slightly curved sides and top of flat lid.
a: 2½ x 4½ in.
b: ¾ x 4½ in.
PAC, C.F., BA 805 a&b

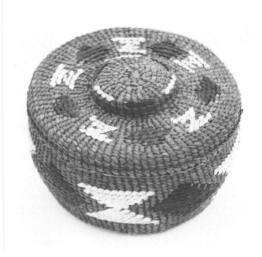

206. BASKET BOWL

Tubatulabal (collected Yokut), ca. 1900.
Made by Mary Ann Brazzanovitch.

Coiled. Willow warp; juncus, martynia and red-
bud weft. Flat base; tipi designs with quail top-
knot like appendages in vertical rows around
widely curved sides.
7 x 16 in.
PAC, C.F., BA 75

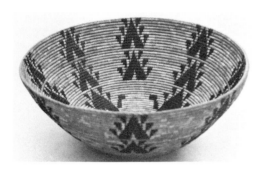

207. BAG

Umatilla, 19th C.
Made by Klamath girl named Aunty after
capture.

Twined with false embroidery. Indian hemp
warp and weft; corn husk decoration. Flat and
rectangular with designs of vertical rows of
step-edged diamonds on one side; horizontal
rows of upright and inverted triangles on
reverse.
17½ x 13¼ in.
PAC, C.F., BA 76

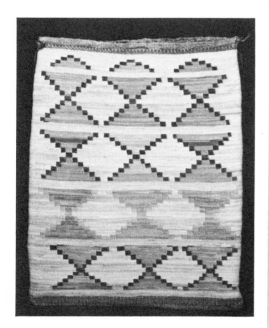

208. CEREMONIAL BASKET

Southern Ute or Paiute, made for Navajo,
ca. 1940

Coiled. Willow warp; willow martynia and tree
yucca root weft. Symbolic circular design on
flared surface with break for spirit passage;
commonly used for wedding ceremonies.
4 x 15 in.
PAC, C.F., BA 69

209. BABY CARRIER

Ute (Towae, Colorado), ca. 1943.
Made by Clardy Ute.

Twined, open and wrap twined. Willow warp
and stiff weft; hide flexible weft. Narrow lines of
geometric beadwork decorate soft hide cover-
ing on front of open twined willow back. Warp
curves at top for hood; back reinforced with
hide.
35 x 13 in.
PAC, C.F., BA 557

210. BASKET

Washo, ca. 1917-1918.
Made by Datsolalee (Louisa Keyser).

Coiled. Willow warp; willow, redbud and brack-
en fern weft. Vertical columns of triangular de-
signs in alternate redbud and fern root weft
expand and move apart with widest diameter;
then diminish and move closer together as they
curve inward to orifice at top.
12 x 16¼ in.
PAC, C.F., BA 666

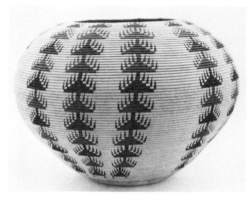

211. GATHERING BASKET

Yakima (Toppenish, Washington), ca. 1940

Coiled; imbricated. Cedar warp and weft; squaw
grass, horsetail (rush) and cherry bark imbrica-
tion. Round and deep with slightly flared
straight sides; stepped zigzag imbricated de-
signs on exterior, filet at rim.
16½ x 14½ in.
PAC, C.F., BA 497

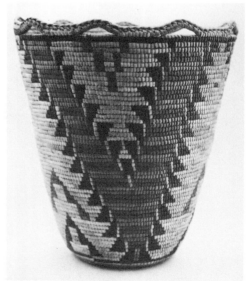

212. GAMBLING TRAY
Yokut, ca. 1900

Coiled. Grass bundle warp; juncus and redbud weft. Large star, various geometric designs and butterflies in dark weft on nearly flat surface. 28 in. diam.
PAC, C.F., BA 257

213. TRINKET BASKET
Yokut (Tulare), ca. 1959

Coiled. Grass bundle warp; willow and bracken fern weft. Bottleneck shape with encircling rattlesnake design motifs and spirally ascending quail top-knot designs.
2¾ x 7½ in.
PAC, C.F., BA 1051

CLOTHING & FOOTWEAR

Dance Aprons

214. DANCE APRON
Chippewa, ca. 1925

Beaded floral designs on velveteen, lined and bound with cotton fabric.
15¾ x 16 in.
PAC, R.C.L., MI-2093

215. DANCE APRON
Probably Otoe-Missouri, late 19th C.

Floral beadwork on broadcloth; sides bound with ribbon and accented with metal sequins; rainbow selvage at the bottom.
16½ x 18 in.
PAC, 76.8.2

Blankets

216. BLANKET
Sioux, ca. 1910

Foundation of rainbow selvage trade cloth in two sections joined at the center; beaded strip on hide attached to trade cloth; braided hide and ribbon tassels.
62 x 89 in.
TU, B.R., 31-168

217. WOMAN'S BLANKET
Osage, ca. 1920-1930

Broadcloth; yarnwork and ribbonwork. Three yarn sashes and white beads across lower portion between vertical ribbonwork at sides; wide four-band selvage at top and bottom.
61½ x 70 in.
PAC, 76.9.2

218. BLANKET
Navajo, late 19th C. Transition Period

Vertical loom; tapestry and wedge-weave. Wool warp and weft. Wedge-weave technique transforms traditional strips to zigzag lines which enclose diamond-shaped spaces on red background between plain wide bands at top and bottom.
84 x 59 in.
PAC, R.C.L., MI-2515

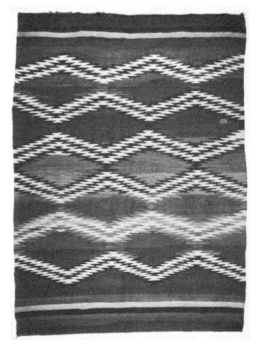

219. MAN'S BLANKET

Navajo, ca. 1880, Transition Period

Vertical loom; tapestry and wedge-weave. Wool warp; wool and bayeta weft. Center blocks of red are merged in this variation of a Phase III nine-spot Chief's Blanket pattern of color spots divided by wide stripes.
65 x 47 in.
PAC, R.C.L., MI-2519

220. BLANKET

Navajo, ca. 1890, Transition Period

Vertical loom; tapestry and wedge-weave. Cotton warp; Germantown weft. Zigzag stripes are added to the bands and background stripes of an earlier period in the popular Germantown yarn of the Transition Period.
72 x 50 in.
PAC, L.J.W. - 15

221. BLANKET

Navajo, ca. 1890, Transition Period

Vertical loom; tapestry and wedge-weave. Wool warp and weft. Deep wavy horizontal lines on red background alternate with traditional wide black and grey bands.
55 x 64 in.
PAC, L.J.W. - 25

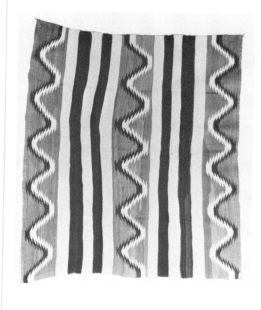

222. BLANKET

Navajo, ca. 1880, Transition Period

Vertical loom; tapestry and wedge-weave. Wool warp and weft. Bold terrace designs on a red background are separated by wide bands of traditional horizontal black and grey stripes.
45 x 63 in.
PAC, NN 85

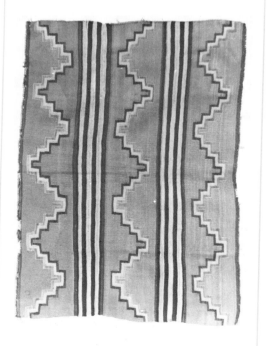

223. WOMAN'S DANCE SHAWL

Hopi, ca. 1900

Loom woven; embroidered. Cotton warp and weft; wool decoration. Vertical stripes with serrate edge embroidered across upper portion and wider stripes separated by designs of diamonds topped by inverted triangles across lower portion; fringe balls at corners.
42 x 60 in.
PAC, W.P., P-486

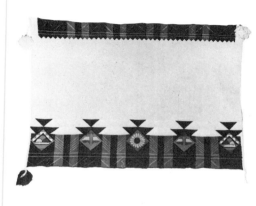

Breechclouts

224. BREECH CLOUT

Chippewa, ca. 1885

Red broadcloth with appliquéd beadwork in a stylized floral pattern.
54 x 17 in.
TU, B.R., 31-179

225. BREECH CLOUT
Osage (Oklahoma), ca. 1890

Red strouding with appliquéd beadwork floral pattern; and ribbon binding with partially beaded border.
50 x 12½ in.
TU, A.M.R., 31-424

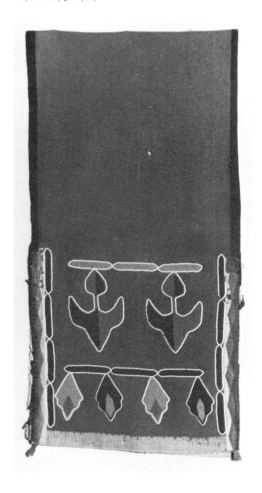

226. BREECH CLOUT
Osage, ca. 1920

Ribbonwork in lightning designs on sides of front and back of strouding; rainbow selvage at ends.
59 x 13½ in.
PAC, P-501

227. BREECH CLOUT
Ponca (Oklahoma), ca. 1910

Blued strouding edged with green silk ribbon and tin sequins, the ends decorated with beadwork in conventional floral patterns.
20½ x 59 in.
TU, B.R., 31-178

Coats

228. COAT
Otoe, (collected Osage), late 19th C.

Beaded curvilinear designs on both front and back of upper portion with horse heads between designs on back; beaded line design around lower edge of trade cloth coat.
39½ in.
TU, G.M.T., TR-30

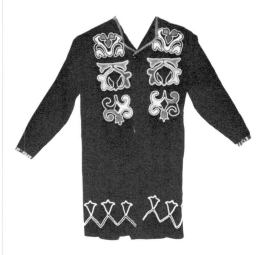

229. CHILD'S COAT
Santee Sioux, late 19th C.

Buckskin with floral beadwork.
16 x 31½ in.
TU, B.R., 31-153

230. COAT
Santee Sioux, late 19th C.

Elkskin decorated with quillwork, the lining of red strouding.
38 in.
TU, E.S., S-2011C

Dresses

231. DRESS
Apache, late 19th C.

Separate top and skirt, both of soft hide construction; the top with extensive hide fringing and a simple band of geometric beading near the bottom edge; the skirt with extensive fringing, a broad attached band of decorative tin jangles and beaded rosettes with long hide tassels (front), and near the bottom (front and back); a heavy fringe of tin jangles and a simple band of beaded swags just above the long bottom fringe.
Top: 27 x 38 in.
Skirt: 42 x 46 in.
PAC, R.C.L., MI-2066

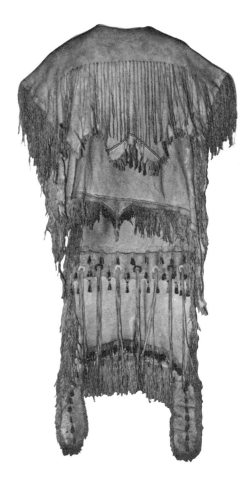

232. DRESS TOP
Apache, late 19th C.

Hide foundation stained yellow, with head opening and collar, short sleeves with long hide fringe, a yoke band of beaded borders, brass buttons and tin jangles, and a scalloped bottom fringe with tin jangles. Sleeve fringes are attached with a hide band cut with holes to reveal red fabric beneath.
48 x 62 in.
PAC, Gift of Waite Phillips, P-485

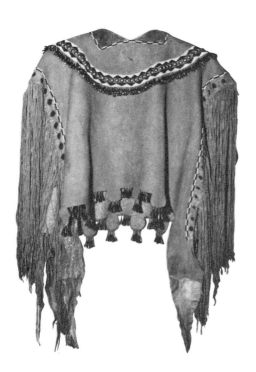

233. DRESS
Cheyenne, late 19th C.

Hide dyed with yellow pigment and decorated with painted geometric designs, seed-strung fringe and narrow bands of beadwork.
49 in. long
TU, B.R., 31-150

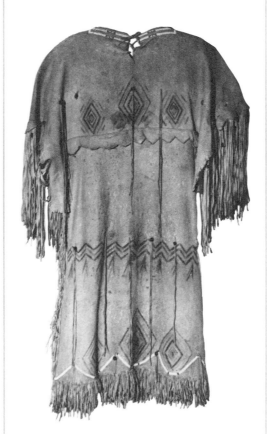

234. DRESS
Sioux, ca. 1880

Beaded geometric designs on blue background across yoke and shoulders of hide dress with openings for arms fringed to waist. Lower portion flares widely and is decorated with bands of beadwork, tin jangles and long fringe.
65 in.
PAC. R.C.L., MI-2062

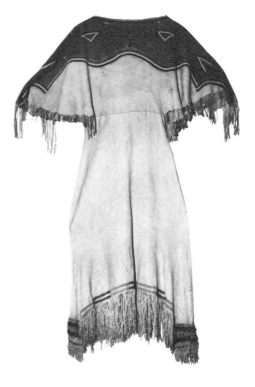

235. GIRL'S DRESS
Sioux, late 19th C.

Hide with all-over beaded decoration, quilled tassels and brass bells.
26 x 28 in.
PAC, P-2124

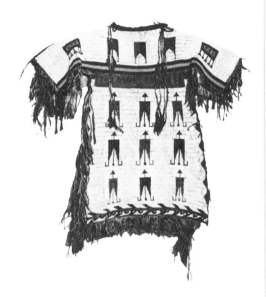

Garters

236. PAIR OF GARTERS
Osage (?), late 19th C.

Loom-woven beaded panels with geometric star design and with yarn fringes.
11 x 2½ in. (beaded panels); 12 in. (fringes)
TU, G.M.T., TR-95,96

237. GARTER
Potawatomi (Oklahoma-Kansas), ca. 1900

Loom-woven geometric pattern beadwork panel with yarn fringes.
11 x 4 in. (beaded panel); 10½ in. (fringes)
TU, B.R., 31-112

238. PAIR OF GARTERS
Potawatomi (Oklahoma-Kansas), ca. 1900

Loom-woven beadwork panels in a tree and flower pattern and with yarn fringes.
13½ x 3½ in. (beaded panels); 8 in. (fringes)
TU, B.R., 31-120

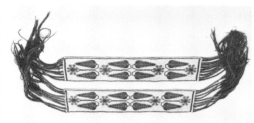

Gloves

239. PAIR OF GLOVES
Probably Chippewa (Eastern Canada), mid-19th C.

Soft hide construction with fine silk thread embroidery in a pattern of leaves and branches, and the cuffs bound with red silk ribbon; lined with black cotton fabric.
11 in. long
PAC, R.C.L., MI-2146

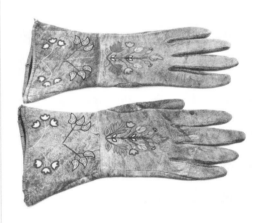

240. PAIR OF GLOVES
Santee Sioux, late 19th C.

Deerskin with beaded decoration.
14½ in. long
TU, E.S., S-2020C

Leggings

241. LEGGINGS
Arapaho, ca. 1890

Beaded horizontal and vertical geometric designs on hide; double-beaded edge on flap.
16½ x 6½ in.
TU, E.S., S-2033C

242. LEGGINGS
Cheyenne-Arapaho, ca. 1900

Beaded geometric designs with white background on hide construction.
19 x 6½ in.
PAC, 76.17.1

243. MAN'S LEGGINGS
Cheyenne, late 19th C.

Yellow-dyed hide with green-dyed twisted hide fringe and bands of beading.
33 in. long
PAC, R.C.L., MI-2094b

244. LEGGINGS
Chippewa, ca. 1925

Beaded floral designs on black velveteen panels sewn around lower edge and on front of flannel leggings.
27 in. long
PAC, R.C.L., MI-2092a

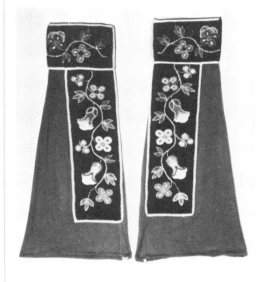

245. GIRL'S LEGGINGS
Crow (Montana), late 19th C.

Red wool cloth with applied beaded strips (probably from a boy's shirt).
13 x 5½ in.
TU, E.S., S-2014C

246. WOMAN'S LEGGINGS
Delaware (Oklahoma), late 19th C.
Dark blue strouding with broad borders of ap-
pliquéd ribbonwork.
19 x 9¼ in.
PAC, R.C.L., MI-2082

247. MAN'S LEGGINGS
Kiowa (Oklahoma), late 19th C.
Hide foundation and fringe decorated with
beads and horsehair.
34 in. long
TU, B.R., 31-140

248. WOMAN'S LEGGINGS
Osage, ca. 1920
Dark blue broadcloth decorated with ribbon
appliqué, and selvage edge at top.
25½ x 25 in.
PAC, MI-3323

249. LEGGINGS
Probably Potawatomi (Kansas), ca. 1900
Fringed hide construction with vertical strips of
appliquéd floral beadwork in an open design.
33 x 13 in.
TU, G.M.T., TR-5

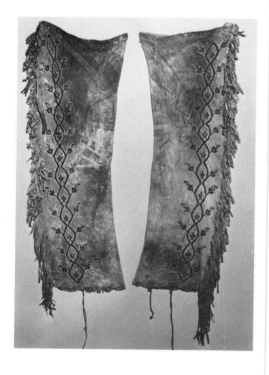

250. HALF-LEGGINGS
Santee Sioux, late 19th C.
Hide with beaded decoration.
18½ in. long
TU, E.S., S-2031C

251. WOMAN'S LEGGINGS
Sioux, late 19th C.
Hide with beaded cuffs.
16½ in. long
TU, E.S., S-2032

252. LEGGINGS
Santee Sioux, late 19th C.
Hide with quill decoration.
16 x 8 in.
PAC, Gift of Carl O'Hornett, MI-2694

Moccasins and Boots

253. MOCCASINS
Apache, late 19th C.
Hide; one-piece uppers, stained yellow, with
painted symbols, fringe and small strip of bead-
ing, and with fringed heels.
10½ in. long
TU, E.S., 31-914

254. MOCCASINS
Apache, ca. 1900
Hide; one-piece uppers partially beaded in a
geometric pattern.
9¼ in. long
TU, E.S., 31-915

255. MOCCASINS
Apache, late 19th C.
Hide; one-piece uppers partially beaded in a
geometric pattern.
9½ in. long
TU, E.S., 31-916

256. BOOT MOCCASINS
Apache, late 19th C.
Hide, one-piece uppers stained yellow and par-
tially beaded with geometric borders, rosettes
and stars.
10 x 13¼ in.
PAC, A.L.D., D-7

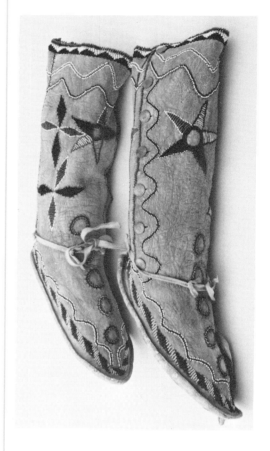

257. MOCCASINS
Arapaho, late 19th C.
Hide foundation with geometric beaded
decoration.
10¼ in. long
TU, E.S., 31-887

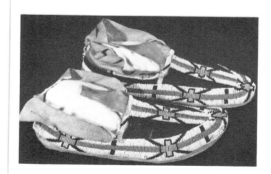

258. MOCCASINS
Arapaho, late 19th C.
Leather foundation with geometric beaded decoration. Soles machine stitched.
11 in. long
TU, E.S., 31-903

259. MOCCASINS
Blackfoot (Montana), ca. 1910
Hide foundation with beaded decoration.
11 in. long
TU, E.S., 31-900

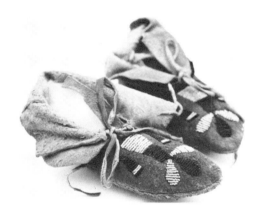

260. WOMAN'S MOCCASINS
Cheyenne, ca. 1930
Hide foundation with beaded decoration.
10 in. long
TU, B.R., 31-37

261. MOCCASINS
Cheyenne, late 19th C.
Hide foundation with geometric beaded decoration.
10 in. long
TU, E.S., 31-806

262. MOCCASINS
Cheyenne, late 19th C.
Hide foundation with geometric beaded decoration.
10 in. long
TU, E.S., 31-871

263. MOCCASINS
Cheyenne, late 19th C.
Hide foundation with geometric beaded decoration.
10 in. long
TU, E.S., 31-890

264. MOCCASINS
Cheyenne, late 19th C.
Hide foundation with geometric beaded decoration.
7 in. long
TU, E.S., 31-934

265. MOCCASINS
Cheyenne, ca. 1935
Hide foundation with geometric beaded decoration.
10 in. long
TU, G.M.T., TR-36

266. MOCCASINS
Cheyenne, ca. 1900
Hard soles, soft pigment-colored hide uppers decorated with strips of beadwork; hide fringe on heels and sides of toes, and double-beaded edge on cuffs and flaps.
10½ in. long
TU, G.M.T., TR-38

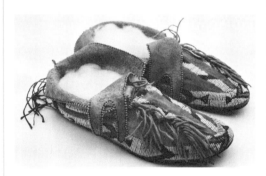

267. MOCCASINS
Cheyenne (Montana), ca. 1900
Leather foundation with partial beaded decoration.
10 in. long
PAC, A.L.D., D-18

268. WOMAN'S BOOT MOCCASINS
Cheyenne, late 19th C.
Yellow-dyed hide uppers with decorative bands of beadwork and German silver concho buttons.
10 in. long x 29 in. high
PAC, R.C.L., MI-2095

269. MOCCASINS
Cheyenne (Oklahoma), late 19th C.
Hide foundation and fringes with three-quarters beaded decoration.
10½ in. long
PAC, R.C.L., MI-2102

270. MOCCASINS
Cheyenne or Arapaho, late 19th C.
Green-stained hide foundation with partial beaded decoration.
10½ long
TU, B.R., 31-94

271. MOCCASINS
Delaware-Kickapoo (Oklahoma), ca. 1900
Soft hide one-piece construction with cuffs; appliquéd beadwork on uppers, and cuffs with ribbon appliqué and beaded borders.
10½ in. long
PAC, R.C.L., MI-2077

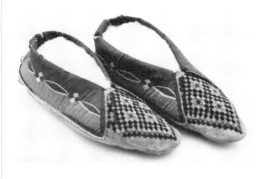

272. MOCCASINS
Delaware (Oklahoma), ca. 1930
Soft hide one-piece construction with cuffs; uppers with appliquéd beadwork, and cuffs with ribbon appliqué and beaded border.
9½ in. long
PAC, R.C.L., MI-2286

273. MOCCASINS
Chippewa (Minnesota), ca. 1900
One-piece soft hide foundation with attached black velvet panels appliquéd with floral beadwork.
10½ in. long
TU, A.M.R., 31-423

274. MOCCASINS

Flathead, ca. 1900

Hide foundation with geometric beaded decoration and black strouding fringe at heel.
11 in. long
PAC, A.L.D., D-16

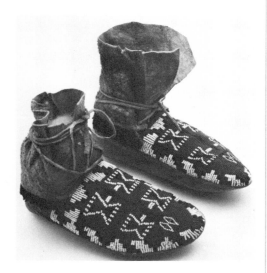

275. MOCCASIN

Gros Ventre or Assinaboin (Montana), ca. 1900

Hide foundation with geometric beaded decoration.
11 in. long
PAC, R.C.L., MI-2101

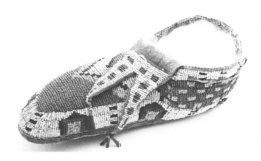

276. MOCCASINS

Hidatsa, ca. 1900

Hide foundation with beaded and quilled decoration.
11 in. long
TU, E.S., 31-926

277. PAIR OF MOCCASIN CUFFS

Hopi, ca. 1900

Foundation warp of sinew woven with a weft of green, red, black and white wool, lined with patterned cotton fabric and bound on the end with cotton fabric.
11 x 3 in.
PAC, P-2004

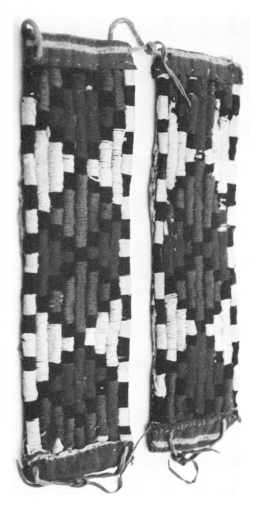

278. BOOT MOCCASINS

Kiowa, ca. 1880

Hide foundation decorated with beads, paint, and metal buttons.
7½ in long x 24 in. high
TU, B.R., 31-98

279. MOCCASINS

Kiowa, ca. 1885

Hide foundation with partial beaded decoration and tin jangles.
10 in. long
TU, A.M.R., 31-432

280. MOCCASINS

Kiowa, late 19th C.

Hide foundation with partial beaded decoration and tin jangles.
11 in. long
TU, G.M.T., TR-37

281. MOCCASINS

Kiowa, late 19th C.

Green-stained hide and fringe with partial beaded decoration.
9 in. long
PAC, R.C.L., MI-2096

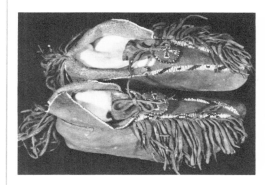

282. CHILD'S BOOT MOCCASINS

Kiowa, ca. 1890

Soft uppers above hard sole are decorated with strips of beadwork around foot and around two rows of metal buttons laced to flap.
5 in. long
PAC, MI-2913

283. BOOT MOCCASINS

Nez Percé or Shoshone, ca. 1930

Soft hide construction with attached sole and legging; toe with appliquéd floral beadwork design; legging upper with appliquéd floral beaded design, border and steel buttons.
9½ in. long x 10½ in. high
PAC, Gift of Mrs. W. J. Zollinger, MI-2011

284. MOCCASINS

Omaha (Nebraska), late 19th C.

Hide foundation with cuffs; partial beading on uppers, with small purple wool tassels, and the cuffs bound with black ribbon and a row of white beads.
10 in. long.
TU, B.R., 31-48

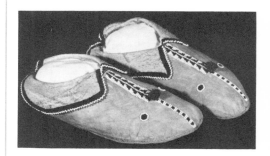

285. MOCCASINS

Osage (Oklahoma), ca. 1930

Soft hide uppers of one piece construction with commercial leather soles; uppers stained yellow and with appliquéd beadwork strips.
10 in. long
TU, G.M.T., TR-56

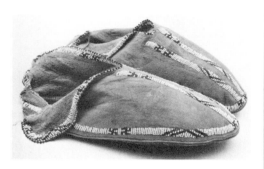

286. MOCCASINS

Potawatomi (Kansas), ca. 1890

Hide foundation including cuffs, completely beaded in a leaf design on a light blue ground.
11 in. long
TU, E.S., 31-858

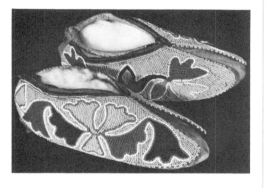

287. MOCCASINS

Shoshone, ca. 1885

One-piece construction with seam at side and added cuff; floral beadwork designs on front and geometric designs at back.
9¼ in. long
TU, E.S., 31-893

288. MOCCASINS

Santee Sioux, late 19th C.

Hide foundation, cloth uppers, with beaded and quilled decoration.
9 in. long
TU, B.R., 31-96

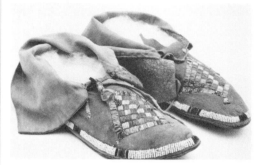

289. MOCCASINS

Santee Sioux, late 19th C.

Leather with partial floral beaded decoration.
10¾ in. long
TU, E.S., 31-892

290. MOCCASINS

Santee Sioux, late 19th C.

Hard soles; soft hide one-piece upper with floral quilled decoration on toes.
10 in. long
TU, E.S., 31-927

291. MOCCASINS

Sioux, late 19th C.

Hide foundation, completely beaded, including the soles.
11 in. long
TU, E.S., 31-874

292. CHILD'S MOCCASINS

Sioux, late 19th C.

Hide foundation, completely beaded, including the soles.
8¼ in. long
TU, E.S., 31-880

293. MOCCASINS

Sioux, late 19th C.

Hide foundation with geometric beaded decoration.
11¼ in. long
TU, E.S., 31-889

294. MOCCASINS

Santee Sioux, late 19th C.

Hide foundation with partial floral beaded decoration.
10½ in. long
TU, E.S., 31-897

295. MOCCASINS

Sioux, late 19th C.

Hide foundation with geometric quill decoration.
11 in. long
TU, E.S., 31-925

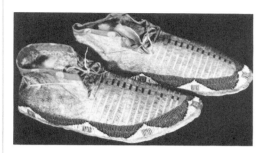

296. CHILD'S MOCCASINS

Sioux, late 19th C.

Hide foundation with geometric bead and quill decoration.
7¼ in. long
TU, E.S., 31-933

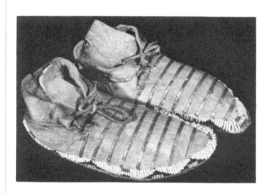

297. MOCCASINS

Santee Sioux, ca. 1890

Soft hide construction decorated with floral beadwork on the toes, and cuffs bound with cotton fabric.
9¼ in. long
TU, E.S., 31-944

298. MOCCASINS

Sioux or Cheyenne, late 19th C.

Hide foundation, completely beaded, including the soles.
10½ in. long
PAC, A.L.D., D-15

299. MOCCASINS

Sioux, ca. 1910

Hide foundation, completely beaded, including the soles.
10½ in. long
PAC, R.C.L., MI-2027

300. MOCCASINS

Sioux, late 19th C.

Hide foundation with quilled decoration, tin jangles and feathers.
11¼ in. long
PAC, R.C.L., MI-2106

301. MOCCASINS

Sioux, late 19th C.

Hide foundation; geometric quilled decoration on toes; heels with quill-wrapped strips joined at bottom and tipped with tin-wrapped red feathers; narrow band of beadwork around lower edge and across flaps which are decorated in same manner as heels.
10¼ in. long
PAC, R.C.L., MI-2108

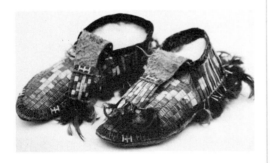

302. MOCCASINS

Sioux, ca. 1900

Hide foundation with partial beaded decoration.
10½ in. long
PAC, R.C.L., MI-2111

Robes

303. CHILD'S ROBE

Sioux, ca. 1885

Consisting of an animal hide decorated with quillwork.
38 x 35 in.
TU, E.S., S-2034M

304. PAINTED ROBE

Sioux or Cheyenne, late 19th C.

Consisting of an animal hide painted with geometric designs.
56 x 53 in.
PAC, R.C.L., MI-2176

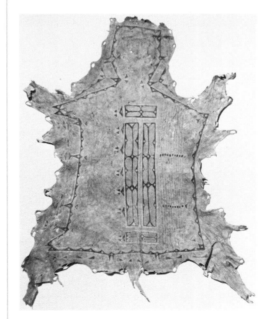

Sashes & Belts

305. SASH

Algonquian (Great Lakes), late 19th C.

Loom-woven beadwork in a geometric pattern, with long green and red yarn fringe.
35 x 6¼ in.
TU, B.R., 31-108

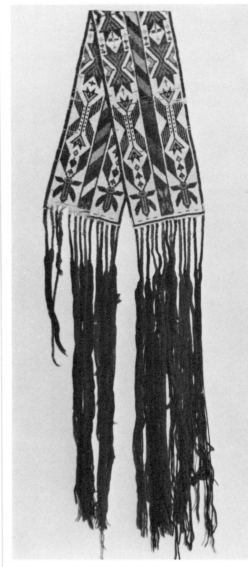

306. SASH

Chippewa (Ojibway), (Wisconsin), late 19th C.

Loom-woven beaded panel in a stylized floral pattern and with tasseled, braided yarn fringes.
36 x 5 in. (panel); 20 in. (fringes)
PAC, R.C.L., MI-2229

307. SASH

Osage (Oklahoma), ca. 1925

Fingerwoven yarn with inserted white beads, and fringe of twisted and braided yarn with white beads.
86 x 7½ in.
PAC, 76.9.4

308. SASH

Potawatomi (Kansas), late 19th C.

Loom-woven beadwork in a stylized floral pattern and with a long yarn, tasseled fringe.
30 x 3 in. (beaded strip); 30 in. (tassels)
TU, B.R., 31-111

309. BELT

Santee Sioux, ca. 1890

Vertical beaded strips and birds against white background on hide edged with beads.
24½ in. long
TU, E.S., 31-996

310. SASH

Southeast woodlands, possibly Seminole, ca. 1850

Woven yarn with white beads and long, woven, beaded tassels.
130 x 16 in.
TU, A.M.R., 31-430

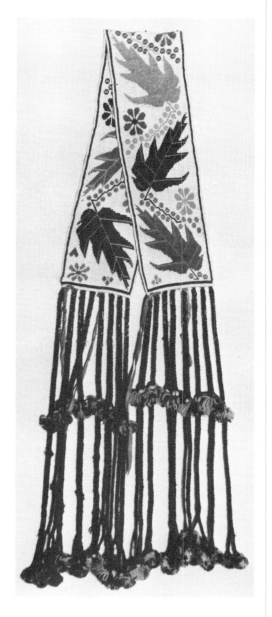

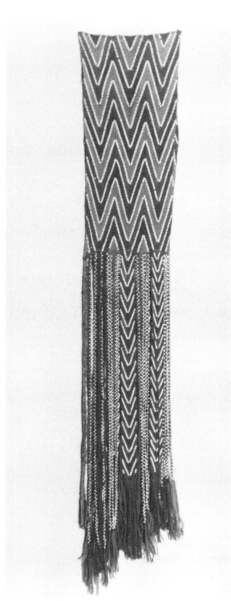

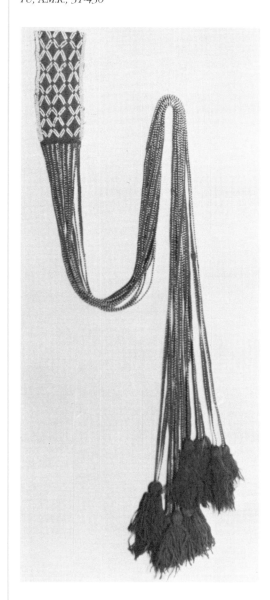

Shirts

311. SHIRT
Blackfoot (Montana), ca. 1900
Hide construction with applied beaded strips.
30 in. long
TU, B.R., 31-149

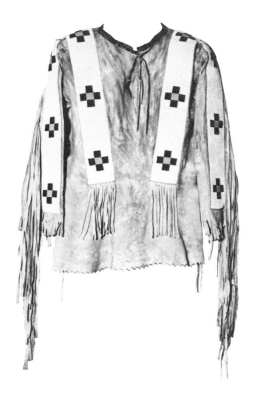

312. SHIRT
Hidatsa, late 19th C.
Hide construction with applied quilled strips.
28 in. long
PAC, R.C.L., MI-2119

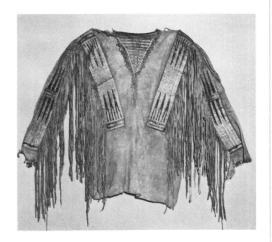

313. SHIRT
Otoe (Oklahoma), ca. 1875
Brown fabric and lining decorated with beaded curvilinear designs outlined in white on front and back; white outlines only on sleeves.
25 in. long
TU, G.M.T., TR-57.2

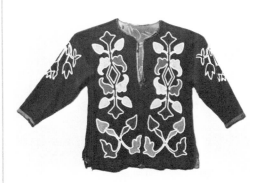

314. SHIRT
Sioux, ca. 1880
Hide construction colored with pigment and decorated with strips of beadwork and hair fringes. Narrow beadwork strips edged with hair tassles outline red and blue strouding on V-shaped neck tabs.
31 x 39 in.
TU, E.S., 31-850

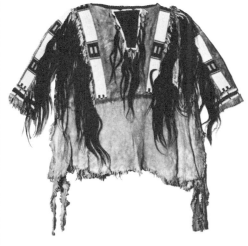

Vests

315. VEST
Chippewa, ca. 1925
Beaded floral designs on black velveteen lined with cotton fabric.
22½ in. long
PAC, R.C.L., MI-2092 b

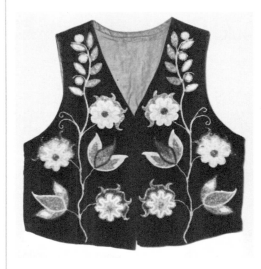

316. VEST
Sioux, late 19th C.
Hide foundation with beaded decoration completely covering front and back.
20 x 20 in.
PAC, R.C.L., MI-2025

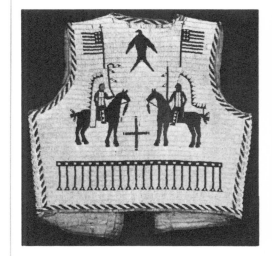

CONTAINERS

Bonnet Cases

317. WAR BONNET CASE
Cheyenne, late 19th C.

Hide case with geometric painted designs.
22¼ x 10 in. (max.), 5½ in. (min.)
TU, E.S., 31-802

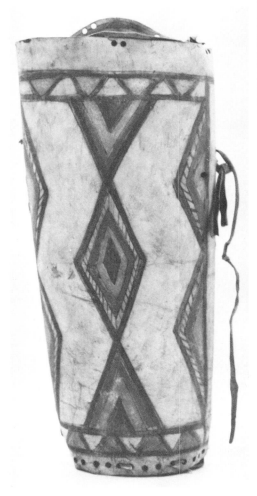

318. WAR BONNET CASE
Sioux or Cheyenne, late 19th C.

Hide case with painted geometric decoration.
20¾ x 9½ in. (max.), 5 in. (min.)
PAC, R.C.L., MI-2220

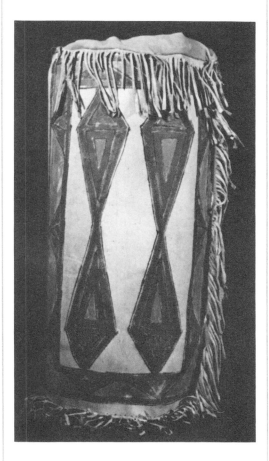

Bowls

319. BOWL
Haida, late 19th C.

Carved cedar with incised designs at both outside ends.
9½ x 7 in.
TU, A.M.R., 31-437

Boxes

320. RAWHIDE BOX
Sioux or Cheyenne, late 19th C.

Hide construction with painted geometric designs.
7 x 16 x 7½ in.
PAC, 76.13

Parfleches

321. PARFLECHE
Probably Crow, late 19th C.

Hide construction with painted geometric designs.
29¾ x 15½ in.
TU, E.S., 31-803

CRADLES & CRADLE HOODS

Cradles

322. CRADLE

Comanche, late 19th C.

Ochre-colored hide carrier with rosary and charm attached at top and velvet hood lining; laced to tack-decorated wooden frame.
43½ x 12½ in.
PAC, Gift of Waite Phillips, P-483

323. CRADLE

Kiowa, (Oklahoma), ca. 1900

Beaded floral and geometric designs on hide with fringe at foot, mounted on tack-decorated wooden frame.
46 x 12⅝ in.
PAC, R.C.L., MI-2068

324. CRADLE

Nez Percé, ca. 1900

Hide cover with red cloth hood covers ellipsoidal board and encloses cloth doll with hide moccasins. Fully-beaded floral designs on front of upper portion; strip of hide fringe attached to back.
35½ x 14½ in.
TU, E.S., 31-810

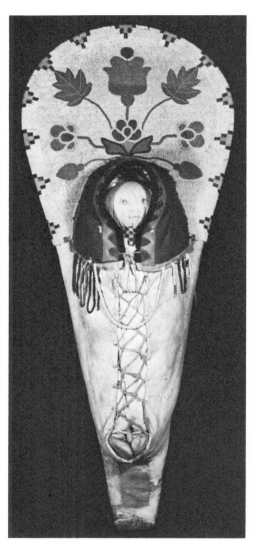

325. CRADLE

Osage, ca. 1920

Cherry wood with incised and painted geometric designs on upper portion above beaded headpiece hung with small bells and lined with blue strouding.
42 x 10 in.
PAC, Gift of Dr. Linus Long, MI-2004

326. CRADLE
Sioux, ca. 1890

Hide carrier with beaded geometric designs and flags against white background attached to plain wooden frame.
39¼ x 10½ in.
TU, E.S., 31-814

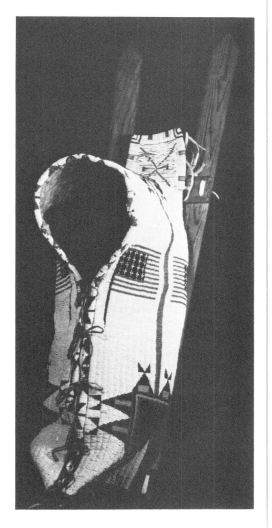

327. CRADLE
Sioux, early 20th C.

Beaded geometric designs on white background cover cloth carrier mounted on tack-decorated wooden frame. Ribbons, large beads and bells tied to sides.
38½ x 12½ in.
PAC, R.C.L., MI-2069

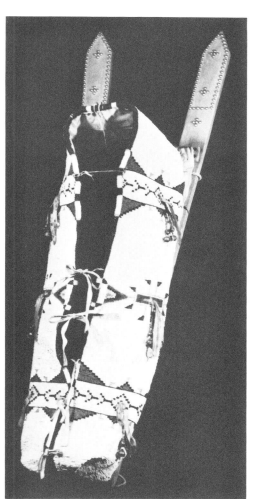

Cradle Hoods

328. CRADLE HOOD
Cheyenne, late 19th C.

Beaded strips on hide hood; geometric designs on hide crest which is hung with small bells; lower portion and lining of calico.
25 x 18 in.
PAC, Gift of Dr. Linus Long, MI-2003

329. CRADLE HOOD
Sioux, late 19th C.

Hide, fully beaded in geometric design on white background; crest and reinforcing strip inside top are taken from an old parfleche.
27 x 14¼ in.
PAC, R.C.L., MI-2064

330. CRADLE HOOD
Sioux, late 19th C.

Hide, fully beaded in geometric designs on white background; calico lining.

31 x 13 in.

PAC, R.C.L., MI-2098

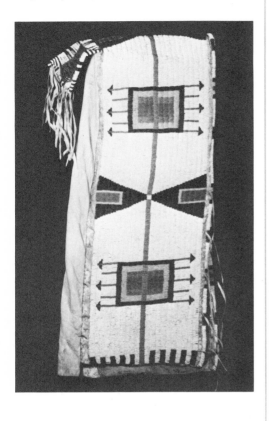

FANS

331. PEYOTE CEREMONIAL FAN
Kiowa (Oklahoma), ca. 1900

Constructed of twelve eagle feathers, each socketed separately and bound with fine spiral tubed beadwork and connected by hide thongs to a common handle, also bound with spiral tubed beadwork, terminating in a long twisted hide tassle with two eagle down feathers attached.

17½ in. long

TU, B.R., 31-66

332. FAN
Possibly Otoe, late 19th C.

Constructed of an eagle wing, the base wrapped with a hide covering and terminating fringe, and decorated with appliquéd beadwork in a floral pattern.

24 in. long

PAC, Gift of Reese Kincaide, P-494

HAIR ORNAMENTS & HEADWEAR

Bonnets

333. CHILD'S BONNET
Sioux, late 19th C.

Cotton foundation with beaded decoration.

6 x 7 in.

TU, B.R., 31-231

334. CHILD'S BONNET
Sioux, late 19th C.

Cotton fabric foundation with quillwork and ribbon border.

6½ x 7½ in.

TU, E.S., S-2010C

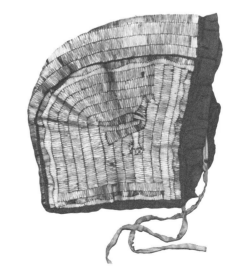

335. CHILD'S BONNET
Sioux, late 19th C.

Cotton cloth foundation with beaded decoration.
7 x 6 in.
PAC, P-2119

Caps and Turbans

336. MAN'S CAP
Cheyenne ?, late 19th C.

Cotton fabric foundation with ermine skin, beading and ribbon decoration.
10 in. long
TU, E.S., 31-1022

337. MAN'S TURBAN
Osage, late 19th C.

Hide construction decorated with two appliquéd floral ornaments and two appliquéd circular rosettes, and surmounted at the top back with a yellow-dyed feather.
6 x 12 in. diam.
TU, G.M.T., TR-93

Hair Ornaments

338. HAIR ORNAMENT
Crow, late 19th C.

Long strips of hair marked at intervals with glue and pigment, fastened to hide strip decorated with beaded netting and topped with feathers.
44 in. long
PAC, R.C.L., MI-2497

339. HAIR ORNAMENT
Sioux, late 19th C.

Fabric-wrapped quillwork and horsehair.
28 in. long
TU, B.R., 31-103

340. PAIR OF HAIR ORNAMENTS
Sioux, ca. 1915

Hide decorated with quillwork, beads and feathers.
12 in. long
TU, B.R., 31-121

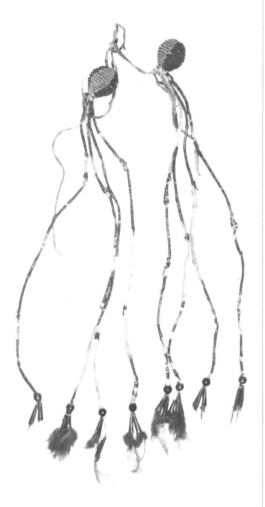

341. HAIR ORNAMENT
Probably Sioux, late 19th C.

Wrapped quillwork and horsehair.
32 x 2 in.
TU, E.S., 31-754

342. HAIR ORNAMENT
Sioux, late 19th C.

Beading, woven quillwork and feathers.
22 in. long
TU, B.R., 31-246b

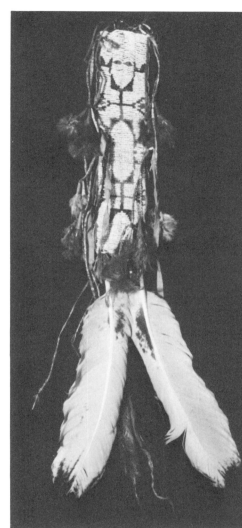

343. HAIR ORNAMENT
Sioux, late 19th C.

Horsehair, quillwork, glass beads and pipe stone beads.
26 in. long
TU, E.S., 31-1024

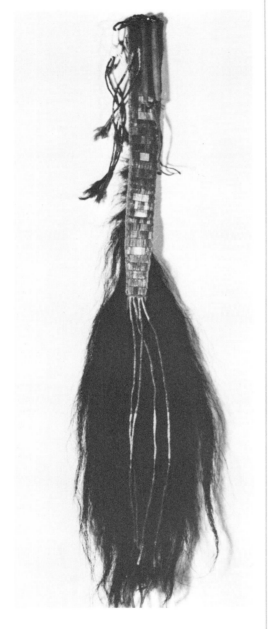

Headdresses

344. WAR BONNET
Sioux, ca. 1900

Golden eagle feather socketed into a headband with beaded border and with fur strips at sides; long trailer of eagle feathers attached to red strouding.
PAC, Gift of Waite Phillips, P-487

345. WAR BONNET
Comanche, early 20th C.

Hide and fabric foundation; thirty golden eagle feathers; brow band of loom-woven beadwork; no trailer.
PAC, R.C.L., MI-2029

Roaches

346. ROACH
Southern Plains, ca. 1900

White horsehair dyed red, yellow and blue.
8 in. long
PAC, R.C.L., MI-2183

JEWELRY

Arm Bands

347. ARM BAND
Cheyenne, ca. 1900

Stamped designs on German silver with hook and slide fastener; red ribbons attached.
15¼ x 2 in.
PAC, Gift of Reese Kincaid, P-495

348. ARM BANDS
Kickapoo (Oklahoma), ca. 1880

Stamped designs on German silver with raised edges and key hole and slide fasteners.
12¼ x 1½ in.
PAC, R.C.L., MI-2524b

349. ARM BANDS
Sioux, ca. 1910

Each composed of three hide loops with wrapped quillwork and three quill-wrapped tassels terminating in tin jangles with red-dyed and yellow-dyed feathers.
3½ in. diam. (loops); 10 in. long (tassels)
TU, B.R., 31-110

Bracelets

350. BRACELETS, PAIR
Kickapoo (Oklahoma), ca. 1900

German silver; curvilinear designs on convex surface and hook fasteners.
8¼ x ⁷⁄₁₆ in.
TU, B.R., 31-183

351. BRACELET
Kickapoo (Oklahoma), early 20th C.

Stamped designs between line borders on German silver; portions of old design on interior.
6⅝ x ⅞ in.
TU, B.R., 31-196

352. BRACELETS, PAIR
Kickapoo (Oklahoma), early 20th C.
German silver with stamped designs and raised
edges.
6¾ x ⅞ in.
PAC, R.C.L., MI-2494

353. BRACELET
Navajo, ca. 1910
Die-stamped silver set with blue glass "stone" at
center.
6 x 1¼ in.
PAC, R.C.L., MI-2509b

354. BRACELET
Navajo, ca. 1930
Die-stamped silver set with turquoise, mounted
on a wide leather band.
9¼ x 3¾ in.
PAC, R.C.L., MI-2509c

355. BRACELETS, PAIR
Plains, early 20th C.
Filed designs on copper and brass.
Copper: 6¼ x ³⁄₁₆ in.
Brass: 6¼ x ⅛ in.
PAC. R.C.L., MI-2506

356. BRACELETS, PAIR
Probably Sauk & Fox, ca. 1900
Stamped designs on German silver.
6 x ½ in.
TU, B.R., 31-184, 31-195

357. BRACELETS, PAIR
Sioux, ca. 1870
Filed grooved design on brass, probably made
from a trade kettle.
6⅝ x 2 in.
TU, A.M.R., 31-419

Breast Plates

358. BREAST PLATE
Sioux, late 19th C.
Bone beads separated with hide strips and brass
beads; fringed hide at sides. Neck loop of hide
and beaded hide.
14 x 13½ in.
TU, B.R., 31-129

Brooches

359. BROOCH
Delaware or Miami (Oklahoma), c. 1890
Cut-out and stamped designs on German silver.
4⅝ in. diam.
TU, B.R., 31-182

360. BROOCH
Osage, ca. 1900
German silver with open-work designs and scal-
loped edge.
2 in. diam.
TU, B.R., 31-191

361. BROOCH
Osage, ca. 1900
German silver with cut-out designs and raised
center.
3⅛ in. diam.
TU, B.R., 31-192

362. BROOCH
Osage, ca. 1900
German silver with cut-out designs and scal-
loped edge.
1⅛ in. diam.
TU, B.R., 31-199

363. SET OF BROOCHES
Osage, ca. 1900
German silver with cut-out designs, scalloped
edge and raised center.
2¾ in. diam.
PAC, P-2007, P-2008, P-2009

364. BROOCH
Osage, ca. 1900
German silver with cut-out designs and raised
center.
2¾ in. diam.
PAC, P-2015

365. BROOCH
Probably Sauk & Fox, ca. 1900
German silver with cut-out design and raised
center.
3¼ in. diam.
TU, BR., 31-180

Chokers

366. CHOKER
Delaware or Potawatomi (Oklahoma-Kansas),
late 19th C.
Bias loom-woven beadwork in a geometric star
pattern.
12½ x 1 in.
TU, B.R., 31-64

367. CHOKER
Northern Plains, ca. 1880
Dentalium shells and brass beads with small
brass ring pendant.
12½ in. long
TU, E.S., 31-986

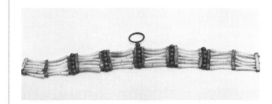

368. CHOKER
Potawatomi (Oklahoma or Kansas), late 19th C.
Bias loom-woven beadwork in a geometric
pattern.
14 x 1¼ in.
TU, B.R., 31-115

369. CHOKER
Sauk & Fox or Potawatomi (Oklahoma-Kansas),
late 19th C.
Bias loom-woven beadwork in a geometric
pattern.
12 x ¾ in.
TU, B.R., 31-113

Conchos

370. CONCHO
Cheyenne, ca. 1910

Stamped designs on German silver with loop on back to fasten to belt.
2½ in. diam.
PAC, P-2011

Ear Ornaments

371. EAR RINGS (OR HAIR ORNAMENTS)
Northern Plains, ca. 1880

Black and white tube beads strung with hide spreaders.
19½ x 1¾ in, 20 x 2 in.
TU, B.R., 31-135

372. EAR RINGS
Northern Plains, ca. 1880

Abalone shell pendants on silver rings.
3½ long
TU, B.R., 31-193

Necklaces

373. NECKLACE
Blackfoot, 19th C.

Graduated strips of bead-wrapped hide fastened through spacers at sides with larger beads on outer ends of hide strips.
51 in. long (max.)
PAC, C.F., MI-3102c

374. PENDANT NECKLACE
Probably Cheyenne, ca. 1870

Buffalo hide disc decorated with brass tacks and hair tassels at bottom, on a necklace of brass beads and lead shot.
30 in. long (necklace); 3¾ in. diam. (pendant)
TU, G.M.T., TR-55

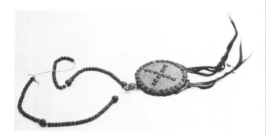

375. PENDANT
Oklahoma, late 19th — early 20th C.

Stamped designs on German silver star and crescent with hanging crescents.
3½ x 3⅛ in.
PAC, NN 107

376. NECKLACE
Sauk and Fox, ca. 1900

Multiple strands of bone beads separated with brass and trade beads; strung on hide with small cloth bag attached to ties.
46 in. long
PAC, R.C.L., MI-2063

Tie Slides

377. TIE SLIDE
Comanche, ca. 1900

Crosses included in stamped design on German silver.
2¾ x 1⅞ in.
TU, B.R., 31-189

378. TIE SLIDE
Kiowa, ca. 1890/Made by Conklin Hummingbird

German silver with face, feather, cross and water bird in stamped design.
3 x 2 in.
TU, B.R., 31-188

379. TIE SLIDE
Oklahoma, late 19th C.

German silver, moon and star shape with stamped designs and attached commercial pendants.
3½ x 2⅞ in.
PAC, Gift of Reese Kincaid, P-502

Medallions

380. MEDALLION
Otoe-Missouri (Oklahoma), late 19th C.

Beaded white cross against blue background on cloth base.
3½ in. diam.
TU, B.R., 31-155

MASKS

381. MASK
Cherokee (Carolina), 20th C.

Carved wood with orange and black pigment. A so-called "Booger" mask.
11½ x 7 in.
PAC, MI-3333

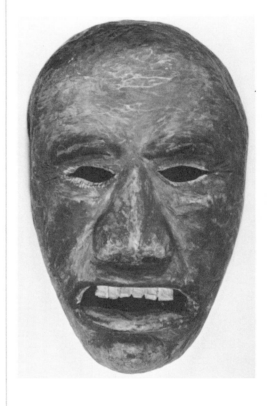

382. MASK
Kwakiutl, ca. 1900

A Hamatsa-type mask of carved and painted cedar with attached hair of pounded cedar.
8¼ x 18¾ in.
PAC, MI-3330

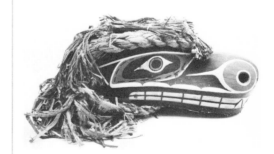

383. MASK
Kwakiutl, ca. 1885
Carved and painted cedar.
11½ x 8¼ in.
PAC, MI-3331

384. MASK (Spoon Mouth)
Iroquois (Seneca, N.Y. State), late 19th C.
Carved wood with red pigment, horsehair and tin circles around the eyes.
10½ x 6¾ in.
PAC, MI-3332

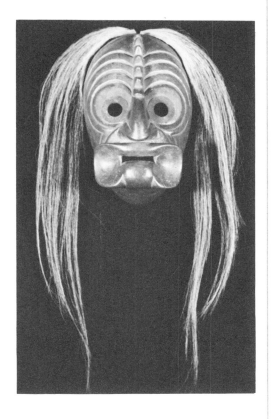

385. MASK
Iroquois (Seneca, N.Y. State), 20th C.
Constructed entirely of corn husks.
15 in. diam.
PAC, MI-3334

MIRRORS & MIRROR CASES

386. MIRROR CASE
Apache, late 19th C.
Small hide pouch with twisted carrying thong strung with large glass beads, the pouch with geometric beaded decoration. Inserted in the pouch is a round glass mirror on a hide backing with brass rim.
2 x 3 in.
PAC, A.L.D., D-13

387. MIRROR BOARD
Probably Osage (Oklahoma), ca. 1900
In the shape of a ball-headed club; constructed of a single piece of hand-shaped wood with a round of mirror glass set into one face of the head.
20 in. long
TU, E.S., S-290M

388. MIRROR AND CASE
Crow, collected as Sioux, ca. 1880
Hide foundation and fringe; completely beaded front and back; quill-wrapped fringe; side fringes partially encased in tube beading on red strouding; braided wool carrying strap. Inserted in the case is a silvered mirror glass set in a hand-fashioned wooden tablet case.
26 x 5 in.
PAC, Gift of Mrs. Mark Dunlop, 78.8

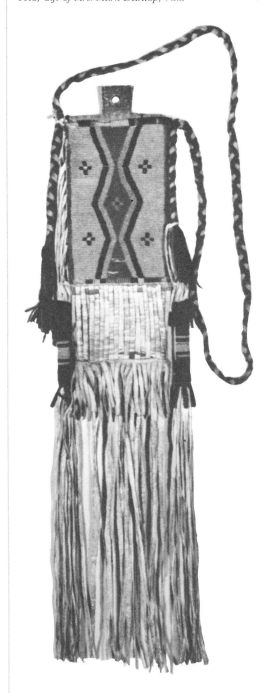

MUSICAL INSTRUMENTS

Drum Sticks

389. DRUM STICKS
Delaware, 19th C.
Wood with carved, red-painted masks in relief on each, and forked tips laced with hide.
18½ x 2½ in.
PAC, MI-2891, MI-2892

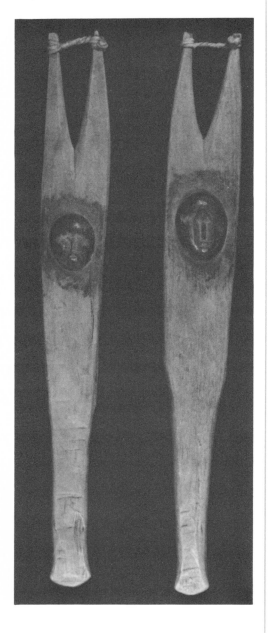

Flutes

390. FLUTE
Pawnee or Osage, 19th C.
Hide-wrapped wood with lead inlay.
24½ x 1¼ in diam.
PAC, R.C.L., MI-2297

391. FLUTE
Collected as San Juan, 19th C.
Cedar glued with piñon gum, hide-wrapped and decorated with rattlesnake and floral design beadwork.
31¼ x 1¾ in. diam.
PAC, R.C.L., MI-2294

392. FLUTE
Probably Santee Sioux, 19th C.
Cedar with catlinite stop; decorated with narrow beaded band and open bird mouth (probably a duck) at lower end.
21¼ x 1¾ in. diam.
PAC, R.C.L., MI-2295

393. FLUTE
Sioux, late 19th C.
Cedar tied with hide; carved duck head at outer end.
28 x 1¼ in. diam.
PAC, R.C.L., MI-2296

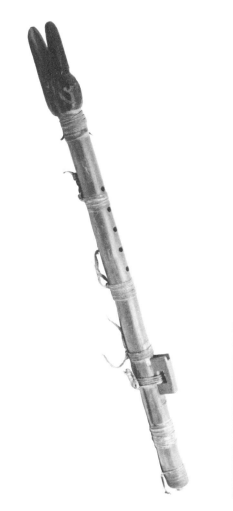

Rattles

394. RATTLES
Delaware, 19th C.
Turtle shells held together with hide laces which form handles, and filled with pebbles.
a. 2 x 4¼ in., b. 2¼ x 5¼ in.
PAC, MI-2894 a & b

395. RATTLE
Iroquois (Ontario), ca. 1900
Turtle shell with neck and head used for handle.
19¼ x 9½ in.
TU, E.S., 31-799

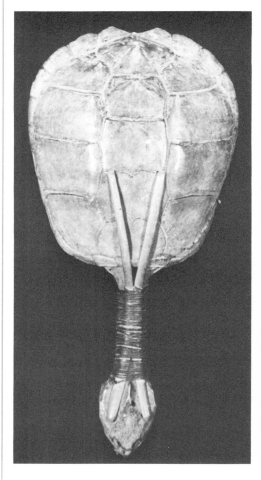

396. RATTLE
Kickapoo, ca. 1880
Large gourd attached to carved wooden handle.
15⅘ x 7 in. diam.
TU, B.R., 31-237

397. RATTLE

Kiowa (Oklahoma), ca. 1920

Gourd with tuft of red-dyed horse hair at top; handle beaded top and bottom with cut glass beads and fringed with twisted hide strips.
22 x 2½ in. diam.
TU, B.R., 31-233

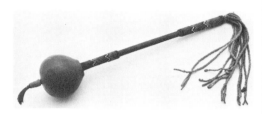

398. RATTLE

Osage, ca. 1880

Gourd attached to wooden handle and decorated with ring of tacks at the top.
10 x 3½ in.
PAC, R.C.L., MI-2191

399. RATTLE

Rio Grande Pueblo, 19th C.

Hide, molded in two sections and glued at the center to form a rattle. Hide strip ties on inner side, hoof rattle attached with hide on outer side.
2½ x 7¼ in.
PAC, R.C.L., MI-2190

400. RATTLE

Sioux, ca. 1900

Dyed pieces of horn fastened to hide-covered stick and fringed with a beaded strip at the lower end of handle.
22½ in. long
TU, E.S., 31-879

401. RATTLE

Sioux, late 19th C.

Hide-wrapped stick; upper two-thirds bead-wrapped with attached carved horn rattles. Fruit pits at top; triangular fringed pendant at lower end.
24 in. long
TU, E.S., 31-924

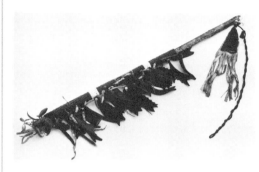

Whistles

402. WHISTLE

Kiowa, 19th C.

Eagle wing bone decorated with bead wrapping and fastened to a narrow beaded necklace.
7½ in. long (whistle); 26 in. long (necklace)
PAC, R.C.L., MI-2303

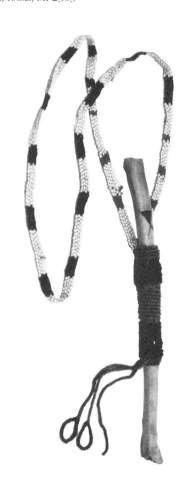

403. WHISTLE

Osage, 19th C.

Cane with attached bundle of sweetgrass and braided horsehair tied with ribbon.
19 x ⅝ in. diam.
TU, B.R., 31-393

404. WHISTLE

Probably Santee Sioux, ca. 1890

Hide-wrapped wood decorated with beads and brass tacks; bird beak opening at lower end.
22½ x 1¼ diam.
TU, B.R., 31-241b

CONTEMPORARY PAINTINGS & SCULPTURE

Paintings

405. Gilbert Benjamin Atencio
(San Ildefonso)
b. 1930
THE BLESSING OF THE DEER DANCER
Tempera and watercolor
18 x 22 in.
PAC, 64.19

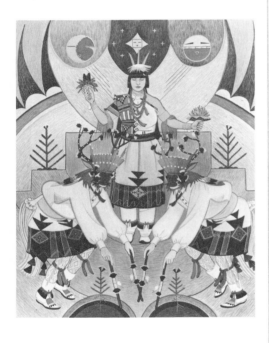

406. Fred Beaver (Creek)
b. 1911
SEMINOLES BRINGING IN SUPPLIES
Watercolor
21 x 31 in.
PAC, 42.12

407. Acee Blue Eagle (Creek-Pawnee)
1907-1959
DEATH SING
Watercolor
19 x 12⁷⁄₁₆ in.
PAC, Gift of Clark Field, 46.45.2

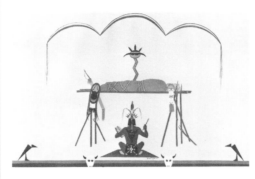

408. Francis Blackbear Bosin
(Kiowa-Comanche)
b. 1921
PRAIRIE FIRE
Watercolor
23 x 33³⁄₁₆ in.
PAC, 53.7

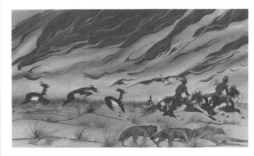

409. Jesse Edwin Davis (Comanche)
1921-1976
AT THE INDIAN FAIR
Watercolor
20 x 18 in.
PAC, 58.13

410. Brenda Kennedy Grummer
(Potawatomi)
contemporary
PROVISIONS
Acrylic
17½ x 18 in.
PAC, 76.11.8

411. Joan Hill (Creek-Cherokee)
b. 1930
THE MAKER OF MEDICINE
Tempera
29 x 21³⁄₈ in.
PAC, 68.9

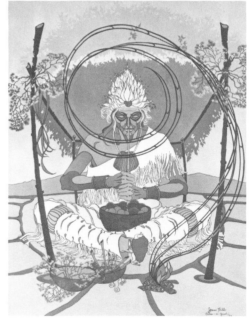

**412. Allan C. Houser
(Chiricahua Apache)
b. 1915
APACHE BABY BURIAL**

Watercolor
22½ x 27½ in.
PAC, 48.9

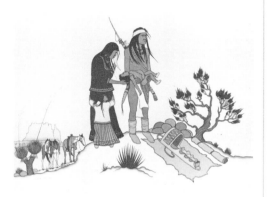

**413. Oscar Howe (Yanktonai Sioux)
b. 1915
VICTORY DANCE**

Watercolor
19⅛ x 12 in.
PAC, 54.6

**414. Wolf Robe Hunt (Acoma Pueblo)
1905-1977
FIRST HORSE COMES TO ACOMA**

Casein
21¾ x 15 in.
PAC, 76.11.9

**415. Albin Roy Jake (Pawnee)
1922-1960
PAINTING OF THE BUFFALO SKULL**

Watercolor
18½ x 33¹⁄₁₆ in.
PAC, 51.13

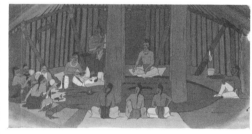

**416. Joseph Kabance (Potawatomi)
b. 1945
OF THE SIOUX**

Oil and mixed media
46 x 58 in.
PAC, 74.22

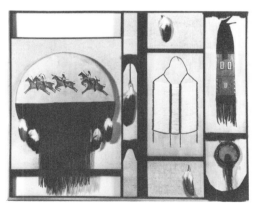

**417. Fred Kabotie (Hopi)
b. 1900
HOPI CEREMONIAL DANCE**

Watercolor
18 x 22 in.
PAC, 46.15
(Grand Purchase Prize, first Annual Indian
Artists Exhibition, 1946)

**418. Solomon McCombs (Creek)
b. 1913
CREEK BURIAL CEREMONY**

Watercolor
19¾ x 26½ in.
PAC, 48.17

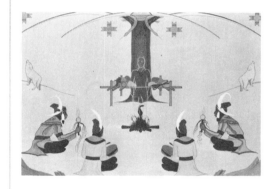

419. Rafael Medina (Zia Pueblo)
b. 1929
ANSWERED PRAYER

Casein
22 x 30 in.
PAC, 66.7

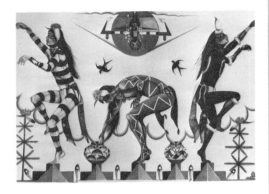

420. Alfred Momoday (Kiowa)
b. 1913
PEYOTE MYSTIC

Casein
20 x 18 in.
PAC, 63.11

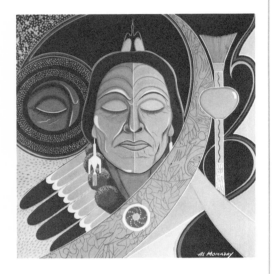

421. Loren Louis Pahsetopah
(Osage-Cherokee)
b. 1934
WAR COUNCIL

Tempera
20 x 32 in.
PAC, 68.10

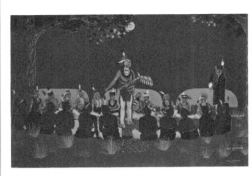

422. Chief Terry Saul
(Choctaw-Chickasaw)
1921-1976
CHOCTAW GRAVE CRY

Watercolor
16¾ x 22½ in.
PAC, 49.16

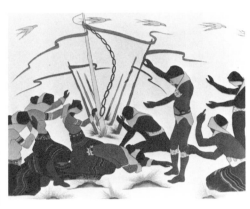

423. Merle Thunderhawk (Sioux)
b. 1950
PAINTED WARRIOR NO. 4

Oil
30 x 30 in.
PAC, 70.12

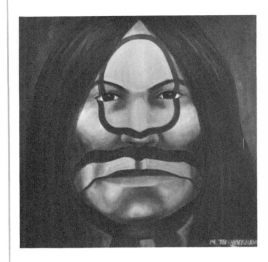

424. Andrew Van Tsihnahjinnie (Navajo)
b. 1918
NAVAJO FIRE DANCE

Watercolor
13½ x 11⅛ in.
PAC, Gift of Dorothy Field, 48.28

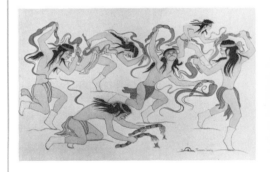

425. Pablita Velarde (Santa Clara Pueblo)
b. 1918
DANCE OF THE AVAYU AND
THE THUNDERBIRD
Watercolor
12 x 15¼ in.
PAC, 55.4

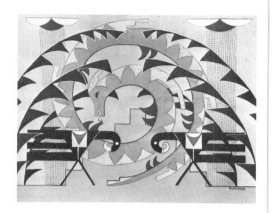

426. Antowine Warrior (Sauk & Fox)
b. 1941
MAKING FRY BREAD
Watercolor
15½ x 21 in.
PAC, 60.6

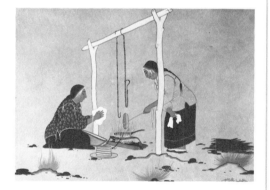

427. Walter Richard West (Cheyenne)
b. 1912
CHEYENNE WINTER GAMES
Watercolor
20 x 26 in.
PAC, 51.14

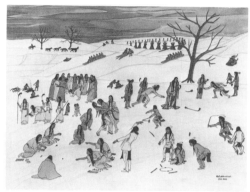

428. David Williams
(Kiowa-Apache-Tonkawa)
b. 1933
APACHE PUBERTY CEREMONY
Tempera and gouache
27¼ x 22½ in.
PAC, 76.11.5

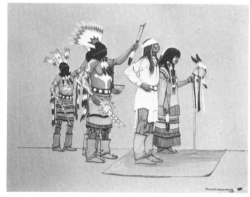

Sculpture

429. Bruce Wynne (Spokane)
b. 1944
THE BABY CARRIER
Walnut
26 in. high
PAC, 76.11.6

PIPE BOWLS & PIPE STEMS

Calumets

430. CALUMET
Great Lakes, 19th C.
Oval-shaped walnut, wrapped with braided quills; braid and ribbon tassels, bird feather and dyed horsehair attached.
42¾ x 1¼ in. max. diam.
TU, B.R., 31-395a

431. CALUMET
Central Plains, 19th C.
Cane decorated with woodpecker bills and feather and swansdown; dyed horsehair and eagle feather strung in a fan from lower side.
31½ x ⅝ in. diam.
TU, B.R., 31-395b

Pipe Bowls

432. PIPE BOWL
Chippewa, 19th C.
Carved stone human head with bowl opening at top and hole for stem beneath the face. Small lateral loop hole beneath to string the bowl as a pendant.
3½ in. high
TU, E.S. 42-1390

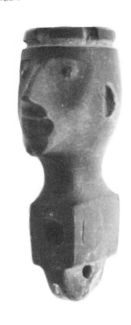

433. PIPE BOWL
Chippewa (Ojibway), 19th C.
Elbow-shaped diorite with round bowl and human face turned toward the smoker.
7¾ x 4⅜ in.
TU, E.S., 42-1417

434. PIPE
Eskimo, late 19th C.
Carved walrus tusk engraved with animal and human figures.
9 in. long
TU, E.S., S-263

435. PIPE BOWL
Great Lakes area, 19th C.
Carved catlinite, the bowl held in a carved eagle claw.
3 x 2⅛ in.
TU, E.S., 42-1273

436. PIPE BOWL
Great Lakes area, 19th C.
T-shaped catlinite with geometric design in lead inlay.
8⅜ x 4⅜ in.
TU, E.S., 42-1291

437. PIPE BOWL
Great Lakes area, 19th C.
Diorite with geometric lead inlay.
7¾ x 3½ in.
PAC, R.C.L., MI-2153

438. PIPE BOWL
Northern Plains, late 19th C.
T-shaped, spiral-carved catlinite.
8 x 3¾ in.
TU, E.S., 42-1274

439. PIPE BOWL
Northern Plains, 19th C.
T-shaped catlinite decorated with bands of lead inlay.
11 x 3¾ in.
TU, G.M.T., TR-66

440. PIPE BOWL
Probably Ojibway, 19th C.
Elbow-shaped diorite inlaid with lead and red catlinite.
3½ x 2 in.
TU, E.S., 42-1275

441. PIPE BOWL AND STEM
Osage, 19th C.

Hide-wrapped cane stem with lock of hair attached. Catlinite bowl is a platform disc inlaid with lead and attached with a hide cord.
20¾ in. long (stem); 3 x 1½ in. (bowl)
TU, G.M.T., TR-91

442. PIPE BOWL
Ponca or Eastern Sioux, ca. 1890

T-shaped black diorite inlaid with lead and red catlinite.
5 x 3 in.
TU, B.R., 31-247a

443. PIPE BOWL
Sioux, late 19th-early 20th C.

Elbow-shaped catlinite with carved buffalo head and hump extended from the front.
8¼ x 4½ in.
TU, E.S., 42-1235

444. PIPE BOWL
Sioux, early 20th C.

Catlinite, carved with a saddle atop the stem end and bowl inside horse head and neck.
7 x 3¼ in.
TU, E.S., 42-1290

445. PIPE BOWL
Sioux, early 20th C.

Carved catlinite bowl in shape of a tomahawk, the blade decorated with star and floral design.
7½ x 3¼ in.
TU, E.S., 31-1382

446. PIPE BOWL
Southeastern area, 19th C.

Elbow-shaped diorite with wider diameter bowl; lead inlay and brass ring at stem end.
3½ x 2½ in.
TU, E.S., 42-1392

Pipe Stems

447. PIPE STEM
Great Lakes area, early 20th C.

Catlinite carved fish with open mouth at one end and raised tail near center.
9½ x 4¼ in.
TU, B.R., 31-246a

448. PIPE STEM
Great Lakes area, 19th C.

Catlinite carved in the shape of a fish with open mouth at outer end.
7½ x 1⅜ in. diam.
TU, E.S., 42-1378

449. PIPE STEM
Plains style, late 19th C.

Catlinite with low, curved top and straight sides; carved bands across the top.
16¼ x 2 in. diam.
TU, E.S., 31-849

450. PIPE STEM
Plains style, late 19th C.

Catlinite with diagonal carved lines on curved top and bottom.
12 x 1½ in. diam.
TU, E.S., 42-1296

451. PIPE STEM
Sauk & Fox ?, ca. 1890

Wood carved in two ribbed sections with red pigment in grooves. Round ends and center section decorated with hot file.
21¾ x 1 in. diam.
TU, E.S., 42-1267

452. PIPE STEM
Sioux, ca. 1900

Wood with one end decorated with braided quillwork. Colored ribbons, dyed horsehair and mallard feathers attached.
25½ x 1½ in. diam.
TU, E.S., 42-1244

453. PIPE STEM
Probably Santee Sioux, ca. 1900

Round catlinite with small hand carved in relief at one end.
7 in. long
TU, E.S., 42-1246

454. PIPE STEM
Sioux, (Pine Ridge), late 19th C.

Wooden shaft of flattened form. On one side, carved in high relief are the figures of a turtle, a buffalo head, deer head and a ram head. Inscribed in pencil on the under side: "Sioux Peace Pipe, Iron Bull, Pine Ridge Agency".
29½ x 1⅝ in. diam.
TU, E.S., 42-1247

455. PIPE STEM
Sioux, ca. 1910

Carved wood wrapped with two sections of dyed braided quills and with tufts of faded red-dyed horsehair.
16 x 1⅜ in. diam.
TU, E.S., 42-1257

456. PIPE STEM
Sioux, late 19th C.

Catlinite shaft partially carved in hexagonal profile; inscribed in pencil, "Chief Crow Dog, his pipe," and dated 1883.
15 x 1¼ in. diam.
TU, E.S., 42-1268

457. PIPE STEM
Sioux, late 19th C.

Spiral carved catlinite shaft.
12⅝ x 1 in. diam.
TU, E.S., 42-1270

458. PIPE STEM
Sioux, late 19th C.

Catlinite shaft carved in both round and geometric sections.
13¼ x 1 in. diam.
PAC, R.C.L., MI-2150

Pipe Tomahawks

459. PIPE TOMAHAWK
Plains style, ca. 1860

Iron blade inlaid with brass and copper and decorated with stamped designs, set in ash wood and hot-file decorated.
23¾ long; 8¼ x 4 in. (blade)
TU, E.S., 42-598

460. PIPE TOMAHAWK
Plains style, ca. 1860

Iron blade decorated with stamped designs and engraved floral patterns on both sides, set in ash wood, and hot-file decorated handle.
24¼ in. long; 8½ x 3½ in. (blade)
TU, E.S., 42-605

461. PIPE TOMAHAWK
Plains style, ca. 1850

Ash handle with designs of small brass nails; iron blade sometimes referred to as "Spontoon" or "Spear-point" style.
16 in. long; 7 x 2⅛ in. (blade)
PAC, R.C.L., MI-2159

462. PIPE TOMAHAWK
Plains style, ca. 1860

Round ash handle, iron blade forged from a gun barrel and decorated with cut-out heart.
19½ in. long; 8½ x 3 in (blade)
PAC, R.C.L., MI-2162

POTTERY

All pueblo pottery described here is understood to be hand built (as opposed to wheel thrown), with decoration applied before firing.

Acoma

463. JAR
Acoma Pueblo, ca. 1900

Round form with concave bottom. The body of the jar is decorated in a floral pattern in nine sections around the body, and with five sections of geometric designs above the shoulder. The lower exterior and rim interior are dark red.
7¼ in. high x 8⅜ in. diam.
PAC, NN-4

464. CANTEEN
Acoma Pueblo, ca. 1900

Slightly flattened round form with spout, handle lugs, and fabric carrying strap. One side undecorated red, the other with polychrome floral and geometric designs.
9 in. high x 8 in. wide
PAC, NN-39

465. JAR
Juanita B. Pino, Acoma Pueblo, ca. 1939

Sloped neck, high shoulder and concave bottom; decorated in polychrome with three large circles enclosing hatched lightning symbols and with curved and geometric floral motifs in the center.
10½ in. high x 14 in. diam.
PAC, C.F., PO-208

466. WEDDING JAR
Acoma Pueblo, ca. 1940

Globular body rising to double spouts connected by a twisted handle. Decorated in polychrome with round floral motif on front and back.
14 in. high x 10¼ diam.
PAC, C.F., PO-242

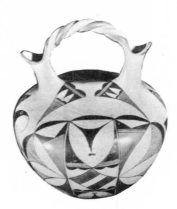

467. STORAGE JAR
Acoma Pueblo, ca. 1890

Large globular body with concave bottom. Decorated in polychrome with four-color geometric design over the upper three-fourths of the exterior while the lower one-fourth is plain red. Design elements include hatching and checker boards.
12 in. high and 12 in. diam.
PAC, C.F., PO-323

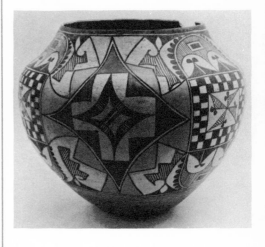

468. STORAGE JAR
Carrie Pancho, Acoma Pueblo, ca. 1940

Round body with sloping neck and concave bottom. Polychrome decoration of diverse elements within divided rectangles.
13½ in. high x 15½ in. diam.
PAC, C.F., PO-402

469. WEDDING JAR
Juana V. Leno, Acoma Pueblo, ca. 1950

Globular body rising to double spouts and decorated in black on white with rectangular spirals forming optical illusions of diamonds and rectangles. Signed on the bottom: "Juana V. Leno/Acoma N. Mexico".
12 in. high x 8 in. diam.
PAC, C.F., PO-468

470. JAR

Lucy M. Lewis, Acoma Pueblo, 1959

Squat round form, tapering toward the bottom, with flattened top and small rim opening. Decorated in black on white with bold, radiating lightning forms. Signed on the bottom: "Lucy M. Lewis/Acoma/1959".
6 ¼ in. high x 10 in. diam.
PAC, C.F., PO-531

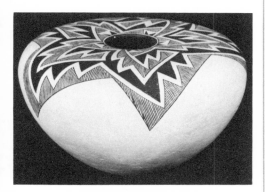

471. JAR

Marie Z. Chino, Acoma Pueblo, ca. 1959

Vertical interlocking step designs expand from slightly concave base around median shoulders; diminish on narrow neck to slightly flared rim.
11½ in. high x 7½ in. diam.
PAC, C.F., PO-533

Cochiti

472. JAR

Seraphia Cordova, Cochiti Pueblo, ca. 1900

Round with short straight neck. Decorated in black on white with figures of four horned toads between four pyramid shapes which enclose yucca designs, and a band of triangles around the neck.
19 in. high x 21½ in. diam.
PAC, C.F., PO-166

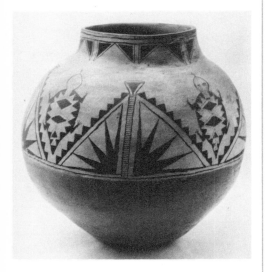

473. BOWL

Stephenita Herrera, Cochiti Pueblo, ca. 1939

Large round bowl, curving in above the shoulder to a straight short rim, and with a flat bottom. Decorated in black on white with geometric designs above the exterior shoulder, and with two birds and a rain design on the interior.
11¼ in. high x 20½ in. diam.
PAC, C.F., PO-168

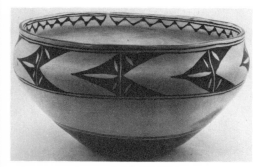

474. EFFIGY BOWL

Stephenita Herrera, Cochiti Pueblo, ca. 1950

Round with slightly flaring mouth and flat bottom, and with figures of four lizards on the shoulder. Decorated in black on white with touches of red.
7¼ in. high x 11 in. diam.
PAC, C.F., PO-440

Hopi

475. BOWL

Fannie Nampeyo, Hopi, First Mesa, ca. 1930

Of flattened round form with high flaring neck. Decorated in polychrome with bear claw motif and a hatched design flowing diagonally round the bowl.
6 in. high x 8½ in. diam.
PAC, C.F., PO-84

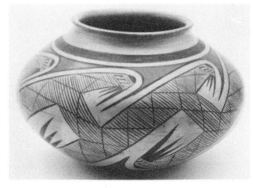

476. BOWL

Sadie Adams, Hopi, First Mesa, ca. 1940

Shallow bowl with rim turning inward, with polychrome decoration of symbolic geometric forms in four sections around the exterior. Signed on the bottom with a stylized flower.
5 in. high x 13½ in. diam.
PAC, C.F., PO-256

477. JAR

Hopi, First Mesa, ca. 1900

High jar with gently flaring sides, high shoulder, nearly straight neck and flat bottom. Decorated in polychrome with figures of four large Kachinas separated by four large erect flowers.
20 in. high x 15 in. diam.
PAC, C.F., PO-308

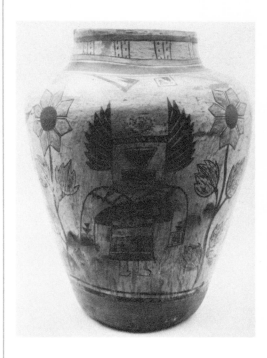

478. JAR

Rachel Nampeyo, Hopi, First Mesa, ca. 1925

Large storage jar with tapered body and broad shoulder. Decorated in polychrome of black and red on buff with a diagonally repeated hatched and black bear claw design around the shoulder.
16½ in. high x 21½ in. diam.
PAC, C.F., PO-401

Isleta

479. BOWL

Isleta Pueblo, ca. 1920

Wide bands of hatched and geometric designs around sides and high shoulder above plain, narrow concave base; narrow fluted rim at top.
5¼ in. high x 6¾ in. diam.
PAC, NN-45

Laguna

480. WEDDING JAR

Mrs. Miguel Riley, Laguna Pueblo, ca. 1935

Globular body, long neck, double spouts with connecting handle, decorated in polychrome with hatched geometric pattern.
12 in. high x 7½ in. diam.
PAC, C.F., PO-329

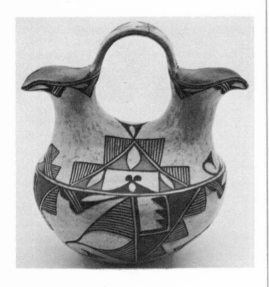

San Ildefonso

481. JAR

San Ildefonso or Tesuque, ca. 1880

Lightly potted globular jar with short straight neck. The upper three-quarters of the exterior decorated in black on white with a design of stylized growing plant forms and at the neck, a repeated swag motif. Red base.
9¾ in. high x 12 in. diam.
TU, G.M.T., TR-86

482. BOWL

San Ildefonso Pueblo, ca. 1900

Low bowl form with nearly straight flared sides ending in a scalloped rim and with an atypical ring around a flat base. Decorated in black and red on white, the interior with six radiating flowers around a blossom-like center and a black scalloped design toward the rim. The exterior design consists of geometric triangular forms repeated around the upper portion with the rim edged in black.
3¼ in. high x 10 in. diam.
PAC, 78.17

483. VASE

Maria and Julian Martinez, San Idlefonso Pueblo, ca. 1935

Round tapered body with high, gently indented neck. Decorated with polychrome geometric design around the shoulder with a floral motif below. Inscribed on the bottom: "Marie/Julian."
10½ in. high x 10 in. diam.
PAC, C.F., PO-42

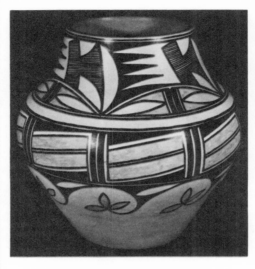

484. JAR

Tonita and Juan Roybal, San Ildefonso Pueblo, ca. 1940

Broad round body rising to a high indented neck. Decorated in the red-on-red technique with the encircling figure of Avanyu, the water serpent. Signed on the bottom: "Tonita and Juan."
11 in. high x 12½ in. diam.
PAC, C.F., PO-150

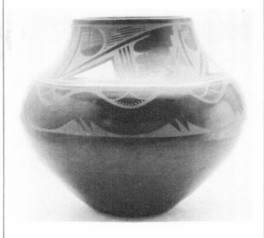

485. BOWL

Made by the grandmother of Mainita Aguilar, San Ildefonso Pueblo, ca. 1910

Of slightly flattened form with short, straight neck. Decorated in a polychrome design of curved and scalloped lines with hanging objects resembling fruit.
9¾ in. high x 15¾ in. diam.
PAC, C.F., PO-173

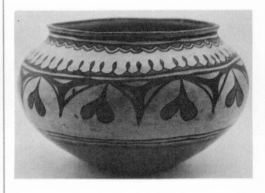

486. JAR

Maria and Julian Martinez, San Ildefonso Pueblo, ca. 1940

Large storage jar with round tapered body and short indented neck. Decorated in the black-on-black technique with scallops, geometric forms, feathers and bear claw motifs. Signed on the bottom: "Ma . . ./. . .ulia. . ."
16¾ in. high x 23½ in. diam.
PAC, C.F., PO-313

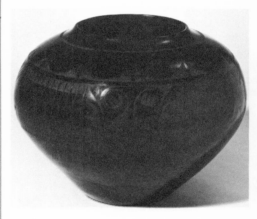

487 PLATE

Maria Martinez and Santana, San Ildefonso Pueblo, ca. 1945

Fine, heavily potted plate with a polished red surface decorated in buff and red with a feather design. Inscribed on the bottom: "Marie/-Santana."
2 in. high x 15 in. diam.
PAC, C.F., PO-334

488. PLATE
Maria Martinez and Santana, San Ildefonso Pueblo, 1946

Fine, heavily potted plate with a polished black surface decorated in matte black with a feather design. Inscribed on the bottom: "Marie/-Santana."
2 in. high x 15 in. diam.
PAC, C.F., PO-335

489. JAR
Rose Gonzales, San Ildefonso Pueblo, 1953

Heavily potted rounded form with flat base and carved completely around with the figure of Avanyu, the water serpent. Signed in pencil on the bottom: "Rose."
PAC, C.F., PO-424

490. PLATE
Maria Marinez and Popovi Da, San Ildefonso Pueblo, 1956

Finely potted unpolished red ware decorated in buff and black around a center triangle with bear claws, clouds and geometric forms. Signed on the bottom: "Maria/Popovi."
1½ in. high x 13½ in. diam.
PAC, C.F., PO-521

491. JAR
Maria Martinez, San Ildefonso Pueblo, ca. 1955

Round tapered body with low shoulder, the gently sloping neck rising to a lightly fluted rim. Undecorated, polished black "gun metal" finish. Signed on the bottom: "Maria Poveka."
10¾ in. high x 11 in. diam.
PAC, C.F., PO-558

San Juan

492. BOWL
San Juan Pueblo, ca. 1900

Polished black interior and plain exterior on high-shouldered bowl with fluted rim.
5⅜ x 11¾ in.
PAC, C.F., PO-130

493. WEDDING JAR
Crucita T. Cruz, San Juan Pueblo, ca. 1940

Rounded body rising to double spouts. Decorated in polychrome with geometric and circular designs of gods on each side, and with a braided polished red handle. Signed on the bottom: "Crucita T. Cruz/San Juan."
12½ in. high x 9¾ in. diam.
PAC, C.F., PO-328

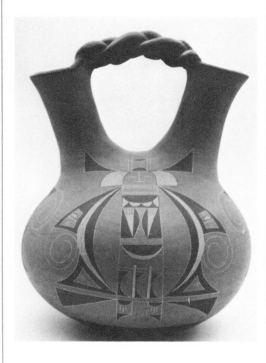

494. BOWL
San Juan Pueblo, ca. 1957

An undecorated polished red ware bowl with a small base and high shoulder gently sloping to a flat rim.
4½ in. high x 8½ diam.
PAC, C.F., PO-517

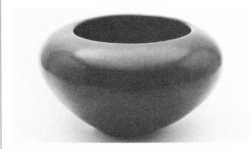

Santa Ana

495. BOWL
Santa Ana Pueblo, ca. 1880

Plain red interior; stepped triangle design in red and white outlined in black on upper exterior of wide, high-shouldered bowl with flared rim.
7 in. x 13 in.
PAC, C.F., PO-291

Santa Clara

496. STORAGE JAR
Santa Clara Pueblo, attrib. to Sarafina Tafoya, ca. 1920

Polished black ware with slightly tapered base, a low shoulder and a high sloping neck with four imprinted bear paw designs.
22 in. high x 20¼ in. diam.
PAC, Gift of Waite Phillips, P-457

497. COVERED STORAGE JAR
Made by the great-great grandmother of Margaret Tafoya and Teresita Naranjo, Santa Clara Pueblo, ca. 1835

Heavily potted, bulbous-shaped polished black ware with handled cover and a skin covering on the bottom laced diagonally to a piece around the neck.
19¾ in. high x 21½ in. diam.
PAC, C.F., PO-98

498. BOWL
Christina and Teresita Naranjo, Santa Clara Pueblo, ca. 1939

Round, melon-shaped bowl of polished red ware. Signed indistinctly on the bottom.
10¾ in. high x 14½ in. diam.
PAC, C.F., PO-111

499. SHALLOW BOWL
Christina and Teresita Naranjo, Santa Clara Pueblo, ca. 1939

Of polished red ware, decorated on the interior in polychrome red, tan and grey with the figure of Avanyu, the water serpent, surrounding a central medallion with rain cloud symbols. Signed on the bottom: "Teresita &/Christina/Naranjo/Sta. Clara pue."
2 in. high x 16 in. diam.
PAC, C.F., PO-134

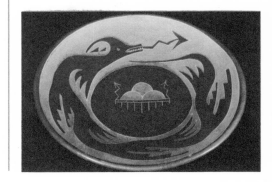

500. SHALLOW BOWL

Christina Naranjo, Santa Clara Pueblo, ca. 1920

Of polished black ware decorated on the interior with three indented bear paws. Signed on the bottom: "Christina Naranjo/Santa Clara Pueblo."
3¼ in. high x 15½ in. diam.
PAC, C.F., PO-135

501. BOWL

Teresita Naranjo, Santa Clara Pueblo, ca. 1940

Heavily potted polished red ware with a deeply carved surrounding design of Avanyu, the water serpent. Signed on the bottom: "Teresita Naranjo."
7¼ in. high x 12 in. diam.
PAC, C.F., PO-252

502. WEDDING JAR

Teresita Naranjo, Santa Clara Pueblo, 1958

Large polished black ware wedding jar with globular body and high neck rising to form double spouts connected by a handle, and decorated with impressed bear paw designs on the sides. Signed on the bottom: "Teresita Naranjo/Santa Clara Pueblo."
17½ in. high x 11 in. diam.
PAC, C.F., PO-530

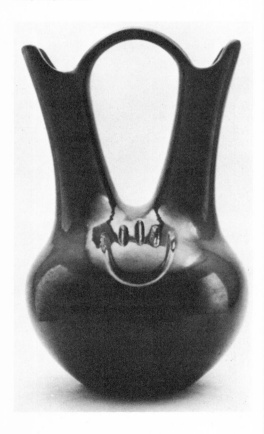

Santo Domingo

503. BOWL

Juanita Lobato, Santo Domingo Pueblo, ca. 1910

Large thinly potted bowl on a rounded base with straight sides terminating in a scalloped rim. Decorated in black on white with curved and geometric designs on the upper part of the exterior. Interior and lower portion of exterior are red.
12 in. high x 19 in. diam.
PAC, C.F., PO-190

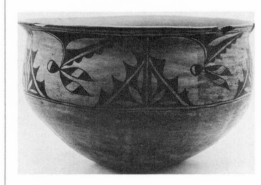

504. STORAGE JAR

Made by the Aguilar-Garcia sisters, Santo Domingo Pueblo, ca. 1920

Large rounded form with high, slightly tapered sides ending at a slightly flared lip, and decorated in black and white on a red ground with large geometric and semi-circular forms.
14½ in. high x 17½ in. diam.
PAC, C.F., PO-316

Taos

505. JAR

Virginia Romero, Taos Pueblo, ca. 1939

Heavily potted, unglazed jar of micaceous clay surrounded by two rope-like bands and with small grooves around the rim simulating cording.
13½ in. high x 14 in. diam.
PAC, C.F., PO-188

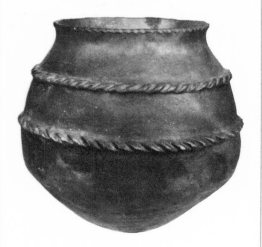

Zia

506. JAR

Zia Pueblo, ca. 1910

Globular jar with concave bottom and scalloped rim. Decorated in polychrome with birds and floral motifs.
8 in. high x 10 in. diam.
PAC, Gift of Mrs. W. J. Zollinger, MI-2866

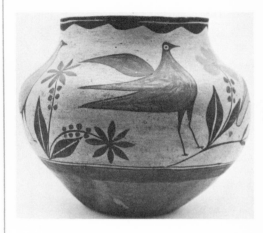

507. BOWL

Zia Pueblo, ca. 1900

Globular bowl with slightly rounded bottom, polished red interior, and the exterior decorated in buff and black over red with a meandering band of flowing geometric forms.
5½ in. high x 19¾ in. diam.
PAC, C.F., PO-131

508. JAR

Virginiana Solas, Zia Pueblo, ca. 1939

Large bulbous jar with high shoulder, concave bottom, and short unflared neck rim. Decorated in black, red and white on a cream ground with a small scalloped motif at the rim, a wide geometric band just above the shoulder, and a wider intricate geometric band around the body of the jar, above a red, undecorated tapered base.
16½ in. high x 16½ in. diam.
PAC, C.F., PO-161

509. BOWL

Zia Pueblo, ca. 1900

Large, high-shouldered bowl tapering to a flat base, the exterior decorated with a polychrome frieze of deer and evergreen trees, the interior painted black.
8¼ in. high x 16 in. diam.
PAC, C.F., PO-202

510. JAR
Trinidad Medina, Zia Pueblo, ca. 1941

Large bulbous storage jar with a flat bottom tapering to a high shoulder which slopes gently to the rim. The interior is unpolished red, and lower third of the exterior polished red. The upper two-thirds of the exterior is decorated with four large running birds separated by long red feather-form stripes and cloud-like geometric devices.
16 in. high x 20½ in. diam.
PAC, C.F., PO-263

511. JAR
Zia Pueblo, ca. 1930

Concave bottom, small base tapering upward to a high shoulder which slopes up to a nearly vertical rim. The interior is painted red. The lower third of the exterior is polished red. Above this, extending to the rim, is a naturalistic polychrome frieze of animals set within a wooded landscape and depicting a tiger, a wounded stag, an unwounded stag, a smaller unwounded stag and a doe, as well as birds and a rabbit sitting in a tree.
9½ in. high x 10½ in. diam.
PAC, C.F., PO-300

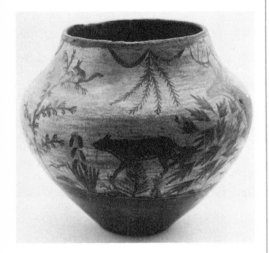

Zuni

512. JAR
Zuni Pueblo, ca. 1910

Large storage jar with concave bottom and tapering upward to a broad shoulder, then gently inward to the vertical rim. The decoration is in black and red on a white ground, and consists of three large floral circles with deer and birds enclosed. Above the shoulder there is a design of geometric shapes and hatching.
19 in. high x 19 in. diam.
PAC, C.F., PO-238

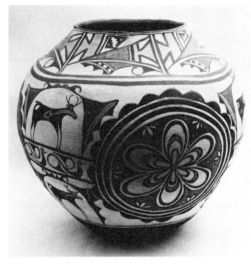

513. JAR
Zuni Pueblo, ca. 1930

Concave bottom, sides tapering upward to a broad shoulder, then gently inward to the short vertical neck. The overall design is in black and red on cream, and consists of seven spotted frogs with two tadpoles between each around the body of the jar. This is repeated between the shoulder and rim with one tadpole between each frog.
12 in. high x 14 in. diam.
PAC, C.F., PO-239

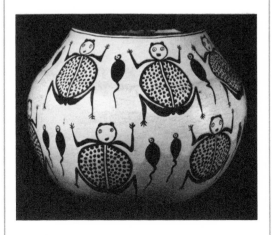

514. JAR
Zuni Pueblo, ca. 1940

Large storage jar of bulbous form with a broad high shoulder rising to an indented sloping neck and vertical rim. The design is in brown on cream, featuring large circles flowing from vertical lines which divide the body of the jar into two large and two small rectangles.
20 in. high x 20 in. diam.
PAC, C.F., PO-307

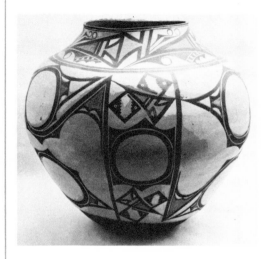

515. JAR
Zuni Pueblo, ca. 1910

Made by "Flora's mother." A bulbous-shaped pot with concave bottom. From the small base the body tapers upward and outward to form a broad shoulder, then inward to the short, vertical neck rim. The exterior decoration is black on a white ground, and consists of tri-sectioned geometric meanders and triangles in hatched and solid black lines.
12 in. high x 7¼ in. diam.
PAC, C.F., PO-319

Pottery Tiles

516. TILES
Hopi, First Mesa, early 20th C.

Images of Corn Maiden, Pollen Maiden and Badger decorate flat rectangular surfaces.
a: 6 x 3¾ in.
b: 5¾ x 3½ in.
c: 6¼ x 3⅞ in.
PAC, Gift of Stanley Marcus, MI-3181 a,b,c

RIDING EQUIPMENT

Horse Masks

517. HORSE MASK
Blackfoot, ca. 1910
Hide decorated with beads, ribbon, red felt and brass bells.
14½ x 12 in.
TU, B.R., 31-124

Riding Quirts

518. QUIRT
Crow, late 19th C.
Turned wooden handle with circles of brass tack decoration; lash of heavy hide partially wrapped in quillwork; grip ornament of beadwork on red strouding sewn to cotton fabric.
43 in. long (including lash)
PAC, R.C.L., MI-2545

519. QUIRT
Sioux, late 19th C.
Hand-fashioned wooden handle covered with a beaded sheath; double-strand hide lash with beading; hide wrist handle, beaded and terminating in tin jangles with blue-dyed feather.
35 in. long
PAC, R.C.L., MI-2544

Saddle Bags (See A. 6.)

Crow MI-2137A (#48.)

Sioux 31-131 (#49.)

Saddles

520. SADDLE
Cree (Saskatchewan, Canada), late 19th C.
Beaded floral designs on corners and geometric designs on tabs hung from corners of hide construction known as a Pad Saddle.
19¾ in. x 16½ in. max. w. x 14¼ in. min. w.
TU, E.S., S-230

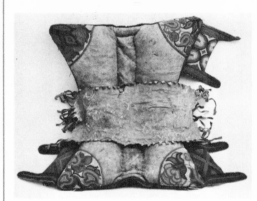

Saddle Blankets

521. SADDLE BLANKET
Crow, late 19th C.
Cotton fabric foundation with applied strips of beadwork on red and brown strouding; beaded hide with fringed tassels at the corners.
30 x 40 in.
PAC, Gift of Henry Gray, MI-2687

522. SADDLE BLANKET
Sioux, late 19th C.
Hide on cloth back with fringe on three sides and traces of red strouding around edges. Both ends totally beaded in geometric designs on white background; center section has beaded band on three sides.
41½ x 15 in.
TU, E.S., 42-1138

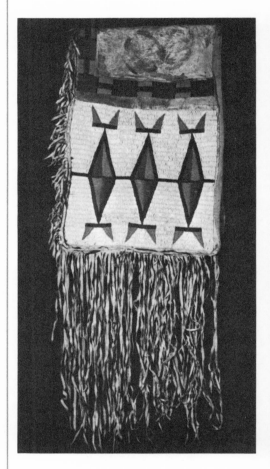

523. SADDLE BLANKET
Sioux, late 19th C.
Hide base with strips of beaded geometric designs on four sides; front and rear strips extend down side and end with fringe.
72 x 27½ in. max. w. x 25 in. min. w.
TU, E.S., S-2035 M

524. SADDLE BLANKET

Sioux, late 19th C.

Hide with quillwork decoration, beaded borders, quilled tassels and tin jangles with red horsehair. Probably for a child's saddle.
22 in x 36 in.
TU, E.S., S-2037 M

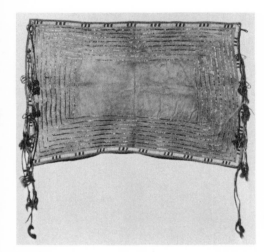

RUGS

525. RUG

Navajo, ca. 1910, Rug Period

Vertical loom; tapestry and wedge-weave. Wool warp and weft. Central vertical row of connected rectangles has row of connected horizontal diamonds at each side; stepped line separates red background from wide white border.
82½ x 61 in.
PAC, R.C.L., MI-2517

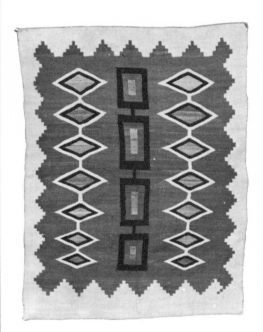

526. RUG

Navajo, ca. 1930, Revival Period

Vertical loom; tapestry and wedge-weave. Wool warp and weft. Ornate border, bold serrate stripes and pictorial elements reflect design traditions developed in the Transition Period of the late 19th Century.
70 x 49 in.
PAC, L.J.W.-17

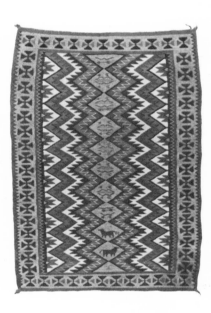

527. RUG

Navajo, ca. 1890, Transition Period

Vertical loom; tapestry and wedge-weave. Cotton warp; Germantown weft. Vertical rows of alternate solid and banded diamonds on green background with wide bands at top and bottom.
76 x 43 in.
PAC, L.J.W.-23

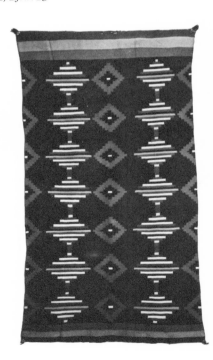

528. RUG
Navajo, ca. 1930, Revival Period

Vertical loom; tapestry and wedge-weave. Wool warp and weft. Two vertical Yei figures at center are framed by bold geometric and horizontal feather designs; smaller Yei figures and geometric elements complete designs against a red background bordered with wide bands.
71 x 64 in.
PAC, L.J.W.-26

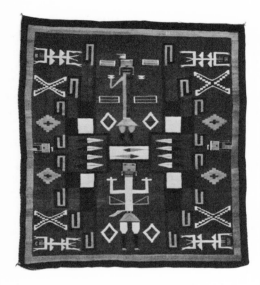

SCULPTURE

Effigies

529. BUFFALO EFFIGY
Sioux or Cheyenne, ca. 1880

Carved wood with hot-file markings, fiber-tuft tail and inset carved wooden horns.
8¾ x 7 x 2⅞ in.
PAC, R.C.L., MI-2277

530. BUFFALO EFFIGY
Sioux or Cheyenne, ca. 1880

Carved wood with hot-file markings, hide, hair, black feathers and remnants of inset carved wooden horns.
8¼ x 6½ x 2¾ in.
PAC, R.C.L., MI-2278

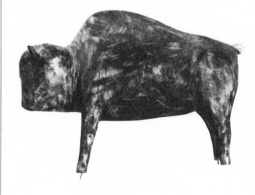

Eskimo Figures

531. WALRUS
Eskimo, 20th C.

Carved stone and ivory.
8 in. long
PAC, Gift of Rainey Elliott, MI-3239

532. SEAL HUNTER
Eskimo, 20th C.

Carved stone.
7½ in. long
PAC, Gift of Rainey Elliott, MI-3240

House Posts

533. THREE SIDE POSTS
Delaware, 1874

From the Big House near Copan, Oklahoma. Carved round wood posts with traces of black and red pigment.
48-52 in. high x 8-9 in. diam.
PAC, MI-2911 a&b and MI-2912

534. CENTER POST
Delaware, 1874

Collected from the last Delaware Big House or Long House, situated on the Little Caney River west of Copan in Washington County, Oklahoma. Square-cut elm with carved masks front and back, originally painted black and red.
46 in. high x 17½ in. max. diam. x 12 in. min. diam.
PAC, Gift of Clark Field MI-3219

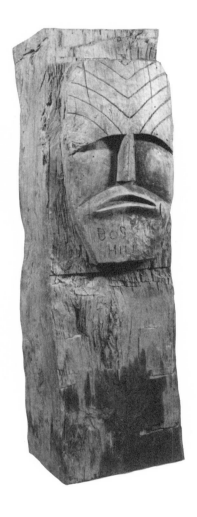

Scrimshaw

535. CRIBBAGE BOARD
Eskimo, 1908

Walrus tusk, engraved and drilled. Inscribed, "Nome Alaska, 1908".
13 in. long
TU, E.S., S-264

536. TUSK
Eskimo, late 19th C.

Ivory tusk engraved with animal and human figures.
12 in. long
TU, E.S., S-288

Totem Poles

537. TOTEM POLE
Haida, late 19th C.

Carved and painted cedar wood.
42 in. long
PAC, Gift of Waite Phillips, P-482

TIPI FURNISHINGS

Liners

538. TIPI LINER
Cheyenne, ca. 1890

Canvas with beaded decoration and quill-wrapped fringe.
86 x 142 in.
PAC, Gift of Waite Phillips, P-2125a

Ornaments

539. ORNAMENT
Blackfoot, late 19th C.

Hide foundation covered with beaded decoration; borders bound with red strouding; hide fringe with remnants of rabbit fur.
29½ in. long
PAC, R.C.L., MI-2537

540. TIPI ORNAMENT
Cheyenne, late 19th C.

Beadwork on a stuffed canvas body.
8 in. diam.
TU, B.R., 31-61

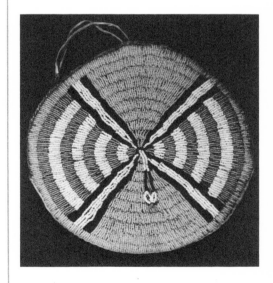

TOYS

Bags

541. SHOULDER BAG
Central Plains, late 19th C.
Hide with cloth lining and geometric beadwork designs.
21½ x 6½ in.
TU, E.S., 42-1212

Charms

542. UMBILICAL CHARM
Sioux, late 19th C.
Hide decorated with beading and horsehair tufts.
3 in. diam.
TU, E.S., 31-980

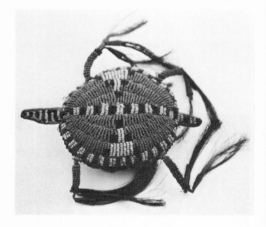

543. UMBILICAL CHARM
Sioux, ca. 1900
Hide with beaded decoration.
6 x 3 in.
TU, E.S., S-2056MH

544. UMBILICAL CHARM
Sioux, ca. 1900
Hide construction decorated with beads, tin jangles and yarn.
6½ x 3 in.
TU, E.S., S-2056 Mb

Cradles

545. TOY CRADLE
Comanche, ca. 1880
Cloth, laced with hide and decorated with shells and brass beads; wood frame decorated at top with brass tacks.
31 x 10 in. max.
TU, E.S., 31-812a

546. TOY CRADLE
Kiowa, late 19th C.
Beaded cloth cover on wooden frame, decorated at top with brass tacks.
20¼ in. long
PAC, R.C.L., MI-2274

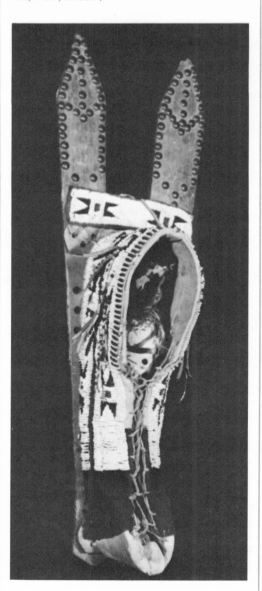

547. TOY CRADLE
Osage (Oklahoma), ca. 1910
Flat wood with incised and painted geometric designs and brass tacks on upper portion above beaded head piece hung with small bells. Woven yarn strips across top of head piece fasten to hide strip at bottom.
21¼ x 5½ in.
TU, G.M.T., TR-106

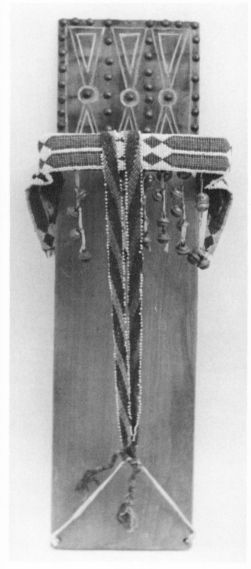

548. TOY CRADLE
Shoshone, ca. 1900
Cloth cover with beadwork on upper portion; small cloth doll enclosed, and mounted over ellipsoidal wooden board.
23¼ x 10 in. max.
TU, E.S., S-2027

Dolls

549. DOLL
Cheyenne, ca. 1890

Cloth; beadwork bands on hide dress, double beaded edge on hide leggings and moccasins.
14¾ in. long
PAC, A.L.D., D-26

550. DOLL
Kiowa, late 19th C.

Cloth and hide construction. Cloth shirt decorated with dyed hide fringe and beaded hide at neck and shoulders. Beaded borders and imprints of brass decorations on hide leggings; double beaded border and tin jangles on moccasins.
15½ in. long
TU, E.S., 31-812b

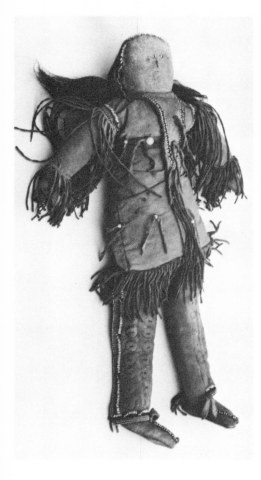

551. DOLL
Kiowa, ca. 1880

Cloth with painted and fringed hide dress, hide boots, beaded choker and belt.
11 in. long
PAC, 76.17.2b

552. DOLL
Sioux, late 19th C.

Cloth and hide construction; beaded hide dress, leggings and moccasins, bead and quill hair ornaments.
10 in. long
TU, B.R., 31-128

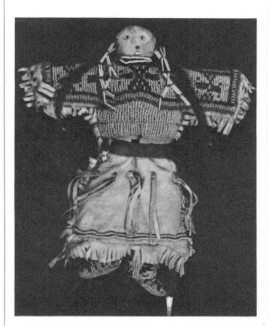

553. DOLL
Sioux, ca. 1890

Cloth; beaded and fringed hide shirt and leggings, beaded moccasins.
13 in. long
TU, E.S., S-2017

Parfleches

554. TOY PARFLECHE
Sioux, ca. 1920

Hide with painted geometric designs.
6 x 5 in.
PAC, R.C.L., MI-2221

Tipis

555. TOY TIPI
Sioux, late 19th C.

Quillwork and fringe decorate hide over stick frame.
14 x 6½ in.
TU, E.S., S-2019M

556. TOY TIPI
Sioux, early 20th C.

Hide over stick frame; decorated with beadwork, quillwork, tin jangles, feathers and hair.
28½ x 15 in.
PAC, Gift of G. H. Davis, P-455

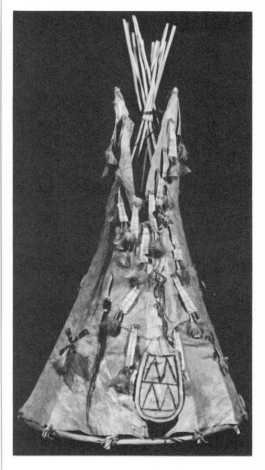

557. TOY TIPI COVER
Sioux, late 19th C.

Beadwork decoration on sides, top and front; tin jangles at front and back of hide cover.
26 in. high
PAC, R.C.L., MI-2128

Quivers and Bow Cases

558. QUIVER AND BOW CASE
Sioux, ca. 1870

Hide cases attached with thongs near top; both decorated at top and bottom with narrow bands of beadwork and long fringe.
Bow case: 26½ in.; Quiver: 18½ in.
TU, B.R., 31-356

WEAPONS & WEAPON CONTAINERS

Clubs

559. WAR CLUB
Osage, ca. 1860
Wooden stock-shaped handle with inset metal blade.
24¾ in.; blade: 8¼ in.
PAC, R.C.L., MI-2167

560. WAR CLUB
Probably Otoe, ca. 1850
Ball-headed wooden club with carved animal at top; horsehair attached to neck and dew-claw rattle looped through tail.
23½ in; head: 3½ in. diam.
PAC, Gift of H.P. Bowen, MI-2681

561. GUN STOCK CLUB
Probably Southern Sioux, ca. 1875
Wood with circles of brass tacks on one side, lines on reverse and tacks on both edges of upper portion. Fur strips, bells, and quill-wrapped hide hang from forward edge.
32 in. long
PAC, N.N.-106

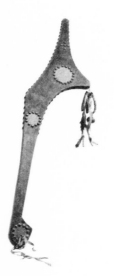

Gun Cases

562. GUN CASE
Crow, late 19th C.
Hide foundation and fringe with beaded decoration.
43 in. long
PAC, R.C.L., MI-2131

Quivers

563. QUIVER
Apache, late 19th C.
One-piece hide foundation stabilized at one side with a stick bound down the entire length. At midpoint the quiver is wrapped with a heavy piece of fringed hide bearing painted geometric decoration, to which is attached a stitched cotton carrying sling. At the mouth and base of the quiver are attached wide bands of red fabric overlaid with cut and pierced bands of hide.
34 in. long
PAC, A.L.D., D-11

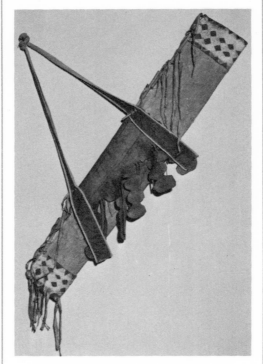

Spear Case Ornaments

564. SPEAR CASE ORNAMENT
Crow (Montana), ca. 1885
Hide with fringe, beading and a bell.
14 in. long
TU, E.S., 31-990

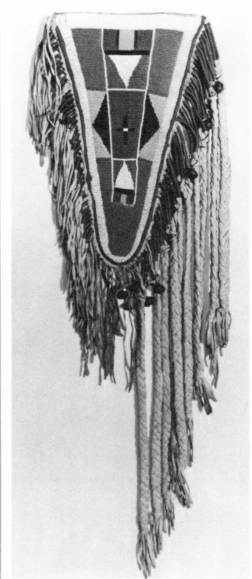

Tomahawks

565. TOMAHAWK

Osage, ca. 1860

Iron blade with five-pointed brass star, set in Osage Orange groove-decorated handle with fur, bells and eagle feather at end. ("Missouri War Axe" type).

21¼ in.; blade: 8 x 4½ in.

TU, G.M.T., TR-71

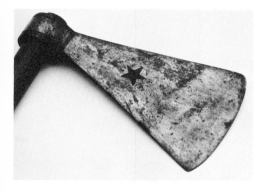

MISCELLANEOUS

Fish Clubs

566. FISH CLUB

Eskimo, late 19th C.

Carved whale bone.

31 in. long

TU, E.S., S-275

Hide Paintings

567. PAINTED HIDE

Shoshone, ca. 1880

Elk skin and pigments. Painted figures in three registers; upper, five buffalo pursued by three mounted warriors; at center a dance ceremony with twenty costumed male dancers and five seated male musicians; lower, seven buffalo pursued by five mounted warriors.

5 ft. 10 in. x 6 ft. 5 in.

PAC, MI-2662

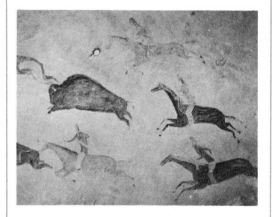

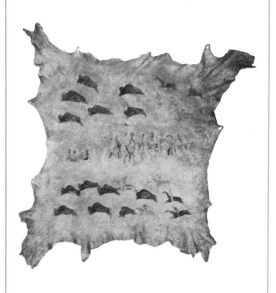

Paddles

568. PAIR OF PADDLES

Haida, ca. 1900

Pair of small cedar paddles, carved and painted.

PAC, MI-2172

Shield Models

569. SHIELD MODEL

Probably Sioux, late 19th C.

Hide stretched over wooden hoop; decorated with pigment and eagle feathers.

17¾ in. max. diam.

TU, E.S., S-2039M

Spoons

570. CEREMONIAL SPOON
Haida, late 19th C.
Carved elk horn inlaid with abalone shell.
12 in. long
TU, E.S., 31-993

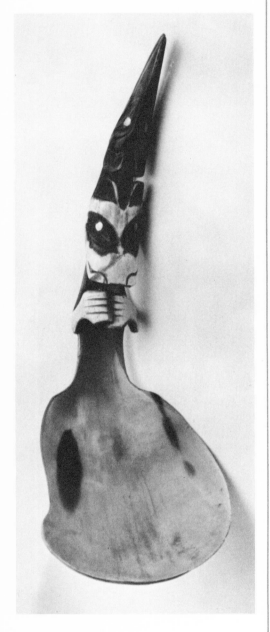

571. CEREMONIAL SPOON
Sioux, late 19th C.
Hide decorated with quill-wrapped handle and quilled, silver jangles.
8½ in. long.
TU, B.R., 31-229

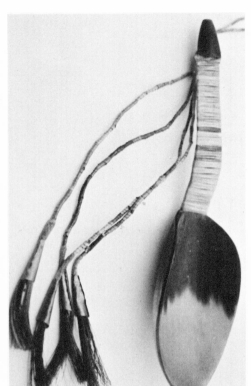

STAFF OF PHILBROOK ART CENTER

Administrative Department

Jesse G. Wright, Jr., President/Director
Marcia Manhart, Vice President/Assistant Director
Frank W. Howard. Chief of Security
Raakel Vesanen, Communications Director
Carol Haralson, Graphic Designer/Editor
Gregory Pitts, Publications Assistant
Elsie McPherson, Executive Secretary
Carolyn Curry, Receptionist

Brad Buffum, Building Superintendent
 Janet Buff, Maintenance
 Johnnie Mae Lemon, Maintenance, part-time
 Rheba Faye Jones, Maintenance
 Darnell Randles, Maintenance
 William J. Rau, Maintenance
 Craig Johnston, Maintenance

John H. Parker, Security Supervisor
 Thomas McKinstry, Security
 Steve Gates, Security
 Susan Cobb, Security
 Harvey E. Bennett, Security
 Dawn Reed, Security
 Richard Johnson, Security
 Anthony Ray Ladd, Security
 Lester C. Neeley, Security
 Gerald P. Howard, Security
 Bascum D. Gates, Security
 Linda Bowlin, Security
 George Shaffer, Security
 William Ryan, Security
 Truman Webster, Security
 Robert Linder, Security

Ralph Bendel, Grounds Superintendent
 Dale F. Everett, Grounds
 Stuart Day, Grounds
 John Douglas Merrell, Grounds
 Julie Hays, Grounds
 Joan Smith, Grounds

Development Department

Helen G. Sanderson, Director of Development
Nancy Durbin, Membership Director
Carmen Cannon, Development Assistant
Sue Vigars, Membership Secretary
Joan Hoar, Volunteer Coordinator

Education Department

Judy Cunningham, Director of Education
Olivia Marino, Curator of Education
Ellen Methner, Assistant Curator of Education
Ronda Kasl, Education Assistant
Heather Paisley, Education Assistant
Michelle Marrs, Public Programs Coordinator
Karen Cochran, Museum School Registrar
Faculty of the Museum School

Exhibitions and Collections Department

John A. Mahey, Vice President/Chief Curator
Christine Knop, Registrar
Isabel McIntosh, Assistant Curator, Indian Department
Charles Taylor, Preparator
Cary Boyd, Assistant Preparator
Rickye Paolucci, Secretary
Thomas Young, Librarian

Finance Department

Michael V. Barnes, Vice President/Business Manager
Louise Grayson, Shop Manager
Carol Ann Perry, Bookkeeper
A. E. Rusin, Bookkeeper, part-time
Dorothy Bread, Secretary
Jennifer Sue Jones, Shop Assistant, part-time

Printed in Tulsa, Oklahoma by R. F. Rodgers Lithographing Co, Inc.
Edition of 5,000

Frontispiece photography by David Halpern